Romi Crawford, Editor

Fleeting Monuments
for the
Wall of Respect

For Margo, Bob, and Zach Eagle

Acknowledgments

This book is an act of commemoration for the Wall of Respect mural. I thus want to acknowledge first and foremost the visual artists of the Organization of Black American Culture (OBAC), the Wall of Respect makers, who in 1967 collaborated on this gift of sorts to a neighborhood on Chicago's South Side: Billy Abernathy (Fundi), Darryl Cowherd, Jeff Donaldson, Elliot Hunter, Wadsworth Jarrell, Barbara Jones-Hogu, Carolyn Lawrence, Roy Lewis, Norman Parish, Onikwa Bill Wallace, Robert A. Sengstacke, William Walker, Myrna Weaver, and Sylvia Abernathy (Laini). Artists who were not members of OBAC but contributed to the Wall include Kathryn Akin, David Bradford, Curly Ellison, Will Hancock, Florence Hawkins, and Eugene "Eda" Wade.

Like the Wall of Respect, this book, more than 50 years later, also emerges out of collaboration. It came together through the efforts of many, but most notably thanks to the steadfast energies of Fulla Abdul-Jabbar and Caroline Picard from Green Lantern Press. From our very first meeting, they were supportive and committed. It was from the start a book based in risk-taking, asking busy artist-thinkers to respond to a prompt to produce something rather hesitant and brief, relative to what they usually make, to memorialize a public artwork that is no longer extant but still holds powerful symbolic weight for those who lean into social justice and freedom of all sorts. I am grateful beyond measure to Fulla and Caroline for their commitment to the process of gathering and retrieving that this project entailed. I am also thankful for their embrace of and care for the work of the makers who contributed to this project in the form of words, art, and images.

I have tremendous admiration for and extend heartfelt thank-yous to the artist-thinkers whose projects bring the fleeting monument concept and this book to life: Abdul Alkalimat, Darryl Cowherd, K. Kofi Moyo, Haki Madhubuti, Robert

E. Paige, Val Gray Ward, Miguel Aguilar, Bethany Collins, Julio Finn, Maria Gaspar, Wills Glasspiegel, Naeem Mohaiemen, Kamau Patton, Rohan Ayinde, D. Denenge Duyst-Akpem, Stephanie Koch, Stefano Harney, Fred Moten, Nicole Mitchell Gantt, Cauleen Smith, solYchaski, Norman Teague, Bernard Williams, Wisdom Baty, Jefferson Pinder, Kelly Lloyd, Damon Locks, Mechtild Widrich, Faheem Majeed, Jan Tichy, Mark Blanchard, Theaster Gates, and Lauren Berlant. The other artists who lend to this book are the courageous and patient design team of Sonnenzimmer.

This book also found support in the form of funding from the Graham Foundation and the Terra Foundation for American Art. Additional assistance came from the Field Foundation, who asked that 1,500 copies of this book be placed in as many public libraries and community centers in Chicago as possible and made available for a reduced cover price of $10. We agreed to this request as it aligns so effectively with the ethos of this undertaking and the Wall of Respect.

Abdul Alkalimat and Rebecca Zorach, co-authors with me of the *Wall of Respect: Public Art and Black Liberation in 1960s Chicago,* loom here too, Abdul ever offering his sage, firsthand knowledge of the Wall history and a more recent account of writer Amus Mor. Haki Madhubuti also imparted useful insights. I thank both of them for keeping the Black intellectual and creative life of 1960s Chicago alive for us.

My ability to realize this project has ultimately been co-determinant with the ongoing availability of, and encouragement I receive from, close colleagues, friends, and family, including Syeeda, Margo Natalie, Melissa, Honey, Bel, Marcus, Say, Malcolm, Dolly, Leslie, Damien, Geoff, Beth, Valerie, John O., Lauren, Mary, Matthias, Kate, Shawn, Kym, Izzy, Saskia, Myiti, and Hanna. Among those very close and dear, I thank my parents. Their pressing love of Black people has been a compelling inheritance. Tim's love and remarkable spirit always portend hope; and Zach Eagle, who at 11 loves the play of words, has been the best motivation, my sun.

Fleeting Monuments and the Wall of Respect

BY ROMI CRAWFORD

Yet, against the tendency of contemporary forms of amnesia whereby the archive becomes a site of lost origins and memory is dispossessed, it is also within the archive that acts of remembering and regeneration occur, where a suture between the past and the present is performed, in the indeterminate zone between event and image, document and monument.
—Okwui Enwezor [1]

There has been a lot of debate in the past few years about either tearing down or speaking back to outmoded monuments, especially those that were erected with intentional or unintentional racist and/or sexist agendas. *Fleeting Monuments for the Wall of Respect* proposes to ignore some of the conflict that surrounds the relevance, history, and existence of such monuments in an effort to recognize and shed light on other histories and battles (both literal and metaphorical) that are neither spoken of as often nor writ in such a declarative way—with obdurate materials and at a lavish scale—onto the town or city landscape.

In other words, one way to complicate the current dialogue around monuments is to not take part in a way that directly concerns those iconic monuments in question—those of historic figures such as Christopher Columbus or Confederate heroes such as Robert E. Lee and Stonewall Jackson. While many of these have been rightly removed or challenged through activism and interventions, such as artist Kehinde Wiley's *Rumors of War* (2019), which mimics the Confederate sculptures on Monument Row in Richmond, Virginia, but makes the heroic subject a young African American man with dreadlocks and contemporary clothing; they might also be ignored more adamantly. Or, one might consider at least how the contemporary moment's stress about monuments may be used as an opportunity to bring consciousness to undervalued histories, in this

1 Okwui Enwezor, *Archive Fever: Uses of the Document in Contemporary Art.* (New York, N.Y.: International Center of Photography, 2008), 46.

9

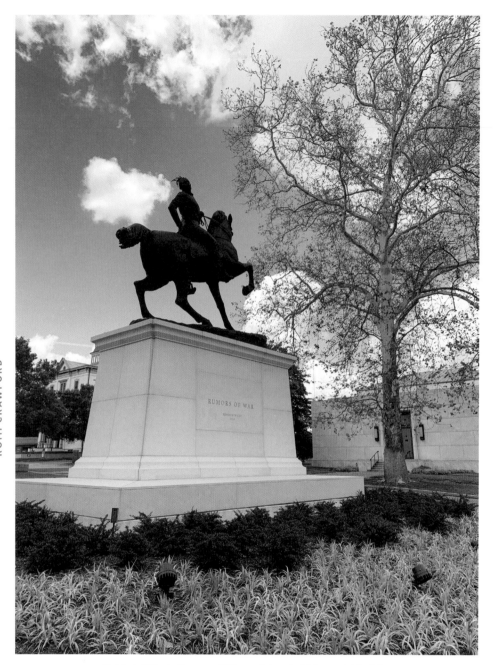

ROMI CRAWFORD

Kehinde Wiley's *Rumors of War* sculpture in Richmond, Virginia.
Courtesy of Valerie Cassel Oliver, 2020.

case African American histories that have not been noted or confirmed on the landscape of the city in any way, much less monumentalized. How might such non-monumental histories be recognized—and in decidedly non-monumental ways? That is to say, how do we recognize histories that are more hesitant, experimental, affective, personal, and minor in scale—those that don't assume a universal or grandiose significance? This is the looming question posed by this book, which asks readers to consider a wider range of possibilities for producing an honorific relation to historical events and persons.

Expanding modes of memorializing inevitably broadens the range of stakeholders. It allows for encounters with the historical event that align with the vicissitudes of personal politics as well as divergent and shifting interpretations of who/what constitutes a worthy historical subject. The normative tactics of memorialization include the use of enduring materials such as bronze or stone, staging the event/person at a larger-than-life scale, and assuming a universalist perspective or take on a given historical concern. But these are reductive and hackneyed. What other media, forms, durations, values, and scales can the memorializing endeavor inhabit? Can the effort to commemorate be something other than a static object? Instead of using a fixed mass of some precious material such as stone or metal, how can the endeavor to memorialize be more fleeting and subjective, a more evanescent, unruly, or intimate event or project? Projects of this sort are better adapted to historical revision and reinterpretation, which has recently problematized the very presence of Columbus bronzes across the country. As such, they anticipate and make a point of the fallibility or potential demise of any memorialization project.

In addition to speculating about new forms of monument-making, this book also makes a case for articulating spaces, events, and scenarios that are underdiscussed or erased historically, that might warrant marking, but in a manner that is less than monumental, that is in some way anti-heroic, un-static, and in no way timeless—what I deem here as "fleeting monuments." In effect, *Fleeting Monuments for the Wall of Respect* offers a retort to the current monument fever, addressing the problem of monuments by amplifying an alternative history of praiseworthy sites and subjects. The recent debate on monuments challenges those in the American South and elsewhere that were often erected to assert the power of certain men and their actions. They were often designed, like those on Monument Row to ward off African American citizenry with less economic and social power from egress through the city. This book moves the responsive energies around these historical monuments in a new direction, away from them for

Chicago street sign in honor of house music legend Farley Jackmaster Funk.
Copyright Romi Crawford, 2018.

a bit and towards minor and minority-centric histories, of people who live within a web of exigencies related to gender, race, class, ethnicity, sexuality, and ability or those whose accomplishments are overlooked and in some instances expunged from local and national recognition.

Fleeting Monuments for the Wall of Respect actively connects the current trouble surrounding monuments with the related dilemma that certain histories—social histories, art histories, the histories of non-white peoples—are not properly commemorated. When there is tribute to these stories, it is often through the familiar, unimaginative language of street signage, statues, and plaques. While the street sign works against pedestalizing, it is perhaps too generic and routine a gesture, one which fails to precisely address how the subject intervenes historically. The *Fleeting Monuments for the Wall of Respect* endeavor expands upon and suggests a greater range within the repertoire. It first proposes addressing histories and events that are underrecognized, and then it recommends celebrating them differently—with fleeting tributes that are necessarily and adamantly occasional, hesitant, small, impermanent, personally experienced, and not precious or costly.

Why the Wall of Respect?

The fleeting monument as I conceive of it here has more than a hypothetical or speculative bearing. The history of the Wall of Respect offers a constructive case in point. The Wall of Respect was a 1967 public artwork, a mural, at 43rd and Langley on Chicago's South Side. It was a decisive artwork in the Chicago Black arts movement, featuring portraits of Black heroes and heroines in the areas of music, literature, dance, politics, religion, theater, and sport, including figures such as John Coltrane, Nina Simone, Billie Holiday, Malcolm X, Muhammad Ali, W. E. B. Du Bois, Darlene Blackburn, and others. Produced by the Organization of Black American Culture (OBAC) and rendered by Chicago artists—including William Walker, Wadsworth Jarrell, Jeff Donaldson, Barbara Jones-Hogu, Elliot Hunter, Carolyn Lawrence, Norman Parish, Onikwa Bill Wallace, Myrna Weaver, Sylvia Abernathy (Laini), Kathryn Akin, David Bradford, Curly Ellison, Will Hancock, Florence Hawkins, and Eugene "Eda" Wade, as well as photographers Darryl Cowherd, Robert Sengstacke, Roy Lewis, and Billy Abernathy (Fundi)—it also became an important platform for Black music, poetry, and political events. Musicians including Joe Jarman

13

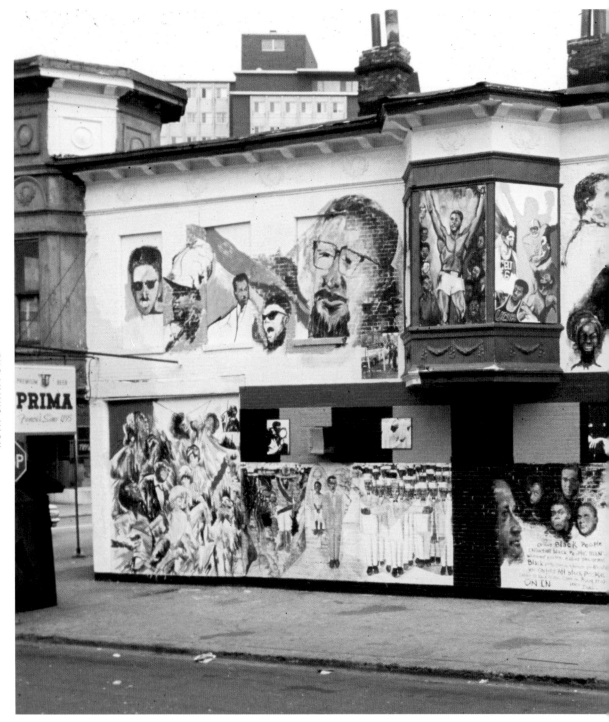

Robert Sengstacke, Wall of Respect, Chicago, 1967.
Copyright Robert Sengstacke estate, courtesy of Myiti Sengstacke.

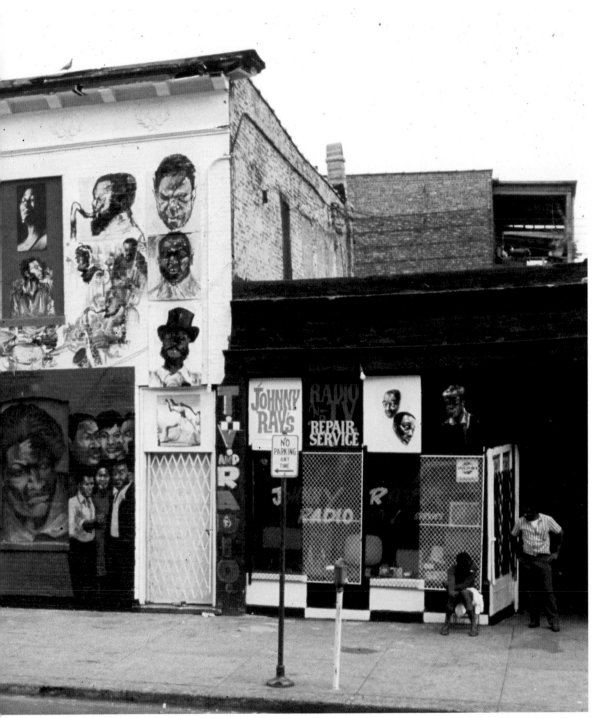

Wall of Respect site at 43rd St and Langley Ave, 2017.
Copyright Romi Crawford.

and Roscoe Mitchell and poets such as Amus Mor, Gwendolyn Brooks, and Haki Madhubuti all practiced at the Wall site.[2]

The Wall of Respect only existed for approximately five years. By 1972, the building on which it was painted was demolished after a damaging fire. If one goes to 43rd and Langley in Chicago today, there is no sign that it was ever there. While it sparked a citywide and nationwide mural movement, while it was an influential work in the context of Chicago's Black arts movement, and while it remains a potent memory in the hearts and minds of those who collaborated on its creation and those who witnessed it some fifty years ago, the Wall of Respect is mostly unknown. Given its art-historical and social significance, the Wall of Respect needs to be recognized in some way. With this book, I argue against making a monument of or at the site, and for paying tribute to it in ways signaled by its very existence.

The Wall of Respect offers the perfect case and opportunity to think about acknowledging important historical events and persons in more fluid and experimental ways than traditional heroic monuments because it instructs against such permanence. Instead, it proffers the spirit of collectivity, collaboration, reduced-capital, trans-disciplinarity, impermanence, experimentation, and improvisation.

All of these traits offer appealing methodological cues for differently marking an historical happening and consequently informed the prompt I gave to a range of practitioners with and without personal experience of the Wall of Respect. These practitioners were asked to realize a "fleeting monument" commemorating the Wall of Respect, with little to no money and in a rather short time frame. They were also prompted to work against it being timeless, static, or too grand. The works collected in this book are thus varied, but they all adhere to one or several of these advisements while also addressing in their own way the memory of the Wall of Respect and its archive.

These works attempt to re-animate the history and public memory of the Wall of Respect on the terms upon which it was produced and the aesthetic propositions it produced. Yes, the Wall of Respect was a noteworthy work within the context of public art and the Black arts movement, but it is also compelling on a conceptual level. Moving the history and memory of the Wall of Respect forward then requires not only establishing

ROMI CRAWFORD

2 For a detailed history of the mural see the following: Abdul Alkalimat, Romi Crawford, and Rebecca Zorach, eds., *The Wall of Respect: Public Art and Black Liberation in 1960s Chicago* (Evanston: Northwestern University Press, 2017). Wadswoth A. Jarrell, *AfriCobra: Experimental Art Toward a School of Thought* (Durham: Duke University Press, 2020). Jeff W. Huebner, *Walls of Prophecy and Protest: William Walker and the Roots of a Revolutionary Public Art Movement* (Evanston: Northwestern University Press, 2019). Rebecca Zorach, *Art for People's Sake: Artists and Community in Chicago, 1965–1975* (Durham: Duke University Press, 2019).

or pointing out the importance of its animating concepts and methods (i.e. collaboration and improvisation), but also providing a platform for these concepts so they have a dynamic relation to its history. There are things to be learned from the Wall case, and to historicize it without moving these epistemological precepts forward presupposes that what Black artists and thinkers know is less significant than what they do. The *Fleeting Monuments* project brings forward the methodologies learned from the Wall as well as its social message, methods which might be drawn upon to revise our sense of monument-making.

Hesitancy, Improvisation, Sentiment, Experimentation, and Impermanence

ROMI CRAWFORD

The Wall of Respect was a complex work of art. It included painting as well as photography and poetry on its surface. In addition, activists, musicians, playwrights, and poets brought an exogenous layer of art-making to the site around the Wall. A commemoration of the Wall that aligns with this complexity is compelling. Also relevant is that the Wall was conceived and made by a collective of at least fourteen artists who variously agreed and disagreed on its elements and the articulation of heroes and "sheroes." In fact, the Wall of Respect was edited or revised several times. Contestation is in fact an important part of its history. The contest of form at the Wall of Respect and the occasional disagreements among the artists about content, as well as the radicalism of its makers, necessitates a form of commemoration that is comparably complex, dynamic, unruly, and tentative. Fixing the Wall's history through simple, hierarchical forms would make it seem like a fait accompli epistemologically, whereas its history points to myriad voices, interpretations, and revisions. Giving weight to any single node of its existence would seem to ignore these cues and significations.

Following from the plurality of the Wall of Respect phenomenon, *Fleeting Monuments for the Wall of Respect* also offers an array of forms. The fleeting monuments collected here run the gamut from works of art to poetry to prose to personal reflection to photography to criticism. Some portend new forms. They together propose a unique take on commemorating the Wall of Respect and simultaneously suggest new strategies for producing shared

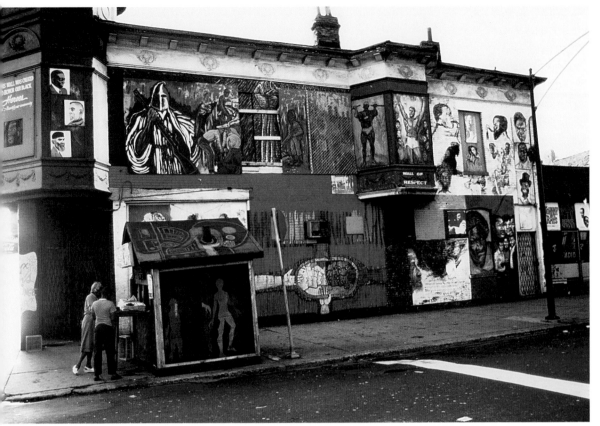

Revised version of the Wall of Respect, 1969.
Copyright Bob Crawford, courtesy of estate.

memory of an historical event. Instead of relying on a traditional, singular, iconic, and uniform edifice to symbolize the historical merit of the Wall of Respect, this collection produces a polyvocal effect that signals (1) an ever-expanding corpus and (2) myriad personal ways into its history. In effect, these works are invitations. They invite everyone to reconsider the tradition of monument-making while also providing alternative strategies for exercising public memory of an historical topic.

While each project is distinct, the fleeting monuments collected here reveal noteworthy patterns and echo formal concerns evidenced at the Wall of Respect. These might be instructive and useful in producing fleeting monuments for other historical events that are also under-recognized and warrant tribute of some sort. Some of the repeated logics that show up here include hesitancy, improvisation, sentiment, experimentation, and impermanence.

These logics also helped to inform how I have interpreted and curated the fleeting monuments that appear in this book. The five sections that follow serve as framing devices for the various works made in response to the prompt. The first section, "Legacy Monuments," includes entries from or about participants and/or collaborators with a lived experience at the Wall of Respect, including the founder of Chicago's Kuumba Theater, Val Gray Ward; the OBAC co-founder Abdul Alkalimat, who was instrumental in conceiving the Wall of Respect; Third World Press founder Haki Madhubuti, who wrote a dedication poem for the Wall of Respect's 1967 inauguration; designer Robert E. Paige, who was a regular participant at the Wall site; and Darryl Cowherd, whose photo of Amiri Baraka is perhaps the only remaining piece of the original Wall of Respect mural. Their contributions to this book are key because they point in two directions at once: to their current work and to their history in connection to the 1960s Black arts moment. Rather than a full retreat into nostalgia, the fleeting monuments produced by this cohort of Wall of Respect stalwarts observe the present as much as the past.

This is followed by a section of "Gift Monuments," which situate and emphasize the significance of social and political alignment to the concept of fleeting monuments. Unlike traditional monuments that are steadfast in their public-ness (in city centers or on main thoroughfares) and often impossible to ignore whether one adheres to the politics of the historical situation or not, fleeting monuments can be observed or not, depending on the degree of alignment one has with the politics of the event they mark. If, normatively, monuments, and the making of them, are politically charged, then fleeting monuments allow for a more trenchant acceptance of that fact while also defining the terms of alignment at an individuated level. This section includes gifted works by Chicago-based artists whose practices of community engagement and social justice align with the aesthetic mores of the Wall of Respect makers, who worked with the people who lived proximally to the Wall. Mural makers and graffiti artists such as Maria Gaspar and Miguel Aguilar present examples of their work as fleeting monuments to the Wall of Respect because of the impact the mural had on their practices and the commitment to community they extend into the current era.

Artists Bethany Collins and Naeem Mohaiemen offer works that encapsulate notions of social critique similar to those represented by the Wall of Respect. Other works, such as those of Kamau Patton, Rohan Ayinde, Wills Glasspiegel, and Julio Finn, recognize the relevance of form (poetry, dance, process) to the Wall history. They are gifts in appreciation of the Wall of Respect and its history, just as the mural itself was a gift,

given to the Black community out of love and respect. This reveals the Wall of Respect as part of a gift economy that incites flows of gifting as part of commemoration.

The "Reflective Monuments" in section three address the Wall of Respect history more directly than the "Gift Monuments." They respond clearly and immediately to the critical potential that emerges from the Wall of Respect history as well as the fleeting monument prompt. Stefano Harney and Fred Moten, whose collaborative writing practice is in tune with the Wall of Respect's ethos of collaboration, think through and interrogate the value of heroes within the context of Black culture, serving as a reminder of the critical revision that produced several versions of the Wall. Artist Cauleen Smith and designer Norman Teague posit personal reflections on their experiences of the South Side of Chicago and share how their work, like that of the Wall makers, was shaped by South Side communities. Smith and Teague share unofficial, off the art historical record, information about the evolution of their practices in the process. Their projects reveal how artists might connect to their art histories on their own terms.

Bernard Williams, a Chicago-based muralist who worked for a period in the tradition of Bill Walker, one of the central Wall of Respect painters, does not render an image of his mural works but, instead, postulates a brief, minor reflection on nature as it relates to mural form. Other abstractions and improvisational works include those by solYchaski, D. Denenge Duyst-Akpem, and musician Nicole Mitchell Gantt, who usually conceptualizes in the language of music but, like Wall artists who experimented with multiple forms, writes for this occasion. The Wall of Respect history and the prompt that follows from it signals even to a master improvisator the freedom to experiment further. Similarly, curator and gallery founder Stephanie Koch draws upon the Wall of Respect's innovative commitment to outdoor, street-level exhibitions by conceiving and conceptualizing a model of collective exhibition-making. These projects which reflect upon or are reflective of the Wall of Respect history point to art-making and art histories that are spurred by its formal openness and the innovation that it compels.

The "Make and Do Monuments," which comprise the fourth section of the book, also are explicit responses to the fleeting monuments prompt. Kelly Lloyd's tear-off fliers, with quotes from Wall of Respect heroes and "sheroes," to be made and then posted on bulletin boards and in semipublic places; Wisdom Baty's workshops for Black mothers; Mechtild Widrich and Jefferson Pinder's scores for moving through the South Side of Chicago; and Damon Locks's listening list all suggest active ways to engage the Wall of

Respect's history. These works stress the importance of self-direction and choice in the project of monumentalizing. They focus on the micro and personal scale of fleeting monuments, which can serve individuated needs and desires to mark historical events and people. They remind us that citizenship does not depend on a universalized relation to national history and memory. Your monument is not my monument, and mine is not yours.

The final section, "Remnant Monuments," attends to what's left behind after the historical happening. It implicates modes of memorializing with those remains. Documentation from a 2017 exhibition that I curated, *Radical Relations! Memory, Objects, and the Generation of the Political*, literally pulls together items that belonged to an intimate cohort of the artists, educators, poets, and political organizers who were involved as makers, and participants at the Wall of Respect. The exhibition captures and stages "odds and ends as well as loose ends" of Chicago's Black arts movement. Theorist Lauren Berlant's contribution points to the significance of critical eavesdropping on a historical object that one doesn't have direct experience of. Photographer Mark Blanchard's digital renderings of the Wall's locale project a sterile future. Meanwhile, Faheem Majeed's tracing of the Wall site and Jan Tichy's documents of muralmaking in the Cabrini-Green projects, as well as his *Fleeting monument* (2019), attest to the potency of emptied or abandoned spaces and delineating, rather than forgetting, histories of failed social progress. Artist Theaster Gates also questions vacancies. His inscriptions of the names of participants at Black Artists Retreat over the past seven years onto a black background comment upon the historical need and desire for Black collectivizing such as that which took place in the making of the Wall of Respect.

These fleeting monuments variously resurrect the scene of the Wall by exposing the residue and remnants of its upsets and injuries (social, economic, art worldly). The Wall of Respect had a short life, five years, yet the economic and social oppression of Black people, which the Wall of Respect sought to counter in 1967 with a message of love and respect, prevails and endures. The "Remnants" section quietly intones the flow of the civil rights era past into the Black Lives Matter era present. Staging the overlap of these two time periods exposes the persistence of racial oppression, which is more and more evident as a through line or historical constant in the United States.

Living Scale

They strike one above all as giving no account of themselves in any terms already consecrated by human use; to this inarticulate state they probably form, collectively, the most unprecedented of monuments.
—Henry James [3]

As a collection, the *Fleeting Monuments for the Wall of Respect* projects reveal an archive of generosity, alterity, the impermanent, the improvised, the hesitant, the revised, the sentimental, and the contested—all indicated by the Wall of Respect as viable strategies for recalling and marking its history. One of the ways to honor and acknowledge the Wall of Respect is to fully take in these epistemological cues that evolved from the Black radical tradition that produced it. And yet, while the Wall of Respect history espouses a type of impermanence, there are definitely minor histories that justify a more lasting form and a more commanding scale. The Chicago Torture Justice Memorial, *Breathe, Form, and Freedom*, for example, is an impending Chicago tribute that would be the first of its kind to commemorate the victims of police torture and violence, and might necessitate a brick-and-mortar memorial structure. Due to the particular nature of offenses which doubly silenced the men who were tortured, the reparatory context may demand a memorial full of presence and visibility. Just as the Wall of Respect messages the potential for memorializing in minor, fluid, ephemeral, and personal ways, the particulars of this torture history messages its own cues for memorialization—in this case, perhaps more enduring materials, an adamant recitation of the names of all who were victimized, and a place for the previously incarcerated to meet. In their own way, both monument forms (those slight and unheroic and those more resilient) actively challenge the norms of singularity and grandiosity, and lead the way towards envisioning a wider, more elastic span of options for paying tribute.

In fact, flexible, adaptable, improvisational, quick, low/no-budget, impermanent, living-scale monuments are not new. We witness them all the time but they often fail to register because they are too slight in size, temperament, and materials. Such monuments evolve out of an urgent need for them to exist. They are not stalled by the procurement of finances or approvals from city officials. This connects the Wall of Respect, which was

ROMI CRAWFORD

3 Henry James, *Lady Barbarina, The Siege of London, An International Episode and Other Tales* (London: MacMillan and Co., Limited, 1908), p. xvi. Epigraph to James Baldwin, *Another Country*, Vintage, 1962. Baldwin was depicted in the "Literature" panel of the Wall of Respect.

not officially endorsed, to such frequent, everyday, urgent memorials—not unlike those made in honor of George Floyd. While there are plans for a city-sanctioned George Floyd memorial at the intersection of 38th Street and Chicago Avenue in Minneapolis, with signage that designates the area as George Perry Floyd Jr. Place, a popular mural was made shortly after his death from police violence. Like the Wall of Respect, the now-iconic Floyd mural is a gift, rendered by several community artists who wanted to portray him as a "hero." [4] For the Wall artists in 1967, Coltrane, Ali, DuBois, and Baraka were Black heroes worth memorializing. In 2020, George Floyd is interpreted as a hero.

The monument idea can hold a wider range of proclivities and gestures and should, now that the limits of traditional monument-making are apparent. *Fleeting Monuments for the Wall of Respect* is a call not only to make new monuments but to recognize and make legible the range of monuments that exist or might be made to memorialize histories that matter along wider, more complex, axes of identification. Monuments of the type I suggest can't be toppled because they are never pedestalized, neither literally nor figuratively. Rather, the works amassed here expose the significance of applying a living scale to historical events, memorializing an historical occurrence through a range of more delicate, faint, evanescent gestures rather than a "larger-than-life" paradigm that insults and disparages so many of the Nation's citizenry. This allows for taking in the historical incident with its discrepancies, contradictions, shortcomings, disarticulations, soul, and fleshiness intact.

4 Nadja Sayej, "The Story Behind The Mural At The George Floyd Memorial," *Forbes*, June 4, 2020.

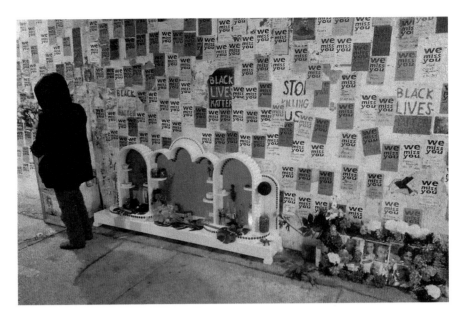

This Black Lives Matter Neighborhood Memorial in Rogers Park, Chicago, records the names of people who were killed by police from 2014 to the present and continues to grow. Managed by Matthias Regan, members of the P. O. Box Collective, and neighborhood volunteers.

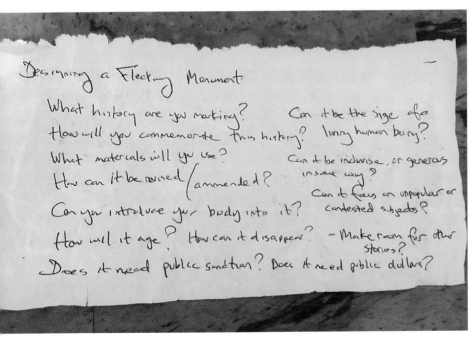

"Designing a Fleeting Monument," notes, 2017.

25

I.
Legacy
Monuments

Abdul Alkalimat
Darryl Cowherd
K. Kofi Moyo
Haki Madhubuti
Robert E. Paige
Visiting Val Gray Ward

I. Legacy Monuments

The commemorations in this section are by a varied group of practitioners who have a lived experience of the Wall of Respect. They were there in 1967 and either contributed to the actual making or conception of the mural, or performed at the 43rd and Langley site.

Abdul Alkalimat co-founded, with Conrad Kent Rivers and Hoyt Fuller, the Organization of Black American Culture (OBAC), which initiated and conceived projects and initiatives around the matter of Black culture, including the Wall of Respect. Here, Alkalimat memorializes a poet whom LeRoi Jones (Amiri Baraka) lauded as among the most talented of his era, Amus Mor, who read and performed at a Wall of Respect publicity meeting in 1967, but who seldom published after the 1970s.

Darryl Cowherd's commemoration is also couched in this section because he was one of the original OBAC artists who collaborated on making the Wall of Respect mural. Cowherd's photo of LeRoi Jones (Amiri Baraka) was removed from the Wall before it expired, making it perhaps the only remaining physical object to mark its legacy.

Other members of this cohort were active participants at the Wall site. They contributed to its ethos and mission but would not be considered producers of the Wall in a literal sense. These include Val Gray Ward, founder

of the Kuumba Theater, and poet Haki Madhubuti, founder of Third World Press, who, like Gwendolyn Brooks, wrote a poem titled "The Wall" for its inauguration event in 1967. Both Gray Ward and Madhubuti (known as Don L. Lee at the time) performed at the Wall site. The Wall simultaneously helped to animate their practices, and their participation at the Wall of Respect brought an additional layer of form (poetry and theater) to it. The Wall supported their work, and their work added to its formal scale and ambition.

Photographer K. Kofi Moyo was not among the photographers noted for working on or at the Wall of Respect, but he was their contemporary and documented areas and pockets of Chicago's South Side that were connected to the Wall scene, such as 63rd Street Beach, where AACM musicians performed, and the Institute of Positive Education. His images of events at these locales expose the wider version of the conversation about Black culture, art, and ideas that the Wall of Respect makers were involved in.

In addition, this section includes several commemorations, not by but of deceased artists who worked on or at the Wall of Respect, who are lesser known or for the most part forgotten. In this spirit of acknowledgment, the design artist Robert E. Paige's contribution recognizes several of those who gravitated (for various reasons) around the Wall of Respect, including Sylvia Abernathy, the woman noted for the design of the Wall, and her husband Billy Abernathy, one of the photographers who contributed to the mural. Through his fleeting monument for the Wall, he commemorates the legacy of Wall artists who are unable to enjoy the moment of its art historical appreciation.

Abdul Alkalimat

the Amus Mor Project

As one of the cofounders of the Organization of Black American Culture (OBAC), the organization that germinated the Wall of Respect idea, Abdul Alkalimat (Gerald McWorter) has a very close connection to the Wall's history. He was on the ground during its production, attending many of the planning events and meetings that preceded the Wall's unveiling in 1967. Alkalimat went on to make Black cultural work his life profession; he has been a scholar and sociologist of African American Studies for the past fifty years, and has made important contributions to the field. His fleeting monument for the Wall of Respect pays tribute by shining light on an underexposed and often forgotten poet, Amus Mor (David Moore), who performed at the Wall of Respect publicity meeting in 1967. Mor, with signature poems about John Coltrane—"The Coming of John" and "Poem to the Hip Generation"—was considered one of the most promising poets of the Chicago Black arts scene yet is virtually unpublished.[1]

Alkalimat and other writers connected to Chicago's Black arts movement of the 1960s formed a working group in 2017 called the Amus Mor Project in an effort to pull together a compendium of the little-known poet's work. Alkalimat writes about his and the group's efforts to bring recognition to Mor and to make his poetry available to present-day audiences. Their collective project mirrors the work that went into the making of the Wall of Respect in the 1960s, and Alkalimat uses his own legacy to produce a biography and legacy for his lesser-known contemporary as his fleeting monument for the Wall of Respect. —RC

1 Amus Mor's work was published in *Negro Digest* in 1969. See David Moore, *Negro Digest* (September 1969), 62-63.

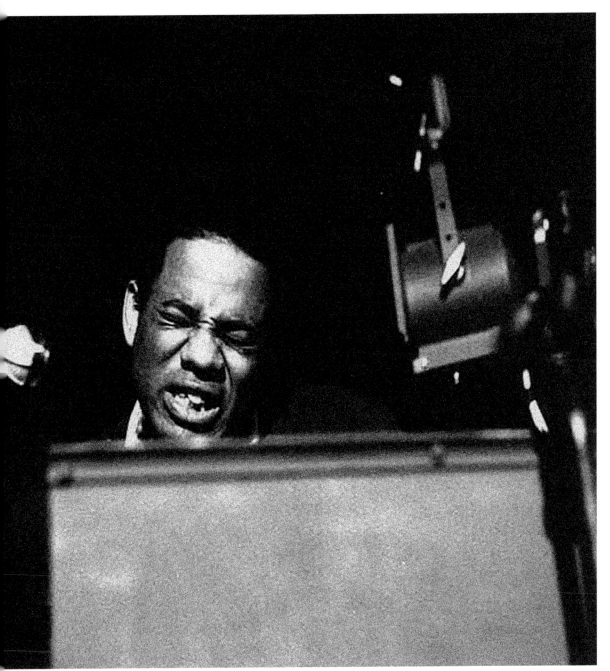

Poet Amus Mor who read at the Wall of Respect publicity meeting, 1967.
Copyright Bob Crawford estate.

Why Amus Mor? Why now?

BY ABDUL ALKALIMAT

Memory is crucial. We always make ourselves stronger in consciousness and culture by remembering those special ones who have made our lives special. Amus Mor was that kind of brother. We have to remember Amus, named at birth David Moore. We affectionately called him Moose cause he was a big dude. We remember Amus for his genius, but we also remember him to honor ourselves. He was our poet.

The sixties were a generational experience, a revolutionary transformation in being Black in this land that was both our home and our prison camp. We reached back and deep into Blackness. Of course this meant that we found ourselves exploring the outsider knowledge that had helped Black people survive America. This was religion, astrology, secret societies, and the prophetic knowledge of wise men of the ghetto: Ali the Star Gazer, KeRa the Cosmic Speaker; Mr. Black the healer; the musical visionary Sun Ra; [Mitchell] Caton, "The Stranger"; the communist Ishmael Flory; the labor activist Tim Black; the food doctor Alvenia Fulton; and many, many others.

We saw power amassed by the Black Panthers—by the teen nations Black Stone Rangers, the Vice Lords, and the Devils Disciples—and so many other young brothers and sisters emerging in the turfs of ghetto blocks and street corners. Gus Savage, Bennett Johnson, Charlie Hayes, and even a transformed Ralph Metcalfe challenged the "Silent Six" Black members of the city council who served master Mayor Daley. We closed down the school system in 1963–64, took the city to the March on Washington and the Mississippi Summer Project. Black Power was alive and well in Chicago.

Black music in Chicago was exceptional. We had Jerry Butler the Iceman, Curtis Mayfield, Muddy Waters, Buddy Guy, Junior Wells, Koko Taylor, Oscar Brown Jr., Terry Callier, Ramsey Lewis, and so many more trained by Captain Dyett at DuSable High School. On the cutting edge was the Association for the Advancement of Creative Musicians (AACM), led by Muhal Richard Abrams. AACM embraced Moose as their poet and you can still hear him on a recording by Muhal.

Amus was the poet of that moment, but his meaning was deeper than the front page of the newspaper. He was deep into our culture and as such spoke our language and affirmed the universality in our particularity. Check this Amus Mor August 1966 poem, "Kiss of Creation":

they first heard bird after recess
when the october sun was a giant ball of energy
over the post war brick
two years from the bomb
he kissed delores perry
under the steps of the new building
and he was just beginning to itch the vibrations
that they were living in the bible
(Holy Koran, Cabala)
taking a primer flight
into the eternal
into a black face that was origin
just knocking a slob
and receiving all that magic
from supremacist lips
told him
that he had never even known
the slightest inkling of beauty or truth
till his autumn 12
he'd seen that mystic slant of eye
the mississippi delta rebirthed
but never really heard his father
talking directly from the books until that now
he looked and found
that his whole maternal family
and even the african methodist church
had been put into a trick bag
and could never envision
eden on an ethopian river
know the blackness of their savior
the 12 original churches
kenya's nitty gritty
the 12 eye mims
creation as a black man's arabic marking
or a land called kim
they would never even see the sun moon and stars
because they couldn't know to want to
dig the heavens above
the tanzanian city
the 5 noblemen

stood around the 7a door
gerald boping as he rapped
 "come on over to mah crib.
 ah got some jams by bird.
 awright na you spose ta know
 so much, who is zat? what do he blow?"
 "you talkin about charlie parker,
 Jim. he mah cousin, blow much alto saxophone."
he said
and so they walked to the ice cream parlor
a starspangled sugarbowl dream
on the highway
the semi trailers just out
with new diesels on the cabs
putting him in mind
of the white bands intermission trombone riffs
the country gone up afresh in herb smoke
off and running to 'obblade' or nowhere really
like the pavement and the trucks
some of the aware cats were saying then
that revolution would be one day
and that the planet pluto would break off
sending a piece a comet lighting the heavens
on the last american evenings
him and his little man
would just walk bad
up to the nickle venda
and play tunesia's night to shake them up
then lay back
the corners of their mouths turned down
like the street addicts they admired
and the kids would turn their backs
and wait for 'looey jerdans'
boogie real close with the blue lights way down low
the start to bellyrubin
so flush up on one another
they might as well be havin on the same pair of drawers
how could they know any of it
or get any of it
with this world just out (oct 1947)

> how could they even begin to dig
> the changes they'd go thru finding out
> that wisdom is justifiable of her children

I had been collecting Amus's work since the mid-1960s, as a grad student at the University of Chicago. Conrad Rivers and Hoyt Fuller led me into the texts of Black literature, but Moose helped me to vicariously experience being hip, to become hip. To the mainstream he was an outsider, but as such his path was deeper into the knowledge we needed than those who adapted for acceptance by that mainstream.

Through work on the Wall of Respect with her daughter Romi Crawford, I met Margo Crawford and we found that many of us were on the same page. We had to anchor Moose the poet into our memory. We had all lost touch with him. We didn't even know if he was alive. It was like the Wall of Respect: an experience we all remembered, including when Moose the Poet was at the Wall himself. With members of our generation starting to make their transitions, we decided to act.

We set up the Amus Mor Working Group with the mission to publish his work and our memories of him. We pulled a beautiful group together: Sterling Plumpp, Pat Akins, Catherine Slade, Robert Starks, Roy Lewis, Darryl Cowherd, and Carol Adams.

We have been meeting, sharing memories, and reaffirming our mission. Every community has to remember its own, and that's what we are doing with Moose. He was our poet and as we remember him he can be your poet. Long live Amus Mor!

Darryl Cowherd

Photography was one of the distinguishing elements of the Wall of Respect mural. The painted depictions of Black heroes and "sheroes" were complemented by more realistic photographic portraits of contemporary heroes, such as musician Nina Simone, choreographer and dancer Darlene Blackburn, and poet LeRoi Jones (Amiri Baraka). These images, rendered on particleboard-like material, were affixed to the surface in respective sections of the Wall's first iteration.

Darryl Cowherd was one of the original cohort of OBAC photographers, along with Bill Abernathy (Fundi), Bill Wallace (Onikwa), and Ed Christmas. Later, Roy Lewis and Robert Sengstacke "passed auditions to contribute images to the mural's surface". Cowherd's image of LeRoi Jones speaking in Chicago in the late 1960s was placed in the "Literature" section of the Wall. Several years after the making of the Wall of Respect, when it was less cared for, Cowherd brought a ladder to the site and detached his photograph from the surface. It is now believed to be perhaps the only extant fragment of the Wall.

The selection of photographs that Cowherd offers to commemorate the Wall of Respect come from his archive of photographs from the period. Several images of the Wall of Respect itself reveal the changing content and revisions that made it a fluid artwork. The return to archives, the move back into the time and space of 1960s Chicago, is a resounding commonality in this section.

The archive is the site of often-curtailed practices. During the 1960s, 1970s, and 1980s, because there were few opportunities for Black artists to exhibit their work, Cowherd and others like him regularly moved into other careers. For marginalized artists working in the 1960s, an artistic career was sometimes brief. Cowherd's fleeting tribute to the Wall of Respect signals the potency of artistic careers which, like the Wall of Respect, have a very certain time span. His photographic archive endures, and images from it have been deployed in exhibitions such as *Wall of Respect: Vestiges, Shards, and the Legacy of Black Power* at the Chicago Cultural Center, *Never a Lovely So Real* at the Art Institute of Chicago, and *The Time Is Now* at the Smart Museum. His piece of the Wall of Respect has been in the *Soul of a Nation* exhibition that toured the United States and abroad. Cowherd's archive, as part of the Wall's legacy, may have extended the span of his art-making career. —RC

Darryl Cowherd's photo of Amiri Baraka from the Wall of Respect
on display at the Tate Museum in the *Soul of a Nation* exhibit.
Copyright, T.F.C. Knowles, 2017.

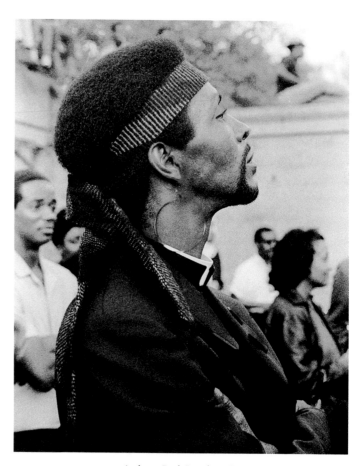

Jackson Park Beach, 1967.

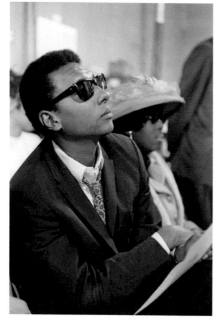

Activist Stokely Carmichael in
Chicago church, circa 1966–67.

Stocking Cap Tommy, circa 1964.

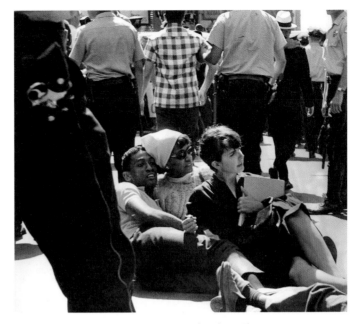

Demonstrators State and Jackson Streets.

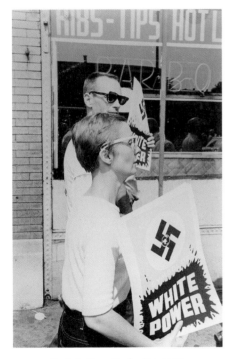

Nazis in Gage Park, circa 1967.

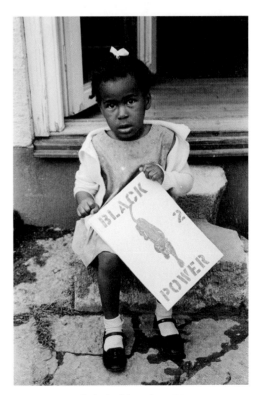

Lil Black Girl Magic, 1968.

39

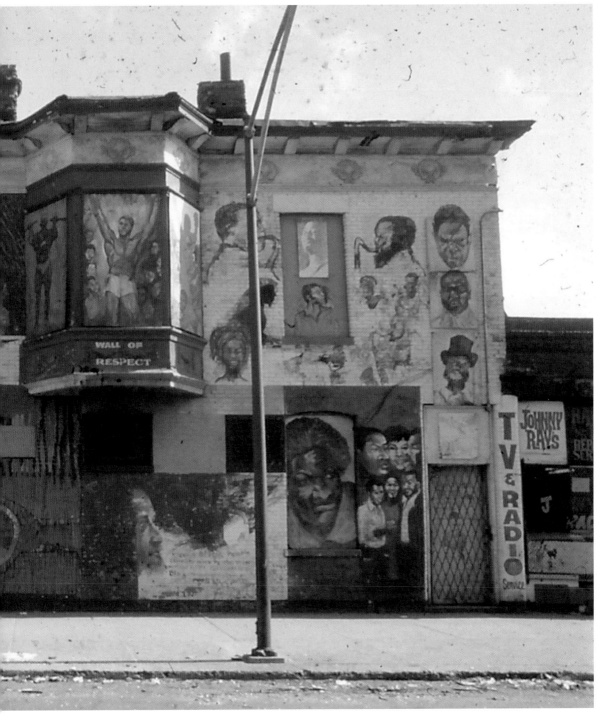

Later version of the Wall of Respect, 1970.
Copyright Darryl Cowherd.

The Wall of Respect, 1967.

The Wall of Respect, close-up of "Theater" section, 1967.

DARRYL COWHERD

K. Kofi Moyo

Karega Kofi Moyo is a photographer who neither worked on the Wall of Respect mural nor participated at the site in the late 1960s, but he was, like the Wall of Respect photographers, nevertheless at work documenting the Black communities of Chicago's South Side. Moyo's fleeting monument for the Wall of Respect rounds out the story and includes other locations and places—such as the 63rd Street Beach, the Institute of Positive Education, and the Communiversity—which were similarly central to Black cultural, political, and intellectual life. As such, Moyo's photographic montage is a visual essay that reminds us of the surrounding social landscape out of which the Wall of Respect emerged, calling attention to other, often less formal but equally important sites for community-making.

Like several of the Wall's artists and participants, Moyo was also among the Chicago participants who travelled to Nigeria in 1977 for a pan-African convening, the Second World Black and African Festival for Arts and Culture, known as FESTAC '77. Images from this convening of artists from the African Diaspora are also in this selection of photographs.

This corpus of work from Moyo's involvement in the legacy of Black art and intellectual culture from Chicago's South Side reveals that the politics of Black liberation represented through the Wall of Respect phenomenon foreshadowed other sites and other socio-aesthetic rituals embedded with music, theater, and politics. Like the Wall of Respect, each of these locales helped to fasten a sense of cultural respect and pride for Black people living on the South Side of Chicago in the late 1960s through the 1970s. —RC

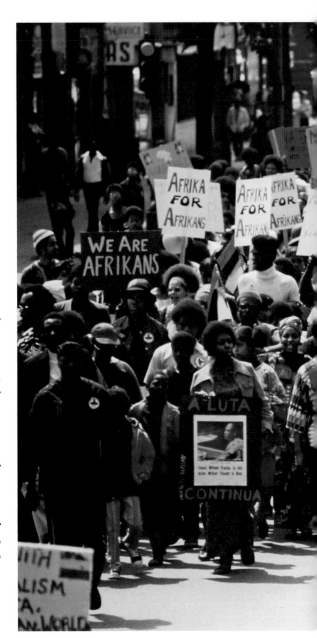

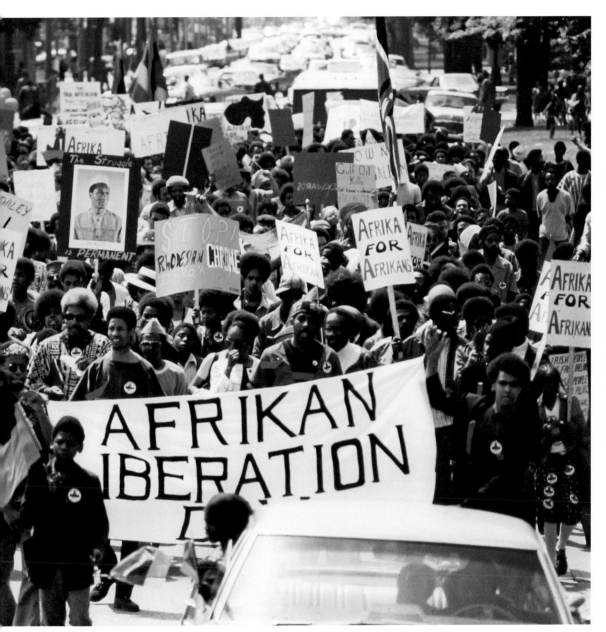

African Liberation Day, Chicago, 1973,

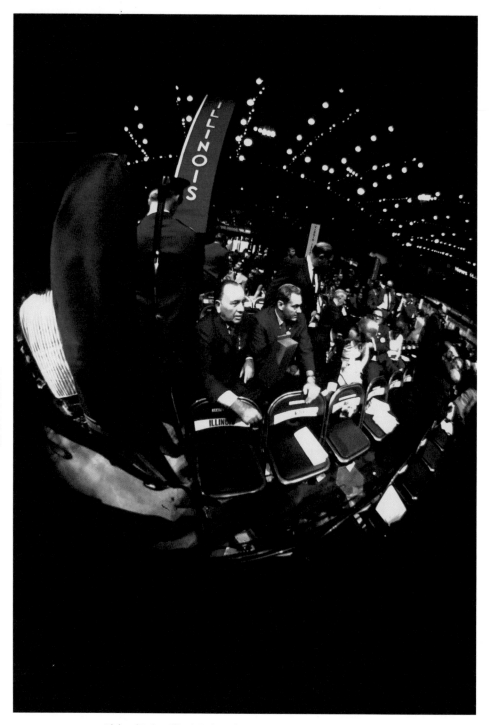

Richard Daley, Illinois Delegation 1968 Democratic Convention.

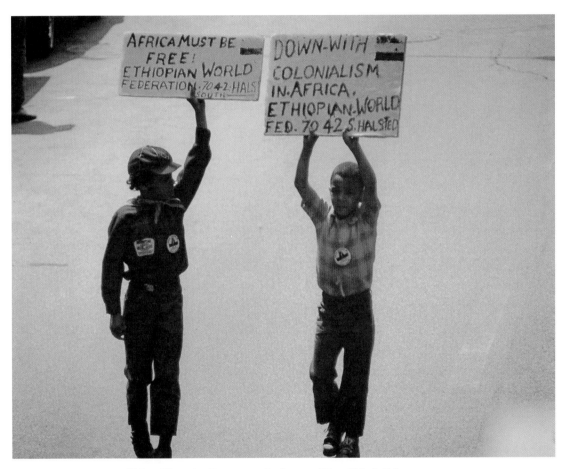

African Liberation Day, young sign bearers "Free Africa", Chicago, 1973.

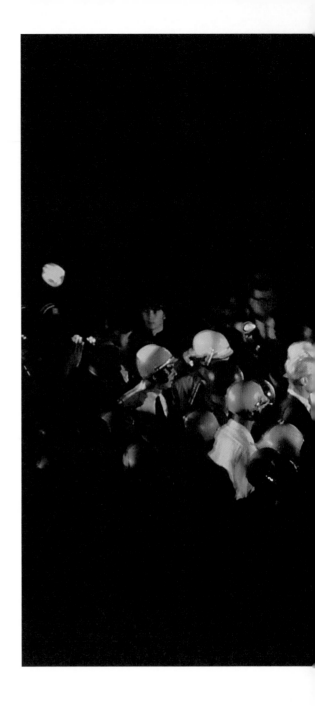

Chicago Police Riot, Democratic Convention, 1968.

Above: Kelan Phil Cohran, Music on the Beach, 63rd St., Chicago, 1967.
Right: Music on the Beach, 63rd St., Chicago, 1967.

K. KOFI MOYO

F.H. Hammurabi Robb, Chicago 1971.

Karamu Ya Imani, Spencer Jackson Family, Chicago 1971.

FESTAC '77, Art Exhibit, Lagos, Nigeria.

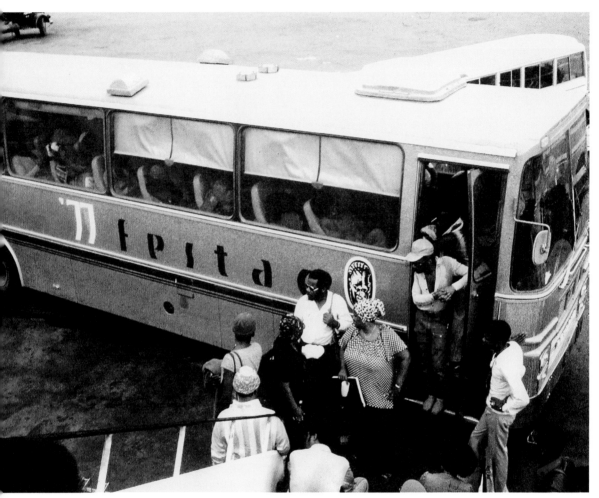

FESTAC '77 Delegation Arrival at FESTAC Village.

Kwame Ture (Stokely Carmichael) at Communiversity, 1970.

K. KOFI MOYO

Louis Farrakhan, Chicago 1976.

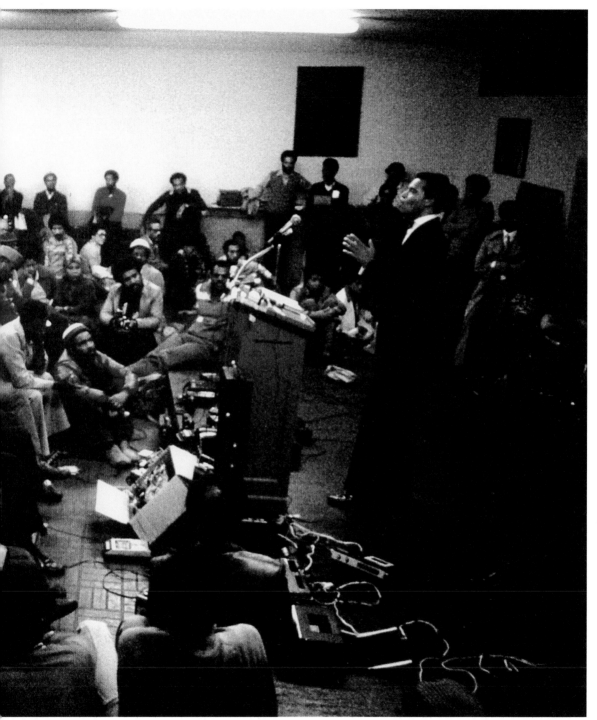

59

Haki Madhubuti

Haki Madhubuti was known as Don L. Lee at the time he wrote a prose poem titled "The Wall" for the Wall of Respect dedication event in August 1967. He is a poet, author, and the founder of Third World Press, the premier and longest-running Black-owned press in the United States.

Madhubuti was among the many artists and writers who performed and made art that complemented but was ancillary to the Wall. Music, performance, and poetry took place in the Wall's environs and extended the logistical and formal context of the mural. The reading of his prose poem tribute, "The Wall," like other performative acts that took place at the Wall of Respect, helped to fasten the Wall's multidimensionality and its visionary multiformal capacity.

Madhubuti's fleeting monument contribution, "Art V: Black Art Lives in a Time of War Culture," comes fifty-one years after he wrote his original prose poem about the Wall. This new prose poem serves as a response to both the current moment of Black Lives Matter and the Black liberation past. It establishes Madhubuti not only at the entry point of the Wall of Respect history but also as a vital voice for this generation. His legacy is entwined with that of the Wall of Respect, and his prose poem presents a persuasive example of staying connected to the commemorated object. —RC

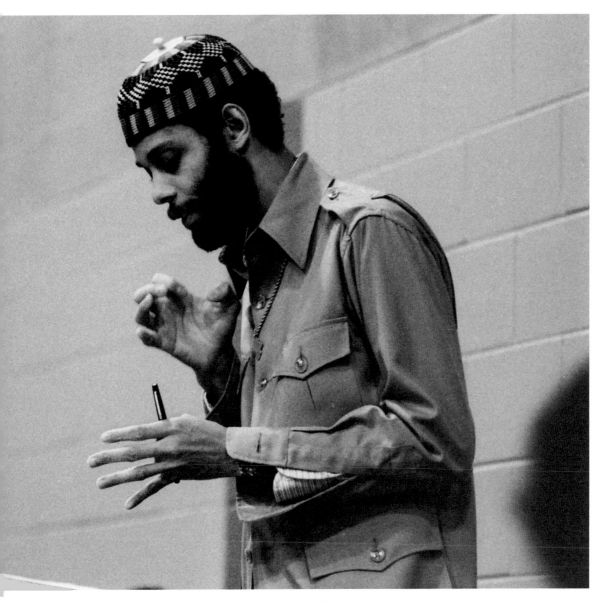

Haki Madhubuti.
Copyright K. Kofi Moyo, courtesy of Black Image Corporation.

Art V

Black Art Lives in a Time of War Culture

BY HAKI MADHUBUTI

I

What does it mean to be consciously Black? Where does the continent of Africa live in the lives of Black people in America and the Diaspora? Ask any ten Black people, anywhere in the United States this question: "How do you define yourself culturally?" and I guarantee you, they will give you ten different, often uninformed, answers. The *Black Arts Movement* (BAM 1965–75), which was jump-started after the death of Malcolm X, moved a generation of Black artists to address the embarrassing ignorance of the Black self. The great majority of our cultural, political, economic, social, educational, religious, and self-defense institutions were also slow to confront our national, cultural, and economic existence in an informed manner.

Chicago was at the center of the philosophical, cultural, ideological, and institutional deep-rooted analysis, answer giving, and practices of BAM. Chicago provided fertile ground for the *Chicago Defender, Ebony Magazine* with its *Negro Digest/Black World Journal* (a leading Chicago chronicler of BAM and Black thought internationally at the time), DuSable Museum, South Side Community Art Center, and more. Chicago was the epicenter of creative Black music, the blues, spiritual, and early rap and hip-hop. Many of the leading poets, fiction writers, literary nonfiction writers, and historians were Chicago-based. It is hard to imagine *BAM* without Chicago's visual artists, with its photographers often taking center stage. One of the nations' major, self-defining organizations was Chicago-born, *OBAC/The Organization of Black American Culture*, whose visual arts workshops created the internationally renowned Wall of Respect. During this period (1967 and onward), we saw the creation of Third World Press, the Kuumba Workshop, eta Creative Arts Theater, AACM Chicago, AfriCOBRA, Afro-Arts Theater, Path Press, Muntu Dance Theater, Black Ensemble Theater, Chicago State's

Writers Conferences, multiple community-based independent Black institutions with the Institute of Positive Education and Betty Shabazz Schools taking the African-centered lead in Chicago.

The list of monumental contributors to Chicago's *BAM* and the cultural life of the nation were Gwendolyn Brooks, Alice Browning, Hoyt W. Fuller, Lerone Bennett Jr., John H. Johnson, Sterling Stuckey, Robert A. Sengstacke, Oscar Brown Jr., Margaret Burroughs, Jeff Donaldson, Billy Abernathy (Fundi), Sylvia Abernathy (Laini), Abena Joan Brown, Margaret Danner, Muhammad Ali, Phil Cohran, Frederic H. Hammurabi Robb, Amus Mor (David Moore), David Llorens, Terry Callier, Conrad Kent Rivers, Barbara Jones-Hogu, Murry DePillars, Bobby Wright, Jacob Carruthers, Calvin Jones and many more. They are no longer with us but their major contributions must live forever in us. Those from that era who are still contributing are Bennett Johnson, Abdul Alkalimat (Gerald A. McWorter), Roy Lewis, Muhal Richard Abrams, Useni Eugene Perkins, Sterling Plumpp, Omar Lama, Darlene Blackburn, Val Gray Ward, Pemon Rami, Jackie Taylor, Carol Adams, Jeremiah Wright, Carl C. Bell, Haki R. Madhubuti (Don L. Lee) and others. All of these *BAM* contributors are too often not recognized or given adequate credit for their deep commitment to the Black world. One of the major reasons that *Black Lives Matter* came into existence is because of our collective failure to continue the work of the *Black Arts Movement*, the critical work of the *Civil Rights Movement* organizations, as well as the hundreds of African- and Black-centered religious and educational institutions.

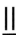

II

My people and I have gone through the gates of other people's definitions, imaginations, incarcerations, provocations, rejections, enslavement, and radically debilitating European American acculturation. This seasoning into negro, nigga, coon, colored people, Black, YellowBlack, Afro-American, Africans in America, and beyond, all still occupying our daily nightly and sleeping consciousness. I, a Black poet, now at the age of 77 still have doubts and questions, after over 57 years of writing, publishing, street activism, university teaching, mentoring, building institutions, local, national and international activism, marriage, raising children, and much more.

If my opening paragraph is confusing, remember that these personal descriptions and fabrications of Black people are the results of white people's ideas of the culture and nation they built for themselves on the backs and

souls of a staggering number of African people, Indigenous people, south of the border people, and critically poor white people who have been forced into accepting the fiction of white world supremacy. These people include the tens of millions of Africans stolen from the continent, transported thousands of miles in horrid conditions, forcefully separated—children from parents, wives from husbands, from families and ethnic communities, all to be auctioned and sold to the highest bidders in the western world. This act resulted in African men, women, and teenagers forced to slave 24/7 from sun up to sun down 365 days a year uninterrupted.

This reality often caused death and placed the women in an environment where European American men freely and frequently raped and abused them. Both African men and women experienced lynching and were killed for seeking liberty, literacy, entrepreneurship, and self-defending organizations. Into the 20th century we were redlined, separated, unfairly yet "legally" incarcerated by the millions and the horror list is neverending. All of this and much, much, more is very basic history, but not often truthfully taught or debated nationally. International white seasoning has produced millions of traitors among our people. We all do what we have been taught to do and too many African people have been traumatized into a self-hating craziness.

Within this context, the personal is political for Black people in America whether we recognize it or not. Deep cultural ignorance has been one of our primary enemies. If you do not know who you are with certainty, vision, self-love, and mission, it is almost guaranteed that you will work against your short- and long-term benefit, and anybody can and will name you within their cultural reality. From African enslavement in the western world to the present, this nation's war on Black people has never ended.

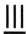

III

who loves black people?
four hundred years. bruising, traumatizing, disfigurement of a people.
forgotten cultural history. Black
the freedom of others to rape uninhibited.
a missing child here. a taken wife all over. the men to breed and work.
the shape of then, now, and what is to come.
our strength comes from not totally forgetting our source. Africa.

the stones, rocks, living earth in the winters of enslavement.
the myths, the stories, the "book" all led to conversion.
tearing and turning our lives into constant earthquakes.
not allowed or encouraged to read, think, remember or
speak in the languages of foreparents, to stay deaf, dumb and ignorant.
a preferred stupidness in the eyes of frightened whip wielders.

who loves Black people?
your ancestors stolen, forced-migrated. Black
ships packed so horrifically that breathing depended upon the breath of
 others.
after a few centuries of racial terror, designating you as less than human
a fraction of wholeness
making legal and commonplace the destruction of a people
whose lynchings were joyfully celebrated by white thieves into the
 20th century.
african nations that once knew your names erased your history from their
 tongues.
christian exceptionalism and the internationalization of cultural ignorance.
 unrestricted brutal capitalism & cultural warfare that stole childhoods.
unaware of the transference of death culture that cemented
itself into the consciousness of the killers and killed,
delivered first-class into the new american century
reclaimed dark days. Black codes, kkk, jim and jane crow laws that devalue
 Black citizenship.
as the hereafter and before agreed that rape is the reward of conquerors.
welcome the invention of negroes and colored people. who
have never known peace, possibilities, enlightenment or quiet time.
who loves Black people?
enter the artist and their art,
enter Black art defining, clarifying, making welcome self-imagination,
enter African centered culture void of outside interpretation,
enter art as brain protector,
 art that beats ugliness back into itself
 art that teaches that there is no statute of limitation on knowledge
 acquisition
 art of beauty, wellness, plant-based foods and loud love.
 art seeking all children, the darker they come louder the screams.
 enter the Black arts of discovery, of clearing dust and dirt,
 eliminating trauma, false stories, picturesque lies, white rites

of passages,
heroic tales of others, spiritual emptiness of a historical and
 current rulership
legislating that everything Black is too Black and
all that is white is not white enough.

IV

art as answer and question.
that which has the power to save lives,
to change lives, to give birth to imagination
that can power question from unknown spaces
of one's expanded brain while unlocking the mystery of
misunderstood relationships and loves all while celebrating the highs
and lows of one's undisciplined, careless, clueless
narrowly focused vision until right vision becomes yes.
thereby humanizing all future growth of a person's production is art.

Art is harmonized voices and instruments, it is painted oils on canvas, clothing, public walls; or it is feet of young dancers and yoga bodies using the air, wind and open spaces to tell a story with each curvature of one's body or bodies; not forgetting the immense power of language artfully combined to visit the strange cultures of one's inclusiveness, now able to burst into the public's commons with metaphors and ideas of likeness, unlikeness and formality of spiritual and secular experiences—all expanded and explained on paper or screen in the unique and written original poems, fictions, literary non-fictions, plays indigenous urban or rural stories, narrations, epics, histories, memoir or fables that are indefinable but easily and early recognized as art. Art as youth focused play-talk and children growth medium.

Enter an earth force against war-talk and gun-talk,
Enter the legalization of outlaw culture.
Enter an art that loves Black people unconditionally.

The most disrespected people in America are Black women—not women of color. The most feared men in America are Black men—not men of color. People of color in America are at risk, are on the watch list; however, Blacks are at the top of the list. The Black energy that propelled us of the *Black Arts Movement* was in part our living elders at the time: Gwendolyn Brooks, John O. Killens, Hoyt W. Fuller, Margaret Burroughs, Dudley Randall, Barbara Sizemore, Rosa Parks, Martin Luther King Jr., Malcolm X, Ella Baker, Fannie

Lou Hamer, John Henrik Clarke, Amiri Baraka, John Coltrane, Charles White, James Baldwin, Romare Bearden, Elizabeth Catlett, Margaret Walker, Richard Wright, Larry Neal, Ray Charles, Ossie Davis, Ruby Dee, Jayne Cortez, Louis Armstrong, Chancellor Williams, Stephen E. Henderson, and countless others.

I must highlight the Black hurricane who propelled many of the young artists and intellectuals into an African motion; he was Hoyt W. Fuller. Mr. Fuller was a founding member of *OBAC*, the genius behind *Negro Digest/Black World Magazine* and had an attitude of "take no bullshit" from anyone, especially white people, when it came to the dignity, respect, and proper acknowledgement of the centrality, power, and beauty of Africa and its people. For the young artists of BAM, Fuller was to most of us the Black example, cultural model, stabilizer, quiet teacher who had traveled to Africa multiple times before most of us had the resources to travel from the West Side to the South Side of Chicago. It must be stated without any doubt or hesitation that Hoyt W. Fuller throughout his life exemplified a Black man who dearly loved Black people. It also can be stated that he would not ever betray a trust or his people. A major contributor to BAM and to the cultural development of Black people in the United States and elsewhere who is a non-Chicagoan and who is still going strong is Dr. Maulana Karenga who gave us Kwanzaa. In any discussion of BAM locally or nationally, Dr. Karenga's contribution cannot be minimalized.

We the young Black artists and mid-level artists of the sixties were still searching for clues toward the deepest understanding of Black. Too many of us were still in the clouds of becoming Black. All of us, somewhat protective of our own unknowing, yet, confirmed that we were on the right avenues toward effective confirmations of self. We all had fire in the brain, swiftness in our feet, rage in our voices, most had graduated from negroness to Black to Black-Black to African Black to face a world unready, ill-prepared, and late to the gate. We, the young artists, intellectuals, and cultural workers created *OBAC (Organization of Black American Culture)* and Chicago's internationally renowned *Wall of Respect*.

The Wall of Respect is gone!

We are Here!

What is Next?

Robert E. Paige

The designer Robert E. Paige was a regular participant at the Wall of Respect and its sister project, the nearby mural known as the Wall of Truth. Timely news items and magazine articles were on occasion posted to the Wall of Truth, which served as a community bulletin board of sorts.

Paige was not one of the Wall of Respect artists. He was, however, closely aligned with several of the OBAC (Organization of Black American Culture) artists who worked on it, including designer Sylvia Abernathy (Laini), who is credited for its design scheme, and Billy Abernathy (Fundi), a well-respected photographer whose photo of Nina Simone was embedded in the mural. Paige was one of many peripheral artists drawn to the Wall site who drew inspiration from its social and creative energy. Such artists, as well as educators, activists, and others, were attracted to the spirit of creative and social freedom that it exuded. They wanted to be part of the scene.

The *Fleeting Monuments for the Wall of Respect* project necessarily includes an homage from Paige, who was there not as an author or primary participant, but as one of the many artists and creatives who were motivated by the vitality of the place. For his contribution, Paige emphasizes the embrace of African culture by the Wall participants, many of whom used both given names as well as African-derived names that they selected as adults. Paige designed a writing system based on those in a book, *Afrikan Alphabets: The Story of Writing in Afrika* (Brooklyn, New York: Mark Batty, 2006), and then used it to transcribe the names of those he associates with his memory of the Wall or those, like the Abernathys, whom he thinks of while reflecting upon and remembering his experiences.

Paige also writes out phrases such as "The Wall of Respect" and "Keeping Memory Alive," as well as the names of those killed due to racial violence in recent years, including Trayvon Martin, Breonna Taylor, Tamir Rice, and George Floyd. His fleeting monument is in the form of these new artworks which make heroes of such "everyday people" and expose racial injustice in a present that is conterminous with the 1960s past. Paige's alphabet sketches and designs are always made in "real time," in the moment wherever he might be, rather than in a studio dedicated to art-making, and are always made with at-the-ready or nonheroic materials such as cardboard or napkins. His practice is based in and affirms improvisational and make-do modes, which the Wall of Respect potentiated as an aesthetic ideal and he potentiates as a genre of accessibly and personally defined memorialization. —RC

Robert E. Paige Advertisement for Dakkabar Collection.
Copyright Romi Crawford, Art Moves, 2018.

Bob Paige and Barbara Jones-Hogu at the Wall of Truth, 1969.

pp. 72–75:
Photo Documentation, Willy Smart.

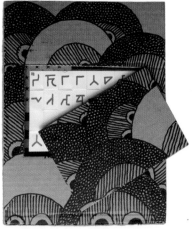

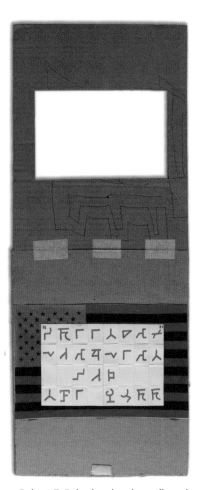

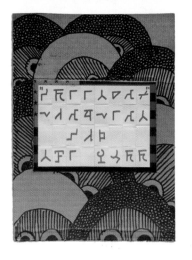

Robert E. Paige handmade cardboard
frames and letterforms derived from
*Afrikan Alpabets: The Story of Writing
in Afrika,* by Saki Mafundikwa.

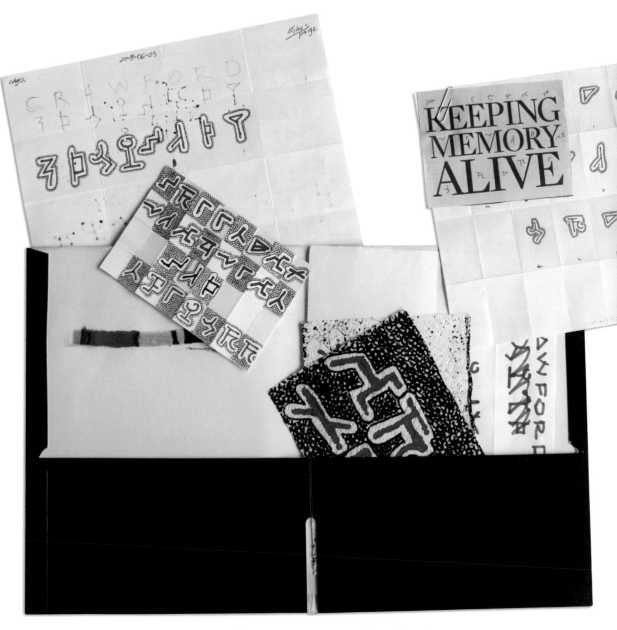

Robert E. Paige phrases derived from the letterforms in
Afrikan Alphabets: The Story of Writing in Afrika.

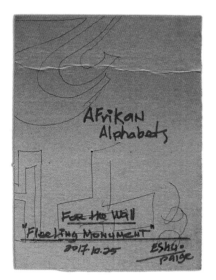

Robert E. Paige, Afrikan
letterforms sketch.

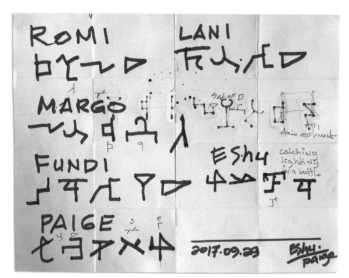

Robert E. Paige letterforms based on the *Afrikan Alphabets: The
Story of Writing in Afrika* with the names of Wall designer, Sylvia
Abernathy (Laini), and Wall photographer, Billy Abernathy (Fundi).

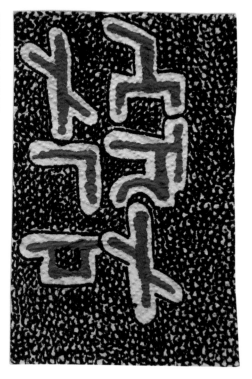

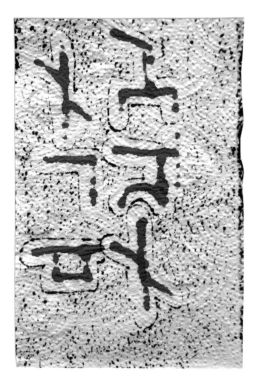

Robert E. Paige, Afrikan letterforms, works on paper napkins, 2019.

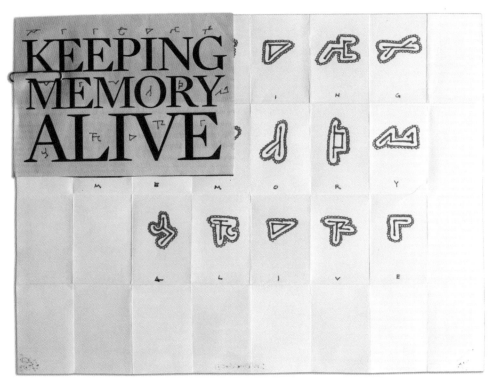

Robert E. Paige, "Keeping Memory Alive " letterforms based on the
Afrikan Alphabets: The Story of Writing in Afrika, 2019.

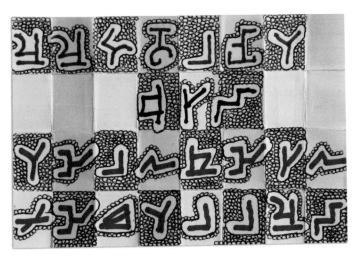

Robert E. Paige, Afrikan letterforms, 2019.

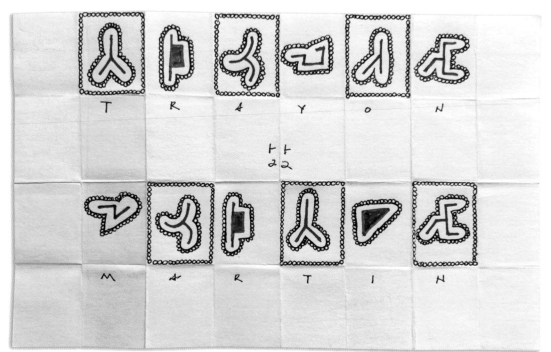

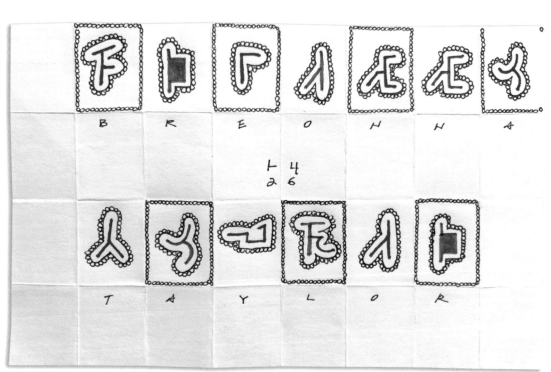

pp. 76-77: Clockwise from top:

Robert E. Paige, "Trayvon Martin", "George Floyd", "Breonna Taylor", and "Tamir Rice", letterforms based on the *Afrikan Alphabets: The Story of Writing in Afrika*, 2020.

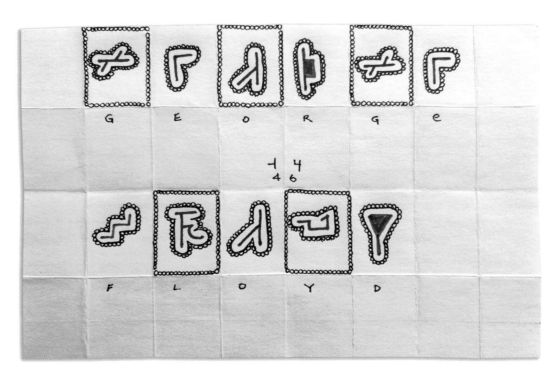

G E O R G E

4 4
6

F L O Y D

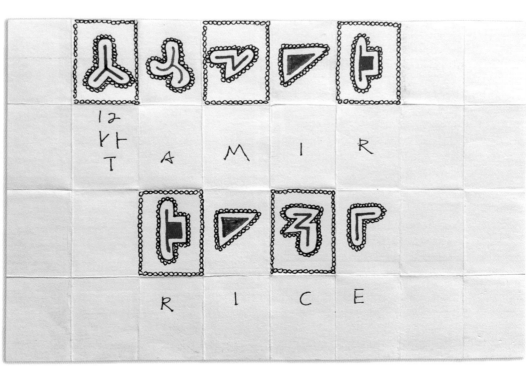

12
T A M I R

R I C E

Visiting Val Gray Ward

Val Gray Ward, who founded the Kuumba Theater on Chicago's South Side, performed at the Wall of Respect site. During my visit with her in 2018, she recounted how a close friend asked her to tell the story of the Kuumba Theater workshop. Gray Ward responded slowly but surely—not with a written document, but rather a quilt. Her response was so enthusiastic that the resulting object is now large enough to generously cover her body and still drag on the floor.

Gray Ward has spent the last thirty-five years stitching the past of Chicago's Black arts and cultural movements into an impressive but familiar artifact that is full of presence and present-ness, composing a collage of fabric designs and even photos, with names of heroes (known and unknown) sewn throughout. She interweaves cultural history with her own personal story. Notables in Black arts and culture such as James Baldwin and Sonia Sanchez are referenced through image and text, alongside images of her children and a pamphlet from her time in Lagos, Nigeria, at FESTAC '77.

Through the medium of her quilt, Gray Ward has been commemorating Chicago's Black cultural scene for decades. She references many active participants at the Wall (including Lerone Bennett Jr. and Hoyt Fuller) by stitching their names and images onto her very personal monument.

In effect, the Wall of Respect yarn was plotted into her quilt long before I came for my 2018 visit. Gray Ward explained that she thinks about the Wall's history and the burst of creativity and pride that it represented every time she works on the quilt or shares or discusses it.

The quilt reveals how new work evolves in the wake of paying tribute. In other words, her project reveals the generative potential that comes from constructing an everyday, or habitual, relation to a notable historical event. Each day that Gray Ward works on her quilt, she commemorates the many bits and pieces of the Black arts movement's history that she was part of and that continue to sustain her. —RC

Val Gray Ward at the Wall of Respect, 1967.
Copyright Bob Crawford estate.

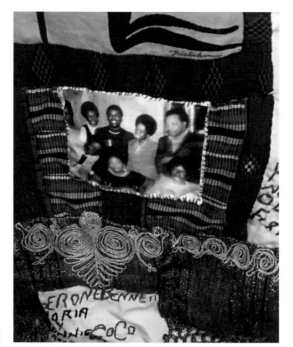

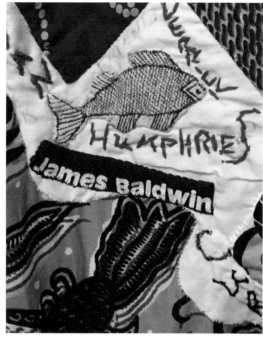

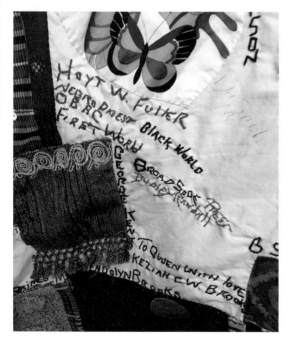

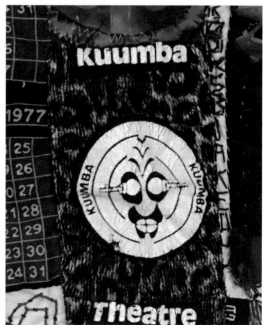

Val Gray Ward memory quilt.
Copyright Romi Crawford, 2018.

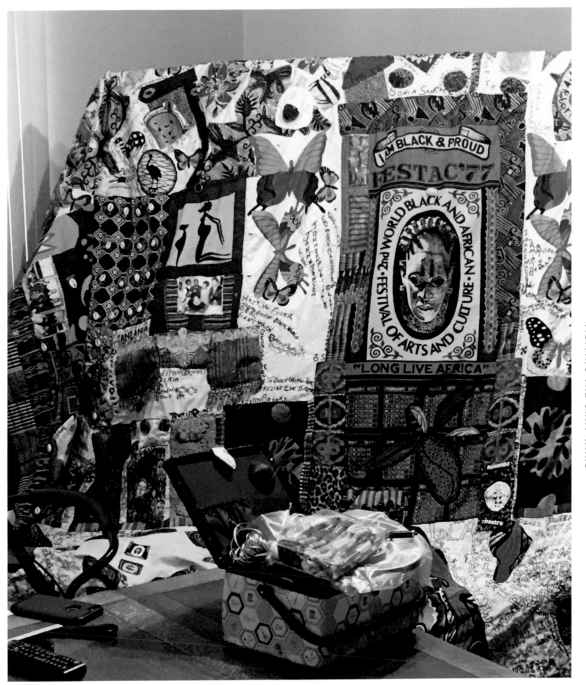

Val Gray Ward memory quilt, FESTAC '77 section.
Copyright Romi Crawford, 2018.

Val Gray Ward wearing her memory quilt.
Copyright Romi Crawford, 2018.

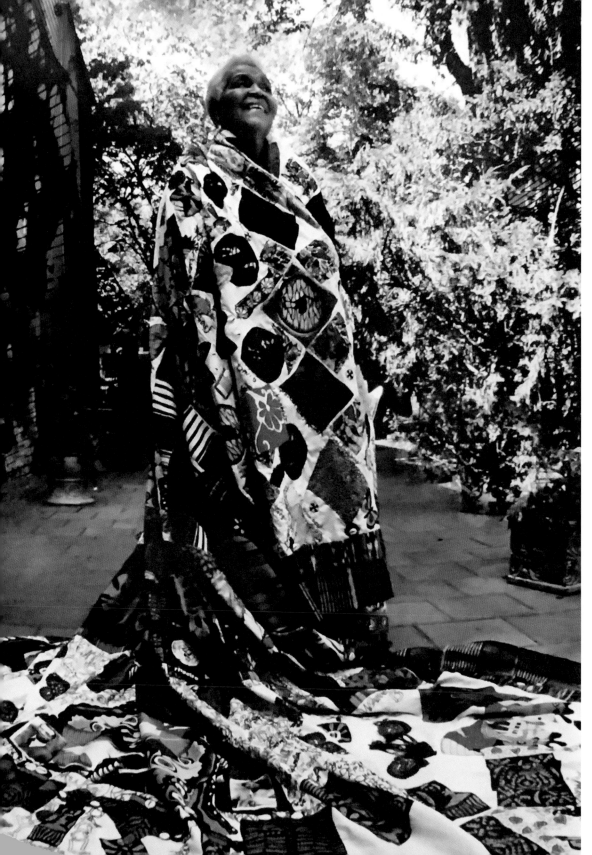

II.
Gift
Monuments

Miguel Aguilar
Bethany Collins
Julio Finn
Maria Gaspar
Wills Glasspiegel
Naeem Mohaiemen
Kamau Patton
Rohan Ayinde

II. Gift Monuments

The contributions in this section are by artists who make tribute to the Wall of Respect through the gifting of work. Most of these works are in keeping with the artists' primary practice (poetry, painting, photography, social engagement) and exist here as offerings, given out of respect and admiration for the Wall's ideology and historical significance.

Love and respect were basic tenets of the Wall of Respect experience—an adamant love of, and respect for, Black people and culture, during a time when Black Americans were threatened by segregation and racial strife. To this end, many of the artists who worked on the Wall of Respect expressed a desire to give something beautiful and heroic to the Black community of Chicago. The mural was that gift.

While all of the contributions in this book are, in a sense, gifts, this section reinforces the significance of gifting because generosity was endemic to the Wall of Respect phenomenon on myriad levels. The artists who worked on it were not commissioned or paid; the community generously safeguarded supplies and materials during its construction; the artists who worked on it did so collaboratively and relinquished any overt authorship. The Wall was unsigned.

The works gathered in this portion stand in for the generosity experienced at the Wall of Respect and its potency with regard to the concept of a fleeting monument. They reveal a willingness to pay homage and memorialize through gifting, precedented by the Wall of Respect itself, but reflected here too on the part of all of the contributing artists and writers who share, give, and/or re-produce their work in a context of speculative and generative collaboration, not knowing what the cumulative outcome might be, but open to the alternative monument that might result from it.

In addition, the projects in this portion of the book reveal a direct bond with the legacy of the Wall and its ethos of social justice. Contemporary artists such as Miguel Aguilar, Naeem Mohaiemen, Maria Gaspar, Kamau Patton, Wills Glasspiegel, and Bethany Collins share works that are part of their ongoing practices, all of which address the relevance of marginalized histories, art, and people.

Love and respect are also demonstrated in the works of writers Julio Finn and Rohan Ayinde, who both have ties to Chicago and Europe. They mark the history of the Wall of Respect with lovingly bespoke words and poetry.

All of the works in this section demonstrate an affection for the Wall, not only from those who were close to it, as in the "Legacy Monuments" section, but also those at a remove from it temporally and geographically.

Miguel Aguilar

Graffiti Institute founder Miguel Aguilar's practice is grounded in social and aesthetic concerns that align closely with those of the Wall of Respect's creators. Like the Wall of Respect, a public artwork produced without formal approval of the city but sanctioned by its local constituents, the handiwork of Aguilar (known as Kane One) is irreverently located in public spaces, placed, for example, on street signs, newspaper boxes, the backs of trucks, and viaduct walls. By situating his work in this way, Aguilar speaks directly to Chicago street and graffiti art communities, similarly to the way the Wall of Respect spoke unambiguously to the Black community.

Aguilar follows, decidedly and consciously, in the tradition of Chicago's street and graffiti art traditions, so it is not surprising that similar strategies of art-world nonconformity indicated at the Wall of Respect can also be gleaned in his work. Of note, there is a common interest in making work beyond the bounds of museums and galleries and in producing art with economical materials.

Works like Aguilar's and the Wall conserve in other ways as well. The Wall of Respect was produced in a relatively short amount of time and had only a five-year existence. Aguilar's works are similarly inscribed by fast/efficient production and are equally short-lived, revealing a sense of durational scale that doesn't align with traditional monuments. Gifting examples of his practice as a tribute to the Wall of Respect affirms the through line between these acts of public art-making in Chicago, exposing common methodologies and modes of aesthetic connectivity. —RC

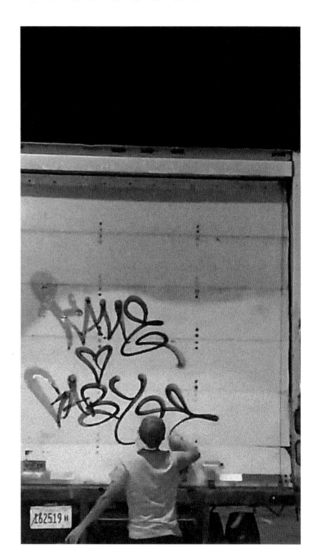

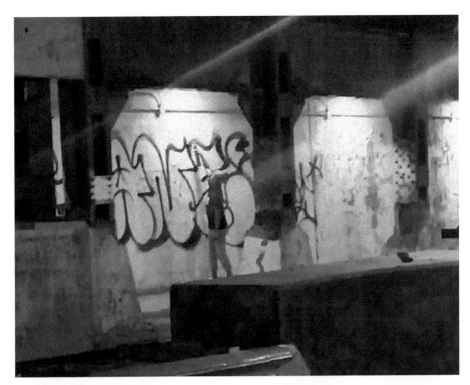

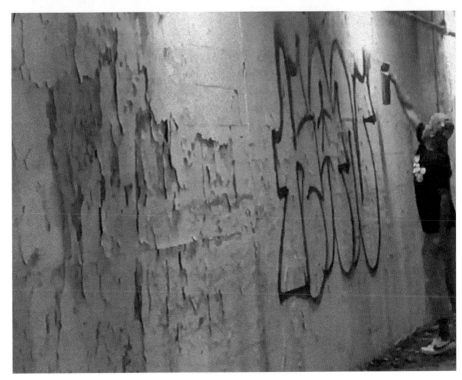

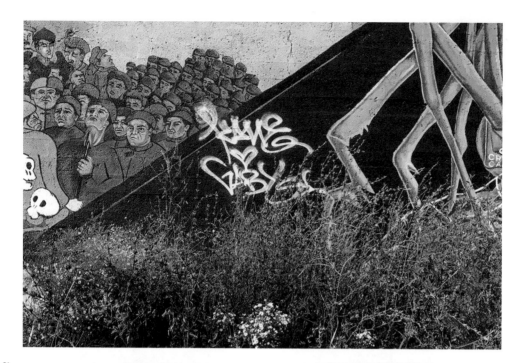

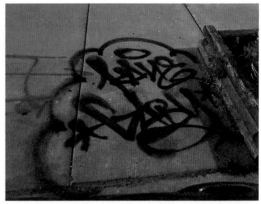

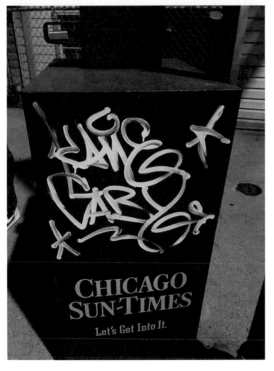

CHICAGO
SUN-TIMES

Let's Get Into It.

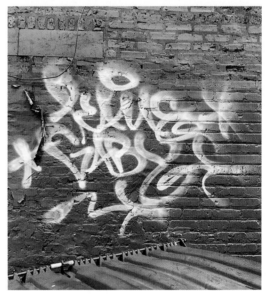

Bethany Collins

The artist Bethany Collins excises, burns, blurs, erases, and otherwise mediates the onerous aspects of racism that are in plain sight, often couched within periodicals, newspapers, and dictionaries. Her practice involves creating works on paper and objects that complicate and destroy the original, often derogatory, historical sources. Collins uses historical material not just as a reference in her work but also as the medium, digging into newspapers such as the *Birmingham News* both literally and figuratively.

For this book, she gifts a fleeting monument from her oeuvre, *The Birmingham News, 1963*, which signals the same trajectory of racism that prompted the makers of the Wall to produce the mural. Collins is well-versed in the history that precedes current-day instances of racial violence in the United States. A full body of work has evolved from her interest in these matters.

With her nod to minimalism, her projects' resolute black-and-white palette and her method of blacking and whiting out incendiary text (which is a signature), Collins expands the formal, conceptual, and aesthetic potential of socially inflected art-making.

While the Wall of Respect was colorful, filled with images of heroic figures and busy in terms of form and content, Collins's embossed works are delicate and elusive but nonetheless ferocious in redressing/addressing the pervasive nature of racism and social inequality in the United States. Its minimalist cues are just as imperative as the loudest protest rally call or the overt politics of the Wall of Respect.

Collins's tribute to the Wall of Respect is a gift of her work, which also registers, in its own way, the racial inquietude of American life. Her interest in conflating 1960s histories with current histories reveals her commitment to excavating the past in the present as a way to address the slow, steady, and systemic procedures and quotidian forms that make racial and social equality a hard-won achievement. —RC

All images, pp. 93–95:

Bethany Collins, *The Birmingham News, 1963*, 2017 (Detail). Twice-embossed newsprint, 25" x 19" each. Promised gift of the Pamela J. Joyner and Alfred J. Giuffrida Collection to the Art Institute of Chicago.

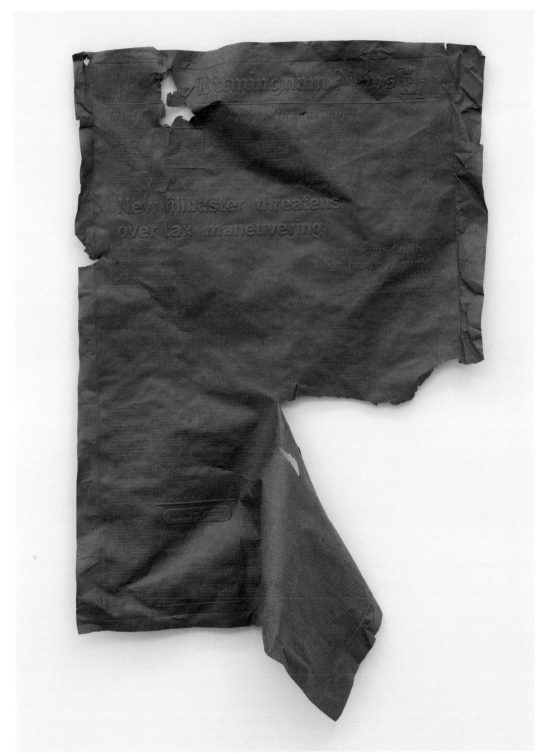

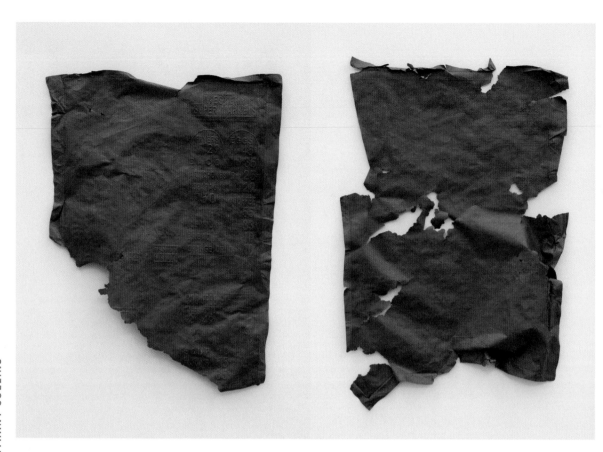

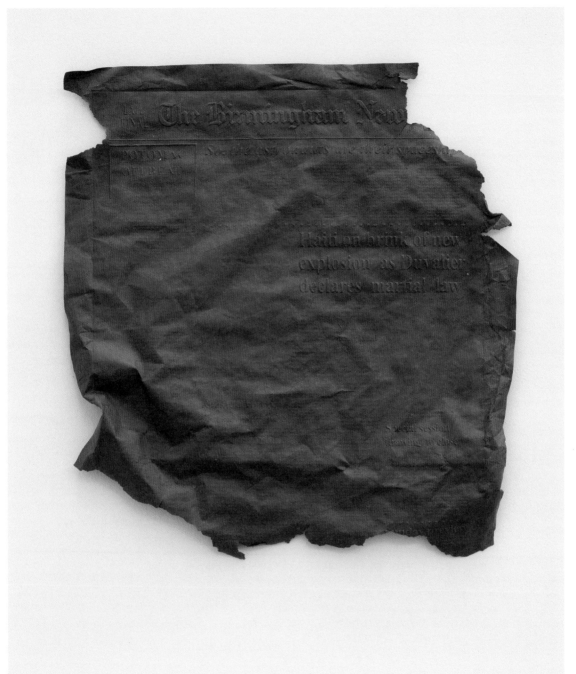

Julio Finn

Writer and musician Julio Finn moved from Chicago to London over fifty years ago. He is a researcher of Blues music and played harmonica on Linton Kwesi Johnson's 1979 epistolary song-poem against police violence, *Sonny's Lettah (Anti-sus poem)*. Musicians figured prominently among the heroes on the Wall of Respect due to their ability to message social justice in their work to wide audiences. Finn's fleeting monument for the Wall of Respect is a bespoke poetic work written for the occasion of this volume. The poem is steeped in nostalgia and longing for the placeholder that the Wall was and is now.

Finn actively interprets the Wall of Respect within the context of the prompt, fully aware that the fleeting monument concept takes its cues from the mural. He parses those cues and redirects them into the content of his poem, which recites the ways of the tao and the ways of the Wall of Respect, which align with the ways of (or tao of) the fleeting monument idea. The poem stresses the Wall's critical and, one might say, conscious unreliability (invisible, incomplete, unpretentious) as a stable art-historical referent, reminding us that a monument can be effective even if it interpolates states of uncertainty. These cues are useful as precepts for making something, whether a poem, a mural, or a monument.

Poetry was one of the many forms in play on the Wall of Respect. And many poets precede Finn in finding inspiration in and writing work about it, most notably Gwendolyn Brooks, Alicia Johnson, Haki Madhubuti, and Useni Perkins. Poems about the Wall are in effect *for* the Wall, dedicatory and appreciative gift works in response to the gift that the Wall of Respect was to the Black community. —RC

The Tao of the Wall of Respect

BY JULIO FINN

A balmy spring wind
Reminding me of something
I cannot recall.
—Jorge Luis Borges

The Wall that lasts forever
Is not the eternal wall.
Explicit though it might be
That name does not reveal its nature.

Even though the scaffold is made of stone
Stone does not constitute its essence.

The genius of the Wall lay in its being incomplete.
In being incomplete it achieved fame.
In being razed it attained to perfection.

Prior to the creation of the Wall
Its scaffold was a derelict storefront.
Whilst the Wall existed people came to see what it was.
After its demise they came to see what they imagined it had been.

Which is more important
The visible or the invisible?

What is rare is valued
Excess denatures.
Absence is not a synonym for nonexistence.
Permanency is no guarantee of renown.

*

Size is irrelevant.
Form is arbitrary.
The pearl in the shell.
The bonsai in its miniscule terrain.

A miniature Mount Everest
 —in every way the twain of the "original"—
is a fit challenge for the intrepid
To scale its daunting heights.

If a tombstone read
"No One is Buried Here"
Would that make it
Less worthy of consecration?

Nothing is so strange as
The idea of strangeness.

Reduce in order to attain equilibrium.
Magnify in order to clarify.

The idea that size is a prerequisite for grandeur
Is a snobbish conceit.

Nothing is too large that it cannot be fitted into
The retina of the eye.

*

The Fleeting Monument is free
from Ozymandian delusions of grandeur.

Fleeting Monuments create a new sensorium
The revolutionary effect of which can be compared
To the synchronization of sound and image in cinema.

Mutants in the world of trad monumentphilia,
Fleeting Monuments navigate between the
perilous shoals of conventional monumentalism.

Monument Fiction holds to the fallacy
that the larger the Monument the greater its aura:
Something akin to the louder the sound
The more impressive the music.

Underestimate the atom and you
Lose the cosmos.
Overestimate time and you
forfeit eternity.

Nanomonuments loom giGanttic
In cyber topologies
Of immeasurable minuteness.

*

The Selfie—act of pseudo vanity—is the Fleeting Monument par excellence.
An act of pure spontaneity that seeks to snare the experience even as disguises
its true aim.

The Selfie is an experience of *participation mystique*
Via cyber technology

The Selfie celebrates the Monument-moment rather than the ego:
Selfishness minus narcissism.

With the Selfie ego becomes no-ego.

The Selfie decolonizes the mindscape from the thrall of tradition.

Invent nothing that you cannot repudiate.

*

Hitherto you have always thought of monuments
In terms of size and design,
 social importance and historical relevance.

Now you shall be confronted with the inconceivable:
The monument that no museum or space shall ever
have the courage to display.
The monument no one has
ever seen or ever shall see.

The Invisible Monument.

The term "Invisible Monument" runs the risk of being
construed as referring to something imaginary.
But I did not say that.

How could a thing be invisible if it did not exist?
Invisible is the appearance of the imperceptible.
The relationship is akin to that of silence to sound.

The invisible monument is void of the attributes
usually associated with monuments.
In the same way as emptiness is devoid of emptiness.

Constructed out of vacuity invisible monuments are
impervious to the wiles of fortune.
How can something lacking the attribute of appearance vanish?

The invisible monument performs the same function as its
visible counterpart; only its influence remains covert.

When a monument that has been destroyed or otherwise
become inaccessible continues to exercise influence, then it, too,
can be said to belong to the realm of invisible monuments.

*

Tao is the Way of the Wayless Way
Always and in all ways.
Leads to what follows
And follows to where it leads.

Seedy hobo of monumenta
Your portrait plastered—
like a Wanted Poster
Inscribed with the words
"Reward for Information"—
on the tavern's beer-stained exterior
Down what fugitive alley are you now tramping?

Traceless like the flight of a bird
Resuscitated
Phoenixlike
Multiplicity of other times, other places
Original Facsimile
Bait
For a waning memory:

The Wall—now living up to its perfect name.

Maria Gaspar

Artist Maria Gaspar makes work in direct conversation with the social mores of the Wall of Respect. She incorporates urban sites, participation, and poignant "collective gestures." Often working in proximity to prisons and especially with Latinx and African American youth, Gaspar examines the connections between spatial and racial justice.

City As Site, like so many of Gaspar's projects, leverages the body as the primary mover in helping youth cohorts to forge a closer understanding of their environment. The outcomes of her practice often entail visceral, haptic, and literal connectivity to a given urban setting, in which participants touch and become one with their environment. While the performative and aesthetic aspects of the project are compelling in their own right, such physical contact with the spatial environment is also symbolic and represents the potential for bonding with, claiming rights to, and establishing a working relationship with the neighborhood and locale where one resides.

In this way, Gaspar's work builds upon the tradition of community-engaged and social-practice artwork in Chicago. Gaspar, who often mentions her esteem for the Wall of Respect mural, offers *City As Site* as a tribute to the Wall of Respect. The way that the community's citizenry was variously absorbed into the production and design of *City As Site* resonates with the involvement of those who lived in proximity to the Wall and who offered advice to the mural artists, safeguarded materials during its production, and, crucially, touched and leaned on it. —RC

pp. 103–107:
Maria Gaspar, *City As Site*, 2011.
Performance still, dimensions variable.
Courtesy of artist.

City As Site

BY MARIA GASPAR

City As Site examined issues of spatial justice through public actions, performances, and ephemeral installations between the North Lawndale and South Lawndale communities in Chicago. Led by Maria Gaspar, fourteen Black and Latino youth from across both communities used their own bodies, sound, and found materials to stage public narratives about their relationship to their communities.

Wills Glasspiegel

Documentarist and scholar Wills Glasspiegel gifts a fleeting monument for the Wall of Respect in the form of an essay and images from his ongoing investigation of the dance and music genre known as Chicago footwork. At 160 beats per minute, footwork movement and music forms are at once smooth and frenetic, evolving out of Chicago's juke and house music cultures.

Footwork has improvisation as its core. The ensuing battles come close to, but are distinct from, the movements found in breakdancing. Dancers don't use the floor for spins but instead rely on extreme speed and lower torso agility to almost defy the ground. The heroes on the Wall of Respect also referenced formal prowess that emanates from Black cultural experience. The Wall signaled the relevance of figures such as James Brown, dancer and choreographer Darlene Blackburn, and Muhammad Ali, all of whom pushed the bounds of their forms, achieving physical breakthroughs and extreme innovation on the concert stage, in the boxing ring, or in the dance studio.

In addition to his essay, Glasspiegel also delves into the history of the Wall of Respect and the prompt by producing a short video work on dancer Darlene Blackburn. Photographer Roy Lewis' image of Blackburn appeared on the Wall of Respect in the Theater section. The film is an extension of Glasspiegel's fleeting monument project. It further exemplifies how notable but minoritized historical subjects might be memorialized. —RC

→ To watch the video, *Dancer of Times*, visit: https://bit.ly/3gm3EB6

Dancing the Wall of Respect

BY WILLS GLASSPIEGEL

Parsing through my photographs and collages of dancers in Chicago, working to select appropriate moments and figures for this book, I kept in mind the lasting image of dancer Darlene Blackburn on the original Wall of Respect, standing at 43rd Street and Langley Avenue on Chicago's South Side.

"They called it exotic... I said, 'I think this is concert dancing,'" Blackburn said of her dance practice, which took her as a young choreographer to Jamaica and to the historic FESTAC '77 festival in Nigeria.[1] While many of the figures on the Wall hailed from disparate locations around the country, Blackburn is local–her presence a grounding connection to the social environment around the Wall and an ongoing history of dance on the South Side.

In 2019, I met Ms. Blackburn and we made a short film together called *Dancer of Times*. She spoke with me about her choreography for the song, "Black Beauty," by jazz luminary Phil Cohran, who also performed at the Wall:

> We was about pride, and I was trying to show all those Black girls, look at my hair, it's short, and look at me, I'm dark. I was trying to get them to relate to me. My movements and my interpretation of "Black Beauty" were throwing it back to them. This is you.

Photographer Roy Lewis captured the stark, black-and-white photograph of Blackburn glued onto the Wall just beneath a painting of Ornette Coleman in a top hat. Its placement recalls Romi Crawford's observations about the Wall. Professor Crawford writes that "layering of forms, such as paint and photographs, signals and even encourages the layering of additional forms such as music, poetry, and performance."

Lewis entitled his photograph "Darlene Blackburn *Dance Sculpture*" (my emphasis), highlighting different manifestations across mediums–as sculpture, as photo, as mural, as performance. Blackburn danced in front of

1 Laura Molzahn, "Chi Lives: Darlene Blackburn, ambassador of dance," *Chicago Reader* (June 24, 1993), https://www.chicagoreader.com/chicago/chi-lives-darlene-blackburn-ambassador-of-dance /Content?oid=882210.

the Wall, too, alongside local jazz artists when the block was a community-gathering center in the late '60s.

The Wall no longer stands, but its spirit and legacy live on at the Bud Billiken Parade, held every August just a few blocks away from the wall's original site. "The Bud," as it's known locally, is a rejuvenating tribute to Black youth empowerment dating back to its launch in 1929. The parade course is from 35th to 55th street on Martin Luther King Drive, a processional connection to Black Chicago's past and future. It is partly through this parade that my work as a scholar and documentarian of the contemporary Black dance called *Chicago footwork* traverses the neighborhood and themes of this book.

The first two of my photographs in this book, taken in 2017, are centered around a hero and friend of mine, Shkunna Stewart. Stewart is a third-generation dance troupe leader on the South Side. Groups like Stewart's troupe, Bringing Out Talent, practice and organize throughout the summer for the opportunity to participate in parades across Chicago and beyond. In the process, Chicago's dance groups provide spaces for community empowerment and building self-confidence, especially for young women and girls living in areas affected by poverty. Stewart's group won first place at last year's Bud, using racecars as the theme for their costuming and float design.

"You need something to take you out of this world and put you into the footwork world," explains dancer Sterling "Steelo" Lofton, a colleague and friend since 2011, and the subject of my third image for this collection. Like Blackburn, Steelo is a Chicago dancer whose work is global and intensely local. As a member of the Chicago collective, The Era Footwork Crew, Steelo has toured from New York City to Kuwait. In making this collage for the group, I used the repetitive looping patterns of footwork music as inspiration for visually sampling and resampling a single frame of Steelo's dancing. It's a palimpsest and portrait at the same time. The image reflects how a single dance move can carry the momentum and memories of many other movements across time and space.

The last of my images features The Era Footwork Crew, with whom I've collaborated as an artist, documentary filmmaker, and community organizer. We used this image on a framed poster for a performance in Englewood at Hamilton Park. The glass frame cracked accidentally in transit. My ensuing picture of a picture conveys The Era breaking through the surface of the image, transcending photography with footwork.

In conjunction with my ongoing work as a filmmaker and nonprofit organizer, I am writing a dissertation on Chicago footwork for a PhD degree in

Shkunna Stewart and her dance group Bringing Out Talent at the Bud Billiken Parade.
Photography, Wills Glasspiegel.

African American Studies and American Studies at Yale University in New Haven. Yale provides me with invaluable intellectual grounding, perspectives, and support for my work in Chicago. However, incidents related to racial inequality have sometimes made life and work on campus uneasy.

One controversy involved Corey Menafee, who was employed as a dishwasher at Yale's Calhoun College, named after slavery advocate John C. Calhoun. Troubled deeply by a stained-glass window in the dining hall that depicted two slaves carrying bales of cotton, Menafee shattered the racist window with his broom, helping catalyze a large-scale institutional change to rename Calhoun College. This image of the Era "breaking through" is dedicated to Corey Menafee, and to the enduring urgency of Black freedom struggles everywhere.

Shkunna Stewart and her dance group Bringing Out Talent in Robert Taylor Park.
Photography, Wills Glasspiegel.

Sterling "Steelo" Lofton from The Era Footwork Crew
Photography, Wills Glasspiegel.

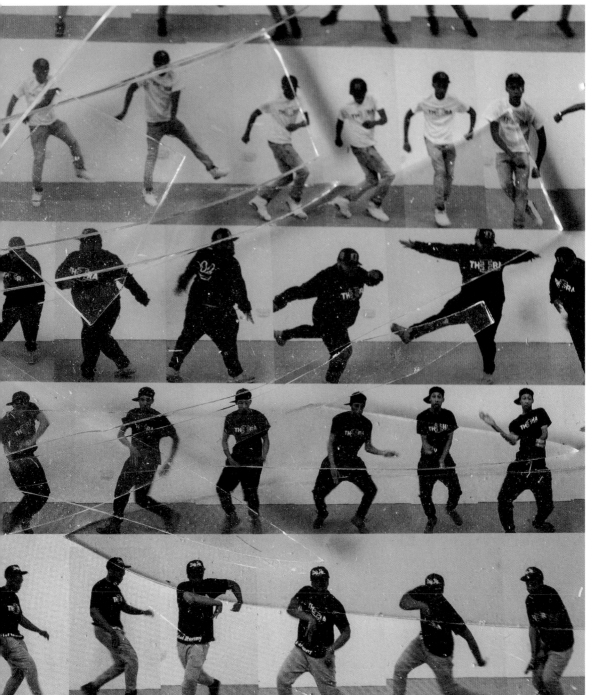

The Era Footwork Crew breaks through.
Photography, Wills Glasspiegel.

Naeem Mohaiemen

Muhammad Ali was one of the heroes depicted on the Wall of Respect, in a central position as part of the "Sports" section of the mural. Artist Naeem Mohaiemen bequeaths to this project an essay that considers Ali—who lived for a time on the South Side of Chicago and was a practicing Muslim—within a more complex interpretation of Black and Muslim intersectionality. Mohaiemen considers how Ali's international mobility was aided by his Muslim faith.

In addition to photographer Robert Sengstacke's image of young women praying at a mosque, which was part of the Wall mural, one of the contested, "unsteady" aspects of the original Wall was a scene depicting the Nation of Islam, in recognition of the religion's large following within the Black community and its headquarters on Chicago's South Side. Due to changing and conflicting views of Elijah Muhammad, this portion of the mural was revised and finally painted over during the course of the Wall's life. Perhaps there is no anecdote of the Wall's history that indicates more clearly the ethos of fleeting monuments than the removal of the Nation of Islam content, as it portends historical and interpretational revisionism, potentiating all heroes' impermanence.

Mohaiemen's take on Ali's years after his 1967 appearance on the Wall of Respect supposes a different version of his Blackness, one which aligns him with a global context far beyond 43rd and Langley or the Hyde Park/Kenwood neighborhood in Chicago where he lived for a time. Mohaiemen acknowledges the unevenness of interpretation which pervades the Wall of Respect's history as well as Ali's. His essay invokes the failed, or at least rutted, flow of revolutionary stamina experienced by Ali and many of the Wall's contributors and participants in the wake of the complex social, political, and commercial interests representative of the late 1970s and 1980s. Here, Mohaiemen reinforces the willfulness of the Wall's makers to posit complexity in the selection of Black heroes and sheroes, even if the machinations of superpowers and super forces made the ongoing, long-term staying power of such heroes precarious. —RC

pp. 117–125:

A version of this essay first appeared in *The New Inquiry* (June 2016) as: "Muhammad Ali, We Still Love You: Unsteady Dreams of a 'Muslim International'."

Unsteady dreams of a "Muslim International"

BY NAEEM MOHAIEMEN

A Bangla prizefight

Our first sighting of Ali is inside an airplane, in wide business-class seats. He is looking out the window, although the flight is not near Bangladesh yet. A moment later, the stewardess serves him a glass of orange juice. The officious British narrator, journalist Mark Alexander, sits next to Ali and tells the audience that he has the privilege of "accompanying Muhammad Ali on this rare *pilgrimage*" (Massey: 1978, 11:04 mins, emphasis added).[1] We could consider Ali's Bangladesh trip as a time-traveling version of scholar Sohail Daulatzai's concept of a roving "Muslim International" (an expanded concept from *ummah*, especially in its reliance on African American experiences). But the careful viewer will catch hints of how Ali's position within this concept had changed, as the fiery and transformative political possibilities of the 1960s gave way to the reversals and defeats of the late 1970s.

Before we can think of all this, the narration has carried us away to Ali's first encounter with General Ziaur Rahman at the Banga Bhavan.[2] A few moments later, an official presents Ali with a Bangladeshi passport, making him the "country's newest citizen" [13:27]. The dialogue that ensues is instructive.

> Official: "Here is a passport for you…"
> Ali: "So I am a citizen of Bangladesh?"
> Official: "Yes that's right."

1 All references to Muhammad Ali's Bangladesh visit are from Reginald Massey's documentary *Muhammad Ali Goes East: Bangladesh, I Love You* (1978). Massey left the production company after a disagreement, and the company itself has since gone bankrupt. The circulating copy is a clandestine recording made by an audience me=mber during a screening in London. Time codes are of the London recording. https://youtu.be/OLpQQA9eEBU

2 For a detailed description of the Bangladesh trip, see Mohammad Lutful Haque's *Muhammad Ali'r Bangladesh Joy* [in Bangla], Prothoma Publishers: 2016.

Ali: "Can I use this all over the world?"
Official: "Yes, you can."
Ali: "Thank you so much. Now, **if they kick me out of America**, I have another home. Thank you." [13:58]

In that moment, I wanted the camera to pan back, so we could see the Bangla officials' startled facial expressions. Ali was positioning his new citizenship as an antidote to his fraught relationship with the United States, especially after his refusal to fight in Vietnam. However, he was enacting this moment in a country that had very recently shifted away from a Soviet tilt and much closer to an American axis—an arc that began as early as 1974, but accelerated from 1976. Ali had not properly understood the nature of the region he was visiting, still dreaming of a Muslim International as inheritor to the idea of a radical Third World. In Bangladesh, Ali was seen as a global athlete. The live telecast of two of his fights made him one of the first global figures to have wide recognition in the country.[3] His earlier opposition to racism in America and overseas empires was largely not understood inside Bangladesh. Even if it had been, that position would not have fitted the distinct "tilt" Bangladesh had gone through by 1978.

Elsewhere, Muhammad Ali was a public figure who broke with the idea of loyalty to America, placing himself within a Muslim International, as when he told the listener:

I belong to the world, the Black world. I'll always have a home in Pakistan, in Algeria, in Ethiopia. (Mike Marqusee: *Redemption Song: Muhammad Ali and the Spirit of the Sixties*. Verso Books, 2005.)

While Ali used the term "Black," he gestured at Pakistan, and later visited Bangladesh. He was aligning himself with a force *outside* America, something he repeats after receiving his Bangladesh passport. Black here was an isomorphism for an intersection between the Third World and the Muslim world. Elsewhere, "Black Britain" was already in use to describe the alliance of Asian and Black migrants against the common enemy of British racism. Ali was indicating a wider possibility: the Black experience as entry point into a Muslim experience, and vice versa.

But Ali's travels, and his fellow travelers, in the 1970s were sometimes at odds with this earlier position. The Vietnam War had ended in

3 For a description of these live telecasts, see chess grandmaster Niaz Morshed's memorial "Kolpona jedin neme eshechilo bastobe (The Day Fantasy Became Reality)," *Prothom Alo*, June 6, 2016, 20.

a dramatic defeat for the United States, and the White House was now occupied by Nixon's antithesis, Jimmy Carter. While Vietnam had been a clearer issue for antiwar protestors, the subsequent war in Cambodia hinted at messier transnational conflicts with dirty shades of grey. The dramatic events in Iran and Afghanistan were just around the corner, and with them would come a fading act of the Cold War (which had most clearly been played out in Vietnam). The clear lines of demarcation for an anti-imperialist platform were starting to fade by 1978, and Ali himself was enervated physically by a brutal fight regimen, and financially by a long exile from the ring. In the coda to the Bangladesh trip, we find an Ali enthralled by the "new" America of Jimmy Carter. The Georgia peanut farmer's arc seemed to suggest a path of redemption for the American project ("I will never lie to you"). A Black radical now shifted from a critique of the American empire fueled by experiences of besieged Black bodies, to a new position of embracing American exceptionalism. Ali was now transformed from a "dangerous" member of a transnational Black network to a "goodwill" ambassador for the American presidency.

Bangladesh, I Love You

Let us return to Reginald Massey's documentary *Muhammad Ali Goes East: Bangladesh, I Love You*, a travelogue that requires decoding of stage-managed images. The original documentary was made for Bangladesh's business interests, with enthusiastic support from the government, and wide popular support for the athlete. After a screening on Channel Four, and a command screening at the White House, the film company went bankrupt and the documentary disappeared into obscurity. A few years back, a VHS copy was recovered by the London-based Brick Lane Circle, which hosted a screening of the film for British Bengalis. In this way, the film finally emerged and now circulates through a clandestine recording made by an audience member at that screening.

Massey's biography says he was born in "Lahore, then in British India." [4] After moving to London, he became an author of books on classical dance in India. His website states, "Some of his books are standard works and used by international bodies such as New York's Lincoln Center." Approached by Bangladeshi businessman Giashuddin Chowdhury in 1977 about creating

4 https://web.archive.org/web/20160110013451/

an event that would "boost the image" of Bangladesh, Massey proposed a state visit by Muhammad Ali. The fighter was then at a declining stage of his career, having been beaten by Leon Spinks in a humiliating match. Massey presented the Bangladesh voyage as a tonic that would re-energize Ali, because "he was still a hero in Bangladesh." [5] The trip was framed as Ali doing his duty for a Third World nation, which we see in his speech at the beginning of the film

> [I want to] help more people in the world to know about
> Bangladesh. One of my goals is to greet all my fans, and do all
> I can to help more people in the world to know about Bangladesh.
> To draw attention to some of the positive things about Bangladesh,
> so much negative things have been said. [10:00]

From the first touchdown, the film is structured as an extended travel film, guiding the viewer through tropes of a visit to Bangladesh: the river cruise (the passing crowd in another boat yells "Muhammad Ali/ Jindabad" [6] [16:28]), the "golden fiber" jute (the camera lingers on two containers marked with destinations of Los Angeles and Savannah), the (already) endangered Sundarban forest, the historic Star Mosque, the Dhakeswary temple, and the Sylhet tea gardens. Along the way were other elements which were not particularly specific to Bangladesh, but were part of the "East" imagery that Ali was dutifully granted: an elephant ride and, of course, snake charmers ("snakes are poisonous to all but the snake charmers" [15:17]). Ali charmed the audience by speaking of his largesse (to the people in Sylhet he said, "Many people could not afford to come to Dhaka, so we came to see you," [30:24]) and his flashes of humor (he pointed to his wife Veronica Ali in front of a group of female fans and said, "The ladies in this country not as tall as her..." [29:50])

By the film's end, Ali has been given a passport, a plot of land in Cox's Bazaar, and the promise of naming a stadium after him. He had performed a symbolic bout with a twelve-year-old Mohammad Giasuddin (later three-time national boxing champion in Bangladesh). The state visit ended with a dinner where renowned Bengali singer Sabina Yasmin sang the special composition "Ali Ali." (A decade later, Yasmin would sing "*Shob Kota Janala Khule Dao Na*" [Open All The Windows], anthem of a military junta). Two million fans came out to meet him, trailing him every-

5 http://www.indiaofthepast.org/reginald-masssey/unforgettable/working-muhammad-ali-boxing-champ

6 "Bangladesh Jindabad" was by then a newly popularized Islam-adjacent phrase.

where on his trip. Driving along the Cox's Bazaar beach with its "miles of unbroken beach," Ali waxed rhapsodic: "we in heaven over here. You want paradise come to Bangladesh ... eat at the President's house" [32:05].

Ali had come to Bangladesh because the country "needed" him—because Massey had said his trip would help improve Bangladesh's image, giving stability to a country that had been through a brutal war and an unstable aftermath. Repeatedly, Ali reminded the camera, "We never get the news in America about how beautiful this place is." But it was Ali who also needed Bangladesh to revive him on a psychic level, after his bruising defeat by Leon Spinks—signaling a physical decline from which he never fully recovered. The film does its best to keep the frame on Bangladesh's place in the world, but in it Ali also takes refuge from a boxing world that has declared him a spent force. Speaking of Bangladesh's potential as a beacon in the world, he says, "So much violence in the world, so much killing... [I'll do] what I can in my power to tell people..." [33:00]. Yet by the end, he is raring for a second chance at Spinks and finally explains why he has to wear sunglasses all the time. "[He] gave me a black eye! Can you imagine?" [50:39]

The Idea of <u>Muslim International</u>

Ali believed in the idea of a shared history between the Muslim parts of the Third World and Black American struggles. Bangladesh was perhaps to be an early stop in a global tour that would rekindle his connection with this transnational concept, just as his 1972 Mecca trip had done. However, there were several instabilities within this project, beginning with Bangladesh as the locus of the dream of a Muslim International that included a critique of Empire. While there were still sites of resistance to forms of Western domination, Bangladesh by the late 1970s was itself seeking a deeper embedding within the Arab power bloc. This bloc, strengthened by the oil crisis, had moved far away from the Nonaligned concept of the 1960s. The realignments of that period increasingly presented the dilemma of Third World leaders who were not in anti-imperialist positions. Journalist Palash Ghosh highlighted some of the more problematic sites of Ali's world travels: "But Ali mixed with some questionable characters during his many overseas jaunts, including such bloody despots as

বাংলাদেশের পাসপোর্ট হাতে মোহাম্মদ অ

Image from Muhammad Lutful Haque's *Muhammad Ali'r Bangladesh Bijoy* (2016).
The Bangla caption reads "Muhammad Ali with Bangladesh passport in hand."

Uganda's Idi Amin and Iraqi strongman Saddam Hussein (both of whom praised Ali no end)." [7]

Grant Farred, in the Ali volume of the series on "Black Vernacular Intellectuals," (*What's My Name*. Minneapolis: University of Minnesota Press, 2002) makes a similar argument, stating that Ali's presence could give Third World nations an "artificial unity." Ali had performed a mistranslation that is common within the conception of the Muslim International. In this conceptualization, every Muslim-majority nation was a source for liberation theology and natural ally with Black radical thinking. Cassius Clay's conversion to Islam had been received ferociously in America, including denunciations from Justice Thurgood Marshall and boxer Floyd Patterson (the "Black Muslim scourge [needed to be] removed"). In response, Ali sought a new home in the Muslim Third World. Yet, this journey landed him into the public relations arena of a location such as Bangladesh, where a transnational Muslim identity was, at least in 1978, highly contested, in flux, and not automatically a progressive force.

Buoyed by the success of the Bangladesh film, Massey began work on a sequel. Ali was flown to India with entourage, and according to Massey, charmed Indira Gandhi endlessly. He gave her a warm peck on the cheek, and quipped, "America kisses Mother India!" [8]. Ali had traveled a long, strange way–the man who once said "the only solution to today's racial problems is separation" [9] was now an ambassador for the post-Vietnam Carter era. Perhaps he believed, as many others did, that the Vietnam period had been a temporary malaise brought about by individual antagonists at the top (Johnson, McNamara, Nixon, and Kissinger). Jimmy Carter was supposed to be the corrective, but all that was soon to unravel with the twin ascendancy of Reagan and Thatcher, and the beginning of the neoliberal backlash.

The looming superpower contradictions were brought to the surface halfway through the India filming. One day, while resting at the hotel, Massey received a direct phone call from the White House. After determining that the "Southern gentleman" voice on the phone was indeed

NAEEM MOHAIEMEN

7 Palash Ghosh, "Muhammad Ali In Bangladesh: 35 Years Ago The Champ Visited A New Nation In Turmoil," *International Business Times*, August 12, 2013.

8 http://www.indiaofthepast.org/reginald-masssey/unforgettable/working-muhammad-ali-boxing-champ.

9 Les Carpenter and Oliver Laughland, "Shunned by white America, how Muhammad Ali found his voice on campus tour," *The Guardian*, June 5, 2016.

Carter, Massey passed on the phone to Ali. After a brief conversation, Ali came to Massey and said:

> Brother Reg, My President has ordered me to immediately fly to Africa and Saudi Arabia. My orders are to tell them all to boycott the Moscow Olympics because the Russians have invaded Afghanistan, *a Muslim country.*" *(Massey in India of the Past website, emphasis added)*

With that, filming was abandoned (Massey said this contributed to the bankruptcy of the company) and Ali was on his way to Saudi Arabia, where he was greeted by the King. The Muslim International shifted away from the idea of being led by the Black experience to the Oil Bloc. Ali was now an emissary of the United States against Russia in the Afghanistan crisis, placing himself in the middle of a superpower battle. Ali once said "no Vietcong ever called me _____"—subsequent errors in judgment do not diminish the courage of that lonely political stance. But in the span of a decade, the Afghan War was another Cold War staging ground (as Vietnam had been) with no possible benefit to the lives of poor Americans.

Ali's later experiences do not negate the potency of the Black International as a framing device for exploring Black radical thought. But it is important to face the combination of factors that produced an Ali who would misrecognize the great game of the Afghan War (the origin point for many of today's entwined wars) as only the invasion of a "Muslim country," stifling other possibilities the Afghan people held within themselves. These moments are unlike the man who once said, "my goals, my own." By the late 1960s, events inside America were moving towards ruptures that isolated Ali. Malcolm X and Elijah Muhammad parted ways, splitting the strength of the Nation of Islam. The fallout was a distancing between Ali and Malcolm, depriving him of a radical mentor. With the twin assassinations of King and Malcolm, Ali lost two leaders who could offer options of incremental struggle or radical resistance. The 1970s saw the waning of the idea of an International that could have derived energy from the African American experience. Ali's later years therefore carry both the weight of sacrificing his body to the sport, and the loneliness of an African American living on after revolutionary possibilities had been taken away, again, from his people.

Kamau Patton

Artist Kamau Patton commemorates the Wall of Respect with images from a performative work which is indicative of his interest in rituals that perpetuate a generative and improvisational relation to an event, site, or ocurrence. Through a mixed formal and mediated approach that infuses poetry, telematics, and sound elements, Patton waits for the "thing" (event, energy, object) to transform into a revised state. Patton often deploys improvised electronic feedback and technological noise to fill the new scene.

Fittingly, the Wall of Respect had as its partial object the project of anticipation. Some made a ritual of going to its site to watch and listen for what might transpire there—some unplanned but expected assortment of music, poetry, or activism—or just to hang out around it in a serious and dedicated way. Patton's performative works also entail watching for and listening to their sound, poetic, and scenic dimensions.

Like the experience of the Wall, where it was hard to know whether looking or listening or both was the appropriate thing to do, Patton's performance elicits a similarly open and improvisatory expectation. In both cases, improvisational impulses outweigh the significance of the aesthetic object, which is second to the experience of its process and unravelling. —RC

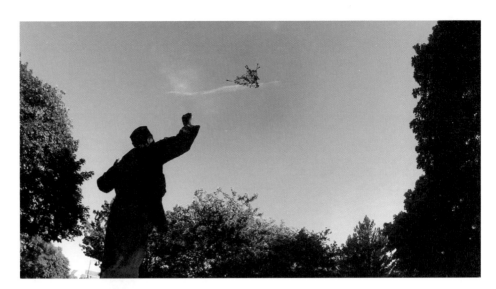

Higher than trees a cryptic crown
Lord of the rebel three
Thorns lay on a sleep of down
And myrrh; a mesh
Of nails, of flesh
And words that flowered free

—Excerpt from "The Dreamer"
in *Idanre & Other Poems*
by Wole Soyinka

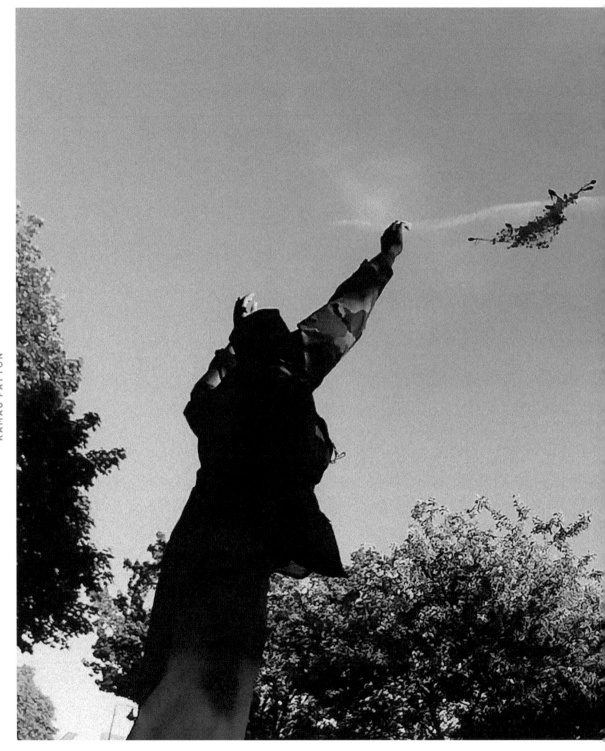

Rohan Ayinde

Poet, artist, and curator Rohan Ayinde has a recent experience with Chicago, its geography, and art histories. His tribute to the Wall of Respect is in the form of poetry, with which Ayinde often includes other elements, such as sound, sculpture, or—as he has here—a single photograph.

In addition to the poems produced for the Wall of Respect dedication in 1967 by Gwendolyn Brooks and Haki Madhubuti, and the images of writers and poets including W.E.B Du Bois, Brooks, and James Baldwin, the Wall, featured a 1965 poem by LeRoi Jones (Amiri Baraka), titled "S.O.S. Calling all Black People." Making poetry visible on the physical terrain of the Wall of Respect was a decisive act. Ayinde's fleeting monument poem alludes to the palpability of poetic form within the context of a categorically urban landscape and geography.

It was important that poetry constitute one of the Wall's varied media. Forcing poetry into the visual art object rather than using it as a solely sonic and occasional part of the Wall experience (as when Don L. Lee, Gwen Brooks, Amus Mor, and others read there) established poetry as an imperative form for Black culture-making in the 1960s. In 2019, Ayinde also brings poetry to the fore, now as a way to mark the Wall of Respect's history, signaling its formal significance and its historical relation to the mural. —RC

Close-up of the "Literature" and "Theater" sections of the wall of Respect with image of Amiri Baraka and text from his poem.
Copyright Darryl Cowherd, 1967.

Pilgrimage

BY ROHAN AYINDE

Bones beneath sidewalks. Ceramic faces smiling from behind cracks. Crumble/ meaning is the cul-de-sac. Bottle the excess taste of residue/hellos peeking from the corners of circles painted moon. You and I both know the place is less remembering, less fixing. Life is the weathering. Ink drops walking up the edges of mouths/canvases spread between respect and truth. Flutter in the wind when walking promises forward. Jump/jump rope joined where time once was. We skip. We beneath. We behind/excess pain. From an open front door take the first left that takes you North. Otherwise I do not have the directions. Imagine them.

When I was younger than I am now I saw a black hole. It was written in braille. I touched its front lawn with the sun/scale tipping the edge of a lake I didn't know/I would live by one day. What is a memory that reveals a future/irrupts into a sky mouth flock of crow? I am asking because I want you to walk there, trace the trace/pilgrim roads lined with saints in cracked sunglasses. Pacing, pacing. The avenue you are walking on is a block away from the lick/slice of tongues who know more than know can appropriately capture. Sightlines shadows hinting/dimensions in-between. The cut could never be doing the static/wall could never beautiful the edge.
SCREAM/now. Loud.

Our landscape is its own monument: its meaning can only be traced on the underside. It is all history.
— Edouard Glissant

The edge is a fold/corner fitted with a down/triangle mashed enmeshing the calm that washes where the peripheral is a natural bassline. Glance with neck and talk eyes/the mouth will do the finding/do the standing in for/walking South. Nosebleeds are the blue/inside coming out/indicating travel drop/by drop. For(get) the violence/it is imbricated where the city grids blood. But here/there is an outside that refuses/winks till the whistle /is a mouthful of water. Sing the note that ripples at the surface/mouth a gaping. Swallow whole the image/your body/ hovering.

Pathways disturb distance/I learn hushing good, roof a dance called wing/black nights patterning promise for bodies that harbour shift. Dislocation is a toward/making echo where the walls are measured footsteps. There is no fold to place movement neatly. Chorus the lifted sts/tonal per(form)ances ebbing in their ache. Here be broken for the here/marking laughter is the creak of swollen porches sighing concrete. The rub migrates/catching at the unnished. Excess makes the ground shimmer with voices sounding water while they arc/the broad beneath them-backs poised. Thread your narratives/like hides who leather for protection, texture moonlight with whispers caulking the deep. Deep it.
The nothing-left is where expansion is neither/outside or before there is a music.

Arrival extends/fugitive handshake/church the memory for the pilgrims walking in the hunch of a limp. Emphasize your broken/and I will sell my heroes for the underneath. Flowers make the cracks on sidewalks/root the place. When I have nished/pick up patois gorge the space with rivers. Silt the way/the glacial weight of black enough is closing. See the islands made/the entropy endemic/pan the drums in steel and let the nervous muscles in your footback s e t t l e .

III.
Reflective
Monuments

D. Denenge Duyst-Akpem
Stephanie Koch
Stefano Harney and
 Fred Moten
Nicole Mitchell Gantt
Cauleen Smith
solYchaski
Norman Teague
Bernard Williams

III. Reflective Monuments

The projects collected in this section produce a chapter of responses to the prompt that are variously theoretical, expository, reflective, and critical. They are all in some way inspired by the Wall of Respect, and its history is either directly or indirectly resourced to animate and reveal alternate ways of producing monuments to a given history, as well as art history.

The works of curator Stephanie Koch, muralist Bernard Williams, and artists Cauleen Smith, Norman Teague, D. Denenge Duyst-Akpem, and solYchaski use the fleeting monument for the Wall of Respect cue to actively think through and reflect upon their own artistic and/or intellectual labor and its connectivity to a given community, disciplinary field, or experience.

Not unlike the connection between art and ideation reflected in the Wall of Respect, all of these reflective monuments move in the direction of collapsing the distinction between artistic and intellectual labor. Williams, for example, theorizes on mural making with a brevity of words and photos of trees. The fleeting monument prompt, predicated by the same efficiencies (of time, cost, and production) as those in place for the making of the Wall itself, gives license not only to alternative forms of memorializing but also to experimental forms of art history,

theory, and criticism, which through their existence offer exciting critiques of the structural norms that these disciplines adhere to. Similarly, Stefano Harney and Fred Moten as well as flutist Nicole Mitchell Gantt reflect upon and dislodge heroes and their use value in Black culture.

All of these projects chip away at prevailing disciplines, practices, and histories, while signaling dynamic and fruitful outcomes from their critical/reflective endeavors.

D. Denenge Duyst-Akpem

Artist and educator D. Denenge Duyst-Akpem's fleeting monument for the Wall of Respect consists of "Mnemonic Studies" in which she ponders, through sketches and drawings, the impact of recurring shape and design elements. How do repeat shapes and visual schemes influence perception and experience? Duyst-Akpem's study addresses the memory and shape of an historical event such as the Wall of Respect. Are there structures within it that we unconsciously embrace and respond to? Her work asks viewers to examine elemental messages and tropes—which reverberate into the present and will resound in the future.

In addition to the facts of the Wall (the artists who worked on it, the heroes it depicted, its location, etc.), the Wall itself will be remembered through the persistent echo of its fact-less contours and atmospheres. Even as it is increasingly studied and analyzed from all angles, and every bit of its art historical merit is borne out and deduced, there will still be aspects of it recalled most effectively by its emotional shape and delineation. —RC

Mnemonic Studies: *Spaceships.*

Mnemonic Studies: *Yam Mounds.*

Mnemonic Studies: *Spaceships.*

Stephanie Koch

Stephanie Koch is an emerging curator and founder of Annas, an independent space dedicated to exhibiting process. She is an arts administrator whose concept of collective exhibition-making aligns with the collective ethos evidenced by members of the Organization of Black American Culture (OBAC) who conceived and produced the Wall of Respect. In a manifesto-like essay, Koch reflects upon the Wall of Respect model of collective exhibiting and bends it towards a genre that might serve a cohort of emerging artists and curators. Sensitive to the social turbulence that her generation must grapple with, Koch conceives a revised plan for collaborating across differences (racial, political, economic) in the present moment.

Among other tenets, the plan de-emphasizes a single site or community, opting instead for a plethora of meaningful exhibition locales. Koch's concept, however much it connects to and breaks with that of the Wall of Respect, continues the work of expanding upon and revising given models for exhibiting and installing work in times of social crises. Like the Wall artists who made and showed their work on the street because they were not regularly invited into galleries and museums, Koch reveals installation and art-making processes as potent forms of museological intervention and critique. —RC

Founding: A collaborative installation model

BY STEPHANIE KOCH

By all appearances, at present, the nation seems to be remarkably tumultuous. However, in the grand scale of its history, moments of unrest abound. Current American crises have their own pressing needs, but this turbulence is not new. In thinking about how art could productively illuminate and intervene in these crises, a standard approach is to confront and interrogate the sociopolitical atmosphere directly.

It has been said that today's moment is oddly familiar; there exists a resemblance to the years of the '60s and the '70s. The artists of those decades felt an urgent need to tackle their immediate events and conditions. In response to a fractured Black community, both locally and nationally, the artists of the OBAC conceived of the Wall of Respect to unite their neighborhood's members through the depiction of Black heroes. These artists affirmed a Black identity and instilled pride in the community's residents by creating a positive self-image.

While the OBAC reached a vision and mode of action together, the focus of today's emerging artists, curators, and writers feels more diffuse. Within their works, one can trace a resonance of embedded energies not overtly declared. There is an underlying desire to create a world that is other to the space and time in which we live. There is a need to construct a sacred space for oneself and one's personal experience. They reckon with their heritage or lack thereof, and they search for their place in history. Rural and urban precarity meet ill-fitting categories of identification to create a climate of uncertainty. Those born into unwelcoming worlds and unreliable environments have a different reaction than those who assumed they were connected to a community. In response to a lack of feeling of home, of belonging and of care, these makers feel their way and make their worlds anew.

The artists affiliated with the OBAC responded creatively to the nature of their conditions. To add clarification to an ambiguous position in society and to coalesce a fractured group through a Black identity, they employed representational portraiture. An ambiguity of position is similarly present today. However, this ambiguity stems from categories of identification akin to that which the OBAC sought to create. Categories of identity related to

race, gender, class, sexuality, and nationality no longer seem to fit the diversity of experiences and abut against one's conception of self, resulting in an isolating, inner crisis. Rather than approaching these crises through clarification and solid representation, the makers of a younger generation explore beyond clean-cut lines and binaries. Whereas the OBAC used representation to reflect and illustrate the Black experience, today's makers accept ambiguity as a space which will complicate their histories and present selves.

Although many of today's makers hold a common intention, they are unaware of each other's concerns and considerations. Siloed and singular, many do not engage collaboration and, as a result, have not found affinities which could resolve feelings of isolation. Similarly, prior to the formation of the OBAC, the contributors to the Wall of Respect created their works in solitude. Their current events and ideological affinities encouraged them to unite. A series of discussions on the crisis present in Black communities is what followed. From these discussions, shared needs and intentions came to the forefront and they formed an organization.

The Wall of Respect created a coalitional effect between artists and established a relationship between artists and the community's residents. As a project focused on community engagement, the Wall not only fostered connection locally but also across communities. These artists raised the consciousness of a similar state of mind and being on a national level.

My exhibition series titled *Founding* seeks to connect today's makers and their work to form communal bonds. As an embodiment of the collaborative nature and the initial principles of the Wall of Respect, I offer an installation model from this series to be adopted into relevant arts education for their youth programs. Outwardly, the nation has a deeply divided image. But, whether or not fully realized, feelings of discontent, confusion, and alienation reside within everyone. Following the form of the Wall of Respect's beginnings, this installation is a collaborative conversation between young makers, but also between the objects they will present. To be a kind of monument, this impermanent installation commemorates the objects of the everyday which serve as comfort in a time when one's best life seems unattainable and any sort of stability is in constant flux.

Overall, the project of *Founding* considers how today's makers use abstraction to process and transform their worlds, with future exhibitions focusing on the thematic of material considerations. Whether by exploration of public forces or through personal narratives, these artists explore culture and history specifically through materiality. Following the process and material interests of the involved artists, this future exhibition will be a display not only their work, but also the objects which initially gave a

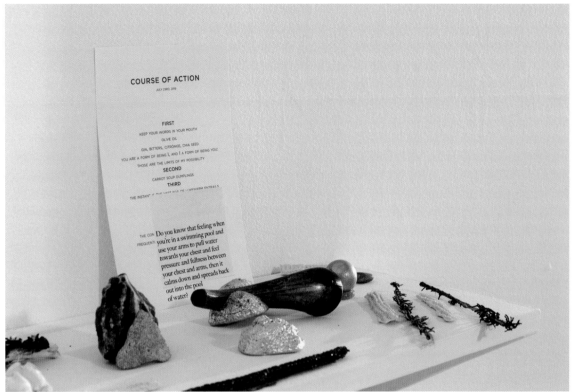

a yolk, suspended. Caroline Dahlberg, Mariel Harari, Azalea Henderson, and Maggie Wong. Curated by Alden Burke and Stephanie Koch at Annas, Chicago, August 2019.

sense of comfort in their personal lives, and then developed into a reference. Artists have always attended to materials with contextual significance. But, today, there is a heightened interest in materials connecting particularly to a memory of home, of place, and of heritage. These materials, the histories they represent and the memories they host, serve as an object of comfort in the face of feelings of displacement and alienation. Although their methods and presentations vary, these artists similarly aim to forge connections and excavate individual and collective histories as they subvert, recontextualize, animate, and activate objects which have personal and historical value.

Within artmaking today, there are collecting practices which ascribe value to the objects of the ordinary and reimagine the form and context of the historical. Objects are not merely passive evidence of a static past that no longer exists. They have social lives and, further, as material things which symbolize a person's individual self and collective identities, they constitute the dynamics of the social sphere.

While the Wall of Respect existed in one location, the model of *Founding* is to be replicated in multiple sites. As an object collection, this installation model can be enacted by any institution, alternative space, group, or organization, both arts-related and civic, for their education programs.

Curators, artists, arts educators, and arts administrators who enact their edition of this installation in their communities will feature the chosen comfort objects of their education programs' young artists to explore how these students think about heritage, displacement, ancestry, migration, and home. The installation's parameters follow the improvisational nature of the Wall of Respect; this installation does not intend to become a concrete collection. For the installation, the students should bring an object that they find comforting or represents a comfort: a letter, a figurine, a necklace, etc. Objects can be placed, moved, and replaced throughout the run of the exhibition. With no set timeline, the installation will evolve, contract, dissolve and reappear. The collection of objects will allow for the histories, of the people and of the objects, to quietly unfold through the simple act of recontextualization.

Although the project is meant to demonstrate commonalities across diverse experiences, this project also aims to create space for organizations to work within their values for their intended audiences. The installation should be made in the timeline and capabilities of its host organization. Although hosted by institutions, just as the Wall of Respect presented imagery outside of the art gallery and within their neighborhood, the objects should be installed within their communities. This installation of *Founding* should reflect their communities' infrastructure and reimagine spaces of the everyday. Suggested spaces could include a china cabinet displayed within a library or photographs of these objects organized into an easy-to-distribute publication.

To connect these disparate sites, the installation should include related interpretive texts in either the form of a wall panel or printed material. The text should detail how *Founding* supplements the values and goals of their institution or space to follow this description of the project-at-large:

Established structures of a secure life believed to be stable are recently discovered to be fragile. The current tumult of the nation disrupts traditional ideas of work, intimacy, and politics. An unknown future and a shifting sense of self is what results. In a moment when the nation seems fractured and disconnection is a common feeling, the exhibition series of *Founding* creates space for communities to gather through the experience of art. This project commemorates the organizational methods and principles of the Wall of Respect, a public mural which aimed to create

local consciousness of a national condition. The Wall's nature of collaboration is the model from which this installation seeks to form relationships between the young artists on view and the residents of the community in which they live.

These artists navigate and respond to unpredictable worlds and they speak to feelings of displacement and of discontent; to wishes for home, for belonging and for care. As a multi-site exhibition hosted by partner institutions, these linked installations do not display their artworks per se. Rather, in a response to an uncertainty of position and self, these artists offer found objects which give them comfort. As conduits of memory, whether a plate from their grandmother's china which points to home or a collection of receipts which gestures toward a candy habit, these objects either represent or directly provide support to their being in the world.

By offering familiar objects in unfamiliar ways, *Founding* provides visitors a space for self-reflection on their position and what they do to take care of themselves and their loved ones. Feelings of doubt and alienation reside within everyone. Through the collection of these objects, these feelings gain visibility and are transformed from that which isolates into that which bonds.

Stefano Harney and Fred Moten

Stefano Harney and Fred Moten are noted for their collaborative writing practice, which in many ways continues the tradition of Black radical intellectualism that went into conceiving the Organization of Black American Culture (OBAC) and, consequently, the Wall of Respect. Harney and Moten extend that critical tradition, ever mindful that it compels its own critique—as this too animates it intellectually.

Self-critique in the form of revision was an ongoing reality at the Wall of Respect, where artists are rumored to have revised paintings at the behest of nearby neighbors, in addition to whiting out or painting over the portraits of more contested heroes.

Harney and Moten's fleeting monument is in keeping with this project. It offers critical insight into "black (ante) heroism." As practitioners who engage in the constant work of raising the critical stakes of Black radical terrain, attentive to its varied modes, including poetry, music, theory, and art, they push at the soft spots and steer away from its comfort zones. Their meditation on the Wall of Respect takes on the hero motif which serves as the thematic hook for the mural. They establish a nuanced confirmation and negation of this precept, taking it to task and complicating its appreciation. —RC

BLACK (ANTE)HEROISM

BY STEFANO HARNEY AND FRED MOTEN

Respect

Against the backdrop, and under the continued protection (even in its disappearance) of its Wall of Respect, conceived, painted and dedicated in 1967, the Organization of Black American Culture allows and requires us to think about heroism. It lets us do so with a gentle, militant demand given in the way they worked, through the conditions under which they worked. And so we are compelled to say that they produced a wall of heroes and did so heroically, in the endless climate change of racial capitalism, that make our heroes as ubiquitous as they are impossible. They pass their passion on to us; they never passed us by, and we can't let that pass without remembrance. But at the risk of being misunderstood, especially misunderstood in our profound respect for OBAC, and in our own "black hero" worship of its members, OBAC whisper a question in our eyes: is the black hero an oxymoron? Unless we are to understand the black hero as a version of a white hero—that is, as a monument to a people that it instantiates and exemplifies—then we must suggest that the black hero somehow and against our own hearts, must be understood as unheroic, or more accurately, anti-heroic, or even (ante)heroic. Indeed, insofar as the black heroic stands in relation to the heroic it must be anti-heroic, and insofar as its formation is outside the heroic, it must be (ante)heroic. Its failure to form the relationship of hero and people makes it anti-heroic but its preservation in and of the deformation of anything as regulatory as the standing for/th of a people by its individuated and monumental-ized hero marks it as (ante)heroic.

It seems clear that understanding the black hero as a derivation of the white hero satisfies only the most derivative class, the most regula-tive and self-regulated class. In fact, the white hero is himself deriva-tive of a derivative, derived of a people who are themselves derived of the human, which is the category that regulates a range of differences with a mechanics of racialization which the very idea of species-being

always already bears. This is the phenomenon of which *a* people are a (di)version. The white hero is erected to monumentalize a people, and to fix a part of so-called humanity in conflictual, regulatory relation with other peoples, who have their own heroes and monuments. If the hero is the individuated monument to a protocol of conflict that cannot be contained as conflict, then racialization might be held—when theories of Afropessimism rightly claim their general application—as the relay between antagonism and conflict. That relay maps onto the distinction between the enemy who, by way of conflict within an assumed equality, can become a friend, and the racialized antagonist who is given as the enemy (and, therefore, the condition of possibility) of all mankind. In the political battlefield that is so charted, the monument is necessarily a racial artifact, a regulatory fetish of a people in the figure of the individual, one and many given now in fallacious relation. Given in this way, in this derivative chain of illegitimate givens, in malls and avenues and gardens of cold, white stone, the state formation of a people riddles itself with monuments. If all the *Wall of Respect* ever did or was meant to do was reflexively and reflectively stand against that, who could object to such righteous objection? Happily, the *Wall of Respect* cuts (the metaphysical and political, racial and psychic, foundations of) respectability to the bone.

There's a telling moment in Martin Heidegger's infamous "Rectorate Address" that is brilliantly noticed in Noam Chomsky's famous essay, also from 1967, called "The Responsibility of Intellectuals." Heidegger speaks of, and Chomsky derisively and rightly criticizes, "truth [a]s the revelation of that which makes a people certain, clear, and strong in its action and knowledge." The hero might be said to embody that truth and it is in this regard that the hero is a monument to a people. *But such monumentality cannot be ours*, a condition that requires us to consider what it is to be a people. Are black people "a people"? What do we call the everyday relinquishing of the fantasy of being a people in which black peoples have been engaged? What do we call that intense entanglement of solidarity and differentiation, which constantly and radically disrupts certainty, clarity, and whatever modality of strength that accompanies them? We want to say that the beauty of black people is in their consistent refusal to constitute a people. We move against heroism and monumentality and we need a word, or something, to correspond to the beauty and intensity of that movement. At the same time, when we have appealed to any such word, or any such something, none has ever really fit, none has ever really persisted or remained, as any successful monu-

154

ment should. And so we also want to say, abjuring any gesture of absolution that might be extended to the forces that erode our monuments, that the *Wall of Respect* beautifully exceeds, even in its disappearance, any appeal to monumentality.

Surely this has to do with a hemispheric tradition of muralism that links OBA-C (and their colleagues from AfriCOBRA—the African Commune of Bad Relevant Artists) to the Syndicate of Technical Workers, Painters and Sculptors in Mexico; and just as surely it has to do with the the general field of relation between whiteness, subjectivity, and heroism, a fantasmatic convergence that models subjectivity in specific ways in the United States. Where common folkways erupt, under constant pressure, in the common production and reception of unregulatably differential style, the black anti-hero, or the black (ante)heroic, is given not so much in a figure as in the cutting of a figure, to use and also slightly to abuse Richard Powell's illuminative phrasing. The soloist is bas antechamber to a social practice; a continuous preface, a swinging door, a blood stain'd gatelessness, a vestibule as Hortense Spillers says, that leads to the rupture, the preservation in deformation, of black social life, by no invitation only. The individual is neither one nor everyone in this regard and portraiture, when given in such constellation, divides or shares or reconfigures the figure. Is there a prefiguration of and through the individual on the *Wall of Respect* that corresponds to the force of the pre-Hispanic in Diego Rivera's *Flower Festival*? Then this is the black (ante)heroic, whose bracketed prefix indicates that heroism isn't the right word until you put some black in front of it that can't wear off.

Dis-honor

Could it be that the white hero must fall, while the black hero must fail? This is the first sense in which those whom we love who are on the Wall of Respect might be honored with something more and less than heroism. They might be honored instead with a redacted heroism, an honor born not of the history of dishonor but the history of disowning honor, which is not honor's collectivization but the socialized refusal of its individuating game. That refusal of that which, according to Orlando Patterson and his forebears, constitutes (properly political) subjectivity as an effect of power and as the degradation of sociality, takes place before it is offered. Here we might index this failure to honor honor with Huey P. Newton. H. Rap Brown and Stokely Carmichael were on it, but Newton was to rise as the *Wall* fell. He was to struggle, in a double sense, through heroism. Honored as a black hero, he was an advocate for revolutionary suicide. Was this something more than dying for the people? Could it be that in the idea of revolutionary suicide, where death is part of life in common, and not its singular monumentalization, Newton suggests that the black hero does not sacrifice for the people, but *is* sacrificed for the people? Such black heroic passion bears an irreducible sociality. Moreover, what if what must die for *the* people is not only the hero but also the very idea of *a* people? The black (ante)hero is sacrificed to preserve the anticipatory and anti-regulatory deformation of the people against the grain of monumentalization and the formation of a people.

Let's approach this again by way of Afropessimism's special stringency. No slave, no world, as Frank Wilderson says; and given that this wall is erected and comes down, like its black heroes, in the world, those heroes have failed (at abolition); and so the world remains, in all its geocidally, genocidally extractive relation to earth and the differences earth bears. Such analysis zeroes in on the undeniably anheroic, the hero who fails, who fails to cohere into the monumental, who fails to instantiate any coherence of a people, as statue, statute, status, or state. She would appear, most devastatingly, as never to have been erected, never to have been torn down, as unable to fall in having always already fallen into abandon and dispossession.

This analysis washes the wall for further revision of the black (ante) heroic, for preservation and priority of this washing away, this washing over and under. Cedric Robinson writes about the preservation of the ontological totality. It is his answer to how something that should have

been impossible, given the laws of the hero and his people, nonetheless exists. The ontological totality is a conjuring of collective African being at the moment of struggle, at the height of insurrection, and even at the point of death in battle. But crucially and excruciatingly it is impossibility that forms its condition as unconditional deformation. The Africanness of the ontological totality is therefore more and less than African and otherwise than being. Its preservation requires its opening, its incoherence, its refusal to coalesce into anything like a people. It is, in other words, not African but Pan-African. Terribly, beautifully, terribly, beautifully, it is foregiven to us and in us to be given away, such dispersion itself being the opposite of the heroic and more in the direction of the profanely, pandemoniously sacrificial. What's continually sacrificed is the soloist in the soloist's continual appearing, his constant showing up to be sacrificed and dispersed, preserving the experiment by failing its monumentalization. This is black art's unbearable brutality. Albert Murray can't quite get to how fucked up it is in *The Hero and the Blues*. No blackened existentialism, no shaded tragic consciousness will do. Nevertheless, Nanny Grigg or Nat Turner, Robinson teaches us, keep something going through their certain deaths, keep something going that cannot win under the rule(s) of the hero and his people, but survives in something more exhaustive. There is something unheroic about this, the failure to win, and something other than heroic about it, too. Under the law of the hero, even tragic heroes are remembered despite their own fall or death through the victory of *a* people. They are monumentalized for having fallen on the road to success. Or, at least, this is the way a white hero is conceived. But the black anti- and (ante)heroic is condensed and dispersed in sacrifice for the victory of *the* people by the ontological totality in its antagonistic relation to *a* people. With the help of OBA-C, AfriCOBRA, and AACM (Association for the Advancement of Creative Musicians)—can we imagine another way to think about the soloists, about the women and men we call black heroes, about certain blacks who groove on love. What did they do, what did they render, beyond the heroic and unheroic as it comes to us in this world? Asking these questions, which loop back to the question they ask us, means looking close enough to hear more in their work, and their way of working (through the work), and the place where their work went on.

Everyday

We notice again, when we keep trying to pay attention, that OBA-C, the street gangs, the tavern operator, the neighbors, survived under daily conditions that we might otherwise say, but should not say too easily, gave rise to the heroic. The place where the work went on and the people who did that work emerged from black social life, from the impossible everyday, conducted daily. Everyday people live (ante)heroically in the world of denied and refused peoplehood. In the space around the *Wall*, the strained superlative, the broken perfect, the impossible under generalized conditions of impossibility, are on from can't see to can't see. In heroism's burdened, burlesque corrosion, we see the quality of the quotidian deed, its constant revision, its common condition, its disruption, its unmonumental apposition. But we have to resist taking away from this unmonumental apposition the idea that everyday black people are heroic, and instead, without denying that idea, focus on its surround: that the black (ante)heroic is (a constant variation on the) routine. It's not so much that daily life is infused with heroic deeds, but rather that heroism is reworked, or unworked, as daily collective social life; that is, as prosaic, repeated, revised, varied, experimental, discontinuously restarted. All that crowdedness and rub that happens on the Wall is given again and again in all that happened to the Wall. There was first and foremost what Romi Crawford calls "a being present and around the Wall." There were plays put on and music played in front of it. Parts of it got painted over, it all got rained on, it supported incalculable drama; a dead body was left propped against it, the FBI took pictures of it, it got burnt. The Wall's eventfulness is sometimes portrayed as what it went through—a sign of the times and symbol of the place. But, really, that *was* the Wall, not what it went through; that's what OBA-C was, and their anti-heroism existed in service to the black (ante)heroic, as everyday commitment to the annihilative provisionality of being that was, at the same time, total. If we look at photos we have of the painting, and hear the poetry around the wall, and the music, we encounter again and again antagonism, painting over, house paint and whitewash, cardboard and string, as well as a total commitment to the impermanence of form because form is to be used, like an everyday thing. You use it, that is to say deform it; you use it without owning it, without permission to use it; you don't keep it for a monumental occasion but preserve it, in letting it go, in acceding to and enacting its transformation, in and for the everyday.

It was never about this or that person being seen; it was always about this or that person being seen through. Nor was it ever about seeing through the special hero to his or her variant from around the way. That's not seeing through opacity, that's mirroring given in transparency. But the Wall's transbluesency, the amplified delta haze it still gives off, let's us misrecognize, pulls our coat to how recognition of the everyday hero threatens the preservation of this ontological totality. It parries and deflects that being-subject to reaction precisely because the bestowal of heroism in the interest of telling the truth of *a* people rings false in the impossibility of its relation to the people's black and open generality.

In other words, the aim of the wall was not *its* preservation, which will have never forestalled what we might call its disappearance, but, rather, its transformation precisely in the interest of the preservation of the ontological totality. In this it differs from the monumental. Nor was the aim, strictly speaking, the preservation of the heroes against the general anti- and (ante)heroism that sent them. Nor, and finally most importantly, was the purpose the preservation of a people, their monumentalization. What OBA-C gives us is the deformation of a people in the name of something else, something stranger and more beautiful—a general antagonism with species-being.

The Wall and its histories help us see that a people is just a regulatory reduction of *the* people; and a person is simply the sign of a people or, better yet, a people's unit of value, pegged to the hero in mutual impossibility. This reductive formula bears the national(ist) subjection of the people's weirdness, the constant differentiation of which—in and as undercommon practice, in and as irreducibly haptical and topographical social poiesis, in and as study—will have been rendered coherent by means of arithmetical separation. This is how nationalism and individuation go together, how there can be this seemingly paradoxical combination of national character and the absolute singularity of persons, since weirdness has to be individuated, and then collected, in order to be calmed. The monument, which is an extension and intensification of the logic of the portrait, is the crystallization, resolution, and/or embodiment of this paradox: the national individual in the glory of a general equivalence he stands for, simultaneously abstract and unique—the representative man as a kind of currency, the coin of the realm. But differentiation is neither individuation nor pluralization. It refuses the law of the integer. Go to any bar to see this weirdness under duress, on display, as it tries to defend itselflessness. Go to a black club, or church, to see how this is done with the greatest and most delicately violent technique, preservation given

in an immeasurable range of dispersion and disbursal, as our romantic disposition, our mantic deposition, our antic apposition. We so crazy we tore up our own monument—kept rubbing it with the furious questions it taught us to ask, kept submitting it to the terrible enjoyment of our condition, until it disappeared. Nathaniel Mackey might say that the wall of respect is another instantiation of our "eroding witness." In this regard, black nationalism is anti- and (ante)nationalism, just as black heroism is anti- and (ante)heroism. That's the African pan.

Washing our work

Now what might this mean for those of us who want to walk in the footsteps of OBA-C today, which is to say in the footsteps of the black radical tradition, and in the footsteps of everyday black social life as the collective honor to refuse honor, the black (ante)heroic? Well, we've always had black heroes. So, what does it mean to render them in our work, in our writing, with this understanding of the (ante)heroic? How do we do that? Does it mean, with OBA-C, we have to find ways to de-monumentalize our work and the work we write or paint or sing about? Is it unfair to say that current cultural form, insofar as it has been adapted in black artistic and intellectual life, places black study at risk to monumentalization, seeks the heroic, pulls away from the black (ante) heroic?

One version of this monumentalization is the amount of honor bestowed on individualized position. Spillers speaks of it as the ruse, or the lure, of personality. The mere presence of the black scholar, the black artist, the figure who would cut the figure, is taken as a victory to be preserved, rather than as an effect of a compromise forced on cultural institutions by the movement of black people and forced on the movement of black people by the powers that operationalize cultural institutions. When we allow this to happen it is not just that this mere presence in the institution assumes a model of heroic representation of a people, but also that this attitude seeks to regulate what that movement might really wish to make disappear or wash over amidst these derivations of appointment and position. There is no culmination, in individuated units, of the people.

On the other hand, taking OBA-C, AfriCOBRA, AACM, and others not only for how they inspire us but for how they undo us, how their (ante) heroics preserve the chance to undermine the temptations of the monumental and the lies of the hero and his people, we can perhaps start to

160

help each other disappear, paint over one another, play over ourselves, let our solos fade into our noise. The *Wall of Respect* was at the service of an undercommon flight from being, and fight through being. It was not the object. It did not merely stand against. Its objection flourished under and around its objecthood. And so long as jobs and shows and books are the object (seen as necessity rather than their necessity being seen and lived through), we will be heroic. We have to find new ways of working that insist on the impermanence of the monuments in exhausted, inconsistent totality. How can we make a living that way? How can that way be our living? It will have been more than a reversal of all we do, though it is that; it is a sacrifice which no one of us can even volunteer. Sacrifice, to share in offering, in pleasure, in mourning, in remembering, is often, now, regarded as obscene, while the single claim upon station is lauded as a virtue. Black virtuosity, black heroism, had better be bad.

Nicole Mitchell Gantt

Many of the artists who worked on the Wall of Respect had an open relationship to form and worked in various media. The photographer Darryl Cowherd, for example, also wrote poetry. Creative flutist and composer Nicole Mitchell Gantt exposes here her text-based endeavors, which are as improvisatory and experimental as her music. Her fleeting monument for the Wall of Respect is in the form of an open prose vignette that centers around African American cultural motifs. Gantt's story depicts and reflects upon a series of subjects, many of which relate to minor figures, who live amongst us but might be worthy of some quiet recognition. Her work fictionalizes the often muted lives of Black men and women, making their labors and struggles more audible and less invisible.

Gantt, who was the first woman president of the Association for the Advancement of Creative Musicians (AACM), takes into account the power of everyday persons and the interpersonal partnerships between people. Her focus is on the hero as someone not alone but in a relational bond with others, their partners or children, coworkers, etc. She implicates monuments, but to ordinary individuals not unlike the regulars who attended events at the Wall.

While Gantt was too young to perform at the Wall of Respect in the late 1960s like earlier AACM members such as Lester Bowie and Roscoe Mitchell did, she continues the same tradition of making Black creative music. Her fleeting monument projects her other voice as a writer. She implores a dedicated listening to inaudible registers of heroic Black life and suggests we keep our ears as well as our eyes wide open. —RC

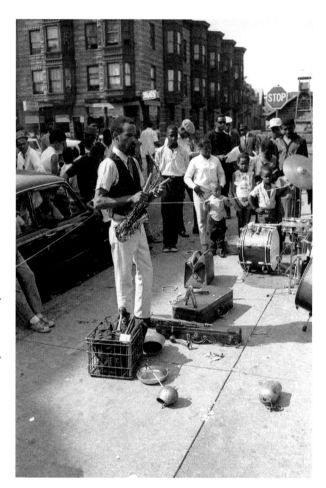

AACM member Joseph Jarman at the Wall of Respect.
Copyright Bob Crawford, courtesy of estate.

Fleeting Monuments: From Behind the Wall

BY NICOLE MITCHELL GANTT

Tunes Day Before Noon

I've looked around and seen that there's a desire to leave at least a little speck of immortality in this flickering moment of life. It seems we want to remember those who have cooked up change, fostered hope, and moved selflessly with courage towards facilitating our liberation. Those people compel us to say "WOW!" So we paint walls and chisel embodiments to leave landmarks of those luminaries for the next generations. The neighbors breathe easier, and the children gaze in awe at those great painted minds that watch over them, bigger than life. But do new memories paint over the ones that have passed? I wonder, are brick walls too square to define wholeness? Who are the bricks? And what's behind that wall? A mural is like one of those futuristic holograms that make a person live forever. That's a powerful image of achievement, even immortalization. Yet our life is in action right now—me and you, in the third dimension. We will always defy some imitative recreation, don't you think? To some, a statue is but a pole blocking the whole truth of what's behind it.

There's a particular monument that I've seen adored and adorned, like a shrine for our ancestors, but I don't really like it that much. It's not just physical; it's emotional and spiritual; it's psychological. I fear it may be a wall too tall to knock down. It's played a role in the messes of most everything, as far as my eyes have seen. I've mostly witnessed this in the underground divided unstoppable states of African America—Centropolis, specifically—but I know it's a global phenomenon for the whole human struggle. You know, it's in our music, on our block, in our churches, in our schools, and it's especially downtown and in any state around. It's everywhere. I've been told (well, I've learned from watching my elders) that I must keep this thing quiet and continue to empower it. I'm supposed to keep these thoughts to myself. It's a well-tended-to monument that I would emphatically like to tear down, like that Confederate flag on South Kennicott. I've been told that this thing that bugs me is really not that important, especially when Black folks continue to be catching hell. Hey, mere survival is at the forefront. That's true. But

163

even so, I watch; I sip my kombucha, and I think about different ways of doing the "knock down." If I acknowledge that it's there while others act like it ain't, would pointing at it dissolve it to rubble? Aretha spelled it out in capital letters, and made us laugh our way towards tumbling it down, in response to Otis, and she's still here to tell it. So maybe I can do this.

There are people—leaders—that we hang posters of. Black leaders. A lot of them love this ugly monument I'm talking about. What if its contorted semblance is all we have? If we topple it, where do we go from there? OK, are you tired of me beating around the bush? Who am I telling anyway? We all already know what this is and it needs to change.

Sunshine Night

See that thick, pretty woman in blue over there writing in her journal? That's Cherese. She'll bite her lip, pout, change her religion, roll her eyes, and even raise her voice, but she will stand by Charles. I mean, Charles, he has so much potential. Cherese will stay put, even if Charles is messing around with other women, and even if he just won't stop drinking, and even if they are not *really* married, and even if they living in his mom's basement and he's not paying rent and *especially* if they have kids. No matter what her girlfriends tell her, Cherese just loves Charles and she will not get out. Even while Cherese is out there working, writing poetry and planning protests, she will never ask him to help. She pays their rent, works, mows the lawn, picks the babies up from school on the bus, fixes the toilet, cooks, and without a single complaint. Because she thinks she's lucky. She says he needs time to get his graphic-design business started. And Charles handles some important business she can't do by herself, if you know what I mean. And at the end of the day, she has a man, after all. And Charles is the smartest man she's ever met, and a charmer too, when he wants to be. I know I did it like Cherese for too long myself. I'm just saying. But, getting back to Cherese, who is sucking her teeth right now. She will forgive Charles time after time. They are a man and woman of the *Word* and people respect them. Hell, I heard he has slapped her a few times. Actually, Cherese might not forgive me for telling you this. But I'm doing it anyway. She says the *Good Book* says, "Honor thy husband." She's my sister and she told me I better not be airing her dirty laundry. Her friend Rose is like that too. She laughed at Cherese's complaints and said, "When he gets to drinking too much, just lock yourself up in the bathroom with the *Good Book*. You'll get through."

But my question is, if Rose puts up with all that, and if Cherese does too, are they really loving them, or are they enabling them? I know I'm not supposed to judge, but I told you I was talking about stuff we ain't supposed to talk about. And you love gossip anyway. Will Rose's and Cherese's kids and grandkids do like her? It can get bad. I lost a friend of mine, Janeese, sometime after her husband Jonathan told her flat out he was keeping his chick on the side. They said Janeese died of cancer not long after that, or did she die of heartbreak?

We don't have to look long at Charles, or Jonathan, for that matter, although I have more to say about that situation. There are some good men to talk about. For example, Marcus is pretty righteous. He's responsible. He keeps his word. He always always keeps a good job, and he takes the boys to Little League. Carla, she's happy to be with him. Marcus speaks to her soft and sweet, and he leads the family so kindly. And Carla, she's smiling all the time, but even she knows she should not "take up too much space." Her mother told her to go ahead and marry him before she finished school, and ever since, she sidesteps her dreams and aspirations, because Marcus needs to be first, and at the head. He didn't want her to get a degree, anyway. She'll go wherever they move to, because he's moving up. Carla's mother was the same way, and so that's how she's going to be. Her mom told her clearly, "Listen, and don't nag. Not too much, anyway. And don't gain too much weight." This is the way we are showed to be. And when we sit in church as children, we're told that everything is Eve's fault, after all. And we all know that feminism is for white women. Black men have it the hardest, so by all means, we must protect, love, and cherish Marcus, Charles, Jonathan, and all of them.

On the African-centered scene, yes, the fight for reparations is real, and the drums, the festivals, and the history lectures are amazing. It's all super energizing. But I'm just saying, I noticed there are plenty religions led by Black folks where women are told point-blank, that it's for our liberation that Black men should have several wives. There are some members (not all, mind you, but enough!) of Ausar Auset Society, Hebrew Israelites, Islam, and Rastafarians who insist this is the best thing since sliced bread. We are told it's better because there is a shortage of Black men, and monogamy is European. So when Christopher told Channel he needs *inspiration* as a jeweler for the community, and that Channel would always be forever wife numero uno, she hesitantly agreed. Christopher is so talented, and so fine, and he has his own business. Anyway, we should honor the polygamic ways of our African heritage, yes? After some years, Channel hasn't seen that play out too well, and especially not for their children. Christopher brought

in the younger and hotter Daria as the second wife and he told Channel and Daria that since he was working for the good of the community, they should get the government to support the family, not him—i.e. food stamps and welfare. Yet, when Channel took a trip back to the homeland, she found out that at least in some parts of Africa, it was the Arab influence that brought polygamy to those regions, and that in some places, the original African religion was monogamous. Daria is still sticking it out for her children though. Bless her heart.

While I'm at it, I want you to see that other young lady over there, with the dashiki. That's Renita. She's so cute, isn't she? I wish I could have some thick perfect braids like that and she's built like a little brick house. But oh, she's got a sassy mouth. It's too much. People say it's understandable for her boyfriend Kenneth to need to silence a woman with a mouth like that. She's always talking back. Kenneth asked Renita to wear a bra and she just won't do it. She says *that's* white! Renita had grown up reading about Angela Davis and Assata Shakur who were heavies in the BLM movement. Weren't they some of the most heroic? They always had a lot to say and they couldn't be told to stay in the kitchen and be cool. Renita knowing that hasn't seemed to help her situation with Kenneth none.

And see, now, there's so many mothers I know, like Lori and Valerie, who are out here, making a way—on their own, for their own. Mostly because they had a mouth and independent mind like Renita. They are career-minded and just couldn't be told what to do. They started with relationships but decided to leave. They follow their dreams, and look how beautiful they are, and how successful they are. Valerie was looking boss on the cover of *Biz Future* magazine last month. I can't understand why they don't have no-one. For years, I've watched how Lori and Valerie do it alone. Then, a magical moment came! Lori met a promising life partner, Dave. He seemed like the one! But damn it, Dave didn't like that Lori could do everything herself. He saw it as a threat to making a serious relationship. You would think he would be happy to have someone that can bring something good to the table to build with. Is there another way to do this? For each of us to contribute something fully? To work as true partners in our families and organizations and help each other and value each other's strengths? Can we tear this old model down and make a new monument for balanced partnership and mutual respect?

Back to Channel. She told me that she had at least three friends—Mike, Joe, and Tina—who were raised by their aunties because they were born out of wedlock and their fathers were preachers. They never got to know

their real momma or daddy, to save the preacher's face. All I can say is: "Hmmmph hmmph hummph."

And did you hear about Cedrick Tall? He was Centropolis's first and only Black mayor, so far. Folks whispered that he might have been gay. Who cares? He did a great job. Does it matter? If so, could we accept that and still embrace him? We finally getting a small bit better at this now, thank goodness. What if our leaders are not all gender binary? Must he/she/they hide their identity to be effective as a leader, because we may reject them otherwise? What if Mr. Tall and the other leaders who are non–gender-conforming disappeared? Where would we be then? Why do we demand mainstream conformity of our leaders, then breed secrets around them if they fall short?

Lamont, now that's a mother's son. You know what that means. He grew up as the man of the house, and he can "do no wrong.' His mom just knew he was going to be a lawyer someday. Such a promising young man. That's why his mom told Jacob (his boyfriend) to go back to him when Lamont hit him the first time. His mom said, "...but Lamont really loves you, Jacob. You're the one." His mom told Jacob he should be grateful to have a good man and that he was not appreciating Lamont enough—that's what the problem was. Lamont is trying so hard to be perfect, after all. I can't say for sure, but I don't think Lamont even wants to be perfect. I know that must be a lot of pressure—having a good job, making good money, and then standing up and doing extra to prove people should respect you. Yes, Lamont is trying his best, to get the little bit of respect he can get as a Black man in a white world. It's not easy. I know it. That's why my friend Caleb over there told me to never tell a soul that he was raped as a child. It's not even Caleb's fault, what happened. He was so small. But don't tell nobody. You got me started now, but there's also my other friend Timothy. He told me he was sexually abused as a baby too, and by a grown-ass woman that he knew from around the block—Trisha. But now Trisha is out there really making a difference. She's a principal of one of the best schools we have, so we shouldn't tell on her, right? If we tell, people will blame the victims if they are men anyway. They will blame Caleb and Timothy for what happened, and they will say their manhood is diminished. They told me and I've kept this a secret until today, until now. I just had to tell someone. I'm telling you, and it's a burden, but not anything close to what they both are carrying. Yikes. This monument of secrets—we breed it within all of us. It demands our silence, though we can't resist whispering.

The people that know of the musician Jimmy Bait, know he left a powerful musical legacy. Jimmy has been celebrated as a community asset of the Mosephan blues, and for his extensive knowledge and his generous

work as a teacher and performances that had all of us enthralled and inspired. Thousands gathered to hear his ensemble sing liberating truth in the 1970s, and to this day Jimmy's name evokes positive memories of musicians and fans. Upon his death, every word spoken was in respect and admiration of what he contributed to Black history and culture. Yet, Jimmy had at least eight kids from six different women. The mothers of some of these children, especially Cathy MacArthur, Tunisha Bait, and Jennifer Toombs, were accomplished artists themselves, but they are not being revered now. Jennifer is a fantastic choreographer, but she just teaches and doesn't perform professionally, and actually all the mothers just focused on their kids. These women did an incredible job navigating through poverty and other hardships while helping Jimmy leave his blues legacy. What would Jimmy's cultural empire have been without the contributions of these women, who gave every ounce of their energy to his vision and to their children? This monument in the Black community, the monument of "women's work is not of equal value to men" is a monument to be toppled. Tear it down.

Let's be all the way real. We need to have to have a look at Loretta Story. Loretta and Claude seemed like an amazing pair, as Loretta was so great at remembering our stories from generations past, and everybody wanted to hear about it. She would have hundreds in the audience for every story she told. Claude owned his own auto business and he made it known to everyone that he loved the hell out of her. He was a good man. He was enterprising and good-looking, and a lot of women in Bridgeview wanted a piece of that tall chocolate man. He was a good dresser and always had on new shoes. But Claude only had eyes for Loretta. He was a bit obsessive with her, but he was true. A lot of women dreamed to have a man like Claude. But no, she had to mess that up, and good. Claude caught her cheating with his cousin Ricky. He will never be the same. Now he doesn't keep himself up, but he's still working and he didn't divorce her. He looks a hot mess now, and he started smoking that reefer too. Loretta has a lot to do with his demise. Yeah if we are going to move forward, Loretta Story has to be looked at too.

Then there was Anita. I'm really upset about her. Maybe she was the last straw in all this—or the last brick? She literally fell dead in the classroom while teaching our children. Anita Sky was a tower of knowledge and love, and she fell. She did so much invisible work for the Stand Strong Organization. Anita was the Board Secretary, the Archivist, the Fundraiser, the Audience Manager for many years, but she didn't get much credit. On top of that, she was an amazing visual artist, yet she didn't leave us one painting of her own, because she was too busy advocating for our young people to do

murals and projects. Sky was brilliant! But she told me she often feared she wasn't *good enough*. Sky was a rare artist who in the twenty-first century was actually approached by a European agent for an international exhibit. (This never happens nowadays!) While I tried my best to encourage and support her to accept the offer, she told me she was *just not ready* to get her portfolio together. Instead she nurtured all her love of art into the hearts of hundreds of children. She spent countless hours teaching, seven days a week—five days at Stand Strong Charter School, Saturdays at the Community Center, and Sundays she sang with her church. Anita Sky dropped dead of exhaustion, pushing, pushing, pushing because we let her, and because that's all she had. She pushed because her biggest delight was seemingly giving and mothering. She was a great woman with a silvery Afro, big hips, and a gorgeous face. She was a brilliant artist, with a percussive brush and sparkling colors that wove Black history into magical illustrative excursions. Yet it was too rare that she stood at the easel, as she was always mentoring a young potential on how to smooth the edges and learn about translating the rhythm and color of the African spirit onto the wall. I know Anita would scold me for telling you all this, because, after all, she would say, "It's not important what role I have. What's important is that I am here." It tears me up that she's gone. She was too young. I can go on and on about it. Many were at a loss when she suddenly died, only then realizing how essential Anita's work was, how brilliant she was, how beautiful she was. She has not been painted on any wall, and I hope that one day someone will.

My monunmentalizing of Anita Sky is too fleeting and not sufficient enough, but I only hope to help us recognize a symbol, a repeating phenomenon where Black women sacrifice in a secondary station, partly of their own making. Too many Black women do not fully claim their power and influence, in reverence to the idea that our men must be first. Anita held the door open for everyone else, while she waited patiently for someone to make a space for her to enter. Anita says, "After you, after you," but the endless trail of others, thought more important, go first, while she stands patiently until she falls lifeless, before even getting a chance to enter herself. Meanwhile, we step over her to get through that door. Anita is an incredible loss and the unfulfillment of her enormous potential is partially our consequence. Knock it down. What if we were truly accountable to each other? If we were compelled to speak out, to encourage, to open opportunities to those who need the extra hand towards liberating themselves?

Moody morning

Some lineages are written. Some are shared through song from one generation to the next. Any memory is a reconstruction, a mixture of fantasy and feeling—myths woven in with some bits and pieces of truth. For the young, out here trying to make a way for yourselves and their children, it's for the next generation that new monuments are needed, though I hope we can make a formidable foundation. Many young people desire to one day have someone he/she can build with—a family, an organization, a nation. Can we look at each other and see equal value in one's partner and one's self? Too many believe that a partner is only the real if they accommodate and/or obey but do not intellectually challenge. Yet some young folk are asking questions, thinking critically, wanting to partner with someone who is working to make a way for themselves and to make a better world. How do we make a monument of mutual understanding? How do we make a monument for real listening? Can we be energized by the challenge of differing opinions rather than being threatened by them?

On top of all this, there are a few monuments I would love to see built—everywhere. First, a monument for that Black man, Emory, over there, the one that the media and the history books totally ignore. Emory really listens, stands his ground, but is also truly willing to change up the program if it's best. He actively encourages and works with his mate, Josephine, with the goal of making their team stronger, while deprogramming himself from the lifelong brainwashing about women. Emory is not intimidated by Josephine, but he's inspired by her accomplishments, and it takes no effort for him to brag about her. Emory is one that steps aside his ego many a time, if it gets in the way of progress. But he'll use it if someone disrespects him or his family. And Josephine? Yes, it's me. I'm Josephine. No, I wish! I'm not telling you who I am, but I'm lucky to be telling this story. I know for a fact that for Josephine to be married to Emory, she probably had to be Cherese, Anita, and Loretta in some past lives before she figured out she was looking for someone like Emory, before she realized, hey, she needed to learn more about herself and find a partner whom she could collaborate with to grow. Where is Emory's statue—a statue for the loving willingness of Black men?

What does all this have to do with anything? Maybe I'm being facetious, but I thought that maybe the most revolutionary thing we could do is to have stronger, more loving families. All these folks I've talked about, they've been steady working for the struggle, though I didn't focus on that part in my gossip about them. It just seems like while we're busy protesting on FB and

Instagram, painting heroes on walls, working slave jobs, and trying to build businesses for ourselves, our relationships seem like they steady unraveling. Maybe stronger families can build more trust and cooperation between us? If we can understand each other better. Meanwhile, it would be great to see the young Araminta—Harriet Tubman—painted on an everlasting wall. The younger, strong Harriet. You know, before she was 90-something? We always see her image at the end of her life, not when she was the first woman spy for the U.S. government, or before that when she strategized the escape of hundreds of African Americans from slavery. Harriet is still here. She's the mother of Resistance for us all. Anything courageous we do is a tribute to her. But would those escaping slavery have trusted and listened to Harriet if she didn't have that gun? She's shaking her head right now.

Do you know some names that could make on a new Great Wall of Respect? Names are but brief portraits, worthy of brushes, ink, and clay, and footnotes to spike our research of the people that activated them. I'm set to get the paint and work on this one myself, and hope others can help. Our memories are full of resilience, struggle, ugliness, and illumination, and woven in is our deification of leadership. In fact, those with great talents strive (but don't always achieve) holistic integrity, and sometimes great ones are shrouded in an embodiment that we collectively don't cherish. Behind the wall are many voices, all articulating the intricate map towards our liberation. We need all of them. If we can open our ears, maybe we can hear them.

Thanks for listening.

Peace and Love,
Misty (a.k.a. not telling you!)

Cauleen Smith

During the time that artist and filmmaker Cauleen Smith was based in Chicago, she regularly made work such as *A Star is a Seed*, 2012, and *Space is the Place (A March for Sun Ra)*, 2011, that invoked the unrivaled experimentation of the musician/perfomer Sun Ra, who resided on the South Side of Chicago. For this book, Smith acknowledges the Wall of Respect's history with a piece of writing that has the sentiment and efficiency of a journal entry. In straightforward language, she recounts her experience among the first cohort of artists in residence at the Washington Park Arts Incubator, a space initiated and conceived by artist Theaster Gates in 2013. Her entry recounts how she processes through a dilemma—what to produce for two exhibitions of her work in divergent spaces. She plots a solution that borrows from the Wall of Respect methods by placing some of her work on the streets where Sun Ra roamed as well as in a museum setting. Smith considers a two-directional approach that could serve as a strategy for other makers who experience the pull of making a project that simultaneously inhabits public and private space.

Smith echoes the history of the Wall of Respect in her recollections of South Side dwellers who found value in the wheat-pasted wallpaper mural she installed in their neighborhood. The care that these neighbors show as they take some bits of her mural away with them, ultimately de-installing it, recalls the support that the Wall's creators received from nearby residents who helped make and tend to the work.

Even more, the contemplative tone of Smith's piece produces an important type of art historical information—a firsthand account from the artist's point of view. It indicates how an artist negotiates the various expectations for producing in multi-directional ways to meet various institutional demands and communities with their work. —RC

pp. 172–173:

Cauleen Smith, *17*, Installation view, Hyde Park Art Center, 2019.

The Distance Between*

BY CAULEEN SMITH

Winter, Washington Park, Chicago, 2013. I have the privilege, along with four other artists**, to be an inaugural artist-in-residence at the Washington Park Arts Incubator*** on Garfield Boulevard. Washington Park is a predominantly African American working-class neighborhood struggling to survive blow after blow of Chicago urban-planning miscalculations and failed considerations. The Arts Incubator presents itself as an ally within the neighborhood, offering the much-needed uplift that we all believe art can provide. It is a generous residency, offering a studio and a monthly stipend as well as opportunities for public exhibition. I am so honored to be there. At the same time, I am opening a show on the neighborhood on the other side of the Olmsted-designed Washington Park in the affluent community of Hyde Park, home to the University of Chicago and the seventy-four-year-old Hyde Park Art Center, an exhibition and education space. My exhibition is to be of some hand-screenprinted wallpapers. I agreed to wallpaper a fifty-foot–long corridor of the Art Center in exchange for the use of their screenprinting facilities.

The wallpapers I designed present tessellations of piano keys, monk parakeets, and vinyl records. These patterns were informed by research into the period of time that Sun Ra, American composer and poet, spent developing his persona and work in Chicago. To understand his process, I also had to learn something of the history of Chicago and the neighborhoods he inhabited. Back in the early sixties, Sun Ra resided on Prairie Avenue, the very cross street of the Washington Park Arts Incubator. Sun Ra did not believe in coincidences, and now, after having been so inculcated by his ideas, neither do I. I am in residence on the same street where Sun Ra was in residence some fifty years previous. The creative legacy of artists in Washington Park is epic and deep and invisible. Hence, I guess, the need for an Arts Incubator.

As an artist, one cannot really ask for a better representation of the disparity of wealth, infrastructure, and institutional support than the distance between the Hyde Park Art Center and the Washington Park Arts Incubator, which are situated less than two miles apart. The Hyde Park Art Center provides classes in various crafts for the surrounding community.

The Arts Incubator, brand-new, is struggling to define its relationship to its surrounding community, but one thing is for sure: they are prepared to receive people in this building! It doesn't even have a doorbell. And so, for the inaugural celebration of the Washington Park Arts Incubator, I took it upon myself to make a mirrored exhibition of wallpapers in the neighborhood on the streets. One block west of Sun Ra's Prairie Avenue, on Garfield Boulevard, stood a large and completely vacant solid block of apartments. (Affordable housing is hard to find in this neighborhood, but abandoned houses and apartment buildings such as this one were everywhere.) The entire ground floor of this building was boarded up. Ripe for graffiti, which no one bothered with...or ripe for wallpaper.

The Incubator was kind enough to commission two workers, neighborhood young men, to help me install the wallpaper on the plywood barriers. Now. It's February in Chicago. Snow is on the ground. It's freezing cold. But these guys took my buckets of wheat paste and my precious rolls of keyboard-patterned, hand-screenprinted wallpaper, and they went to work. As we installed it, people in the neighborhood filled me in on the fate of this building. It was once full of people. Indeed Michael, one of the men helping

me paste wallpaper, had lived there. The lore is that a woman was being evicted. She was outraged and decided to set her apartment on fire. The conflagration took the entire building. Several businesses and hundreds of people were displaced. Whoever owned the building was in no hurry to restore it, though in scoping out the building for wheatpasting, we had noticed quite a bit of renewed activity. Indeed there was much excitement for real-estate speculators in Washington Park, now that the University of Chicago was building offices on this side of the park.

And so, at the very festive opening of the Washington Park Arts Incubator, I privately enjoyed two exhibitions. The official installation of wallpapers at the Hyde Park Art Center, and the unofficial and unsanctioned installation of wallpapers on Garfield Boulevard. For me, it was a way of paying respect to the community that I would come to know over the next few months there in Washington Park. A way of paying respect to the grand and venerable history of that place, now starved out by real-estate developers and city planners. A way of paying respect to Sun Ra, his creative community, and all of the creatives who still live in that neighborhood.

It was a small gesture that required great collective effort. No one really noticed. But after about five days, all of the wallpaper had been neatly stripped away, taken by residents on their walks home. I can't think of a better deinstallation.

Much Respect, Washington Park. Much Respect.

* *The Distance Between* became the title of the art exhibition that featured artwork from the five artists in residence, curated by Allison Glenn: https://arts.uchicago.edu/logan-center/logan-center-exhibitions/archive/distance-between.

** Cecil MacDonald, Tomeka Reid, avery r. young, Leroy Bach.

** The 1920s building located at Garfield Boulevard and Prairie Avenue has been renovated for the University of Chicago's Arts + Public Life initiative. Envisioned by artist Theaster Gates, the Arts Incubator is a space for artist residencies, arts education, and community-based arts projects, as well as exhibitions, performances, and talks. (https://arts.uchicago.edu/artsandpubliclife/ai.)

CAULEEN SMITH

solYchaski

The collaborative work of solYchaski spans various formal domains including music, sound, video, and visual art. As emerging artists, they represent the same ages and stages of career of many of the artists who worked on the Wall of Respect in 1967. As Chicago natives, solYchaski use the geography of the city as a surface, a ground upon which to initiate their fleeting monument. Theirs is a highly abstracted visual theorization of place. Chicago and its parts are presented, but blurred, hazy, x-rayed, and shown only as a topographical relief, which dissociates these spaces from their normative meanings. Atop these images are presented existential quagmires and utopias. The language used in its way parallels the language that prevails in the Organization of Black American Culture (OBAC) manifestos—an idiom that supposes experimentation, play, and syntactical invention as a viable path towards alternate meaning making as well as social justice and progress. —RC

→ Please also reference:
https://vimeo.com/299600676.

+: I'll take you to Utopia. Don't listen to them. Are we all that is bad? Those who have been taken. Radicalized and condemned as stagnant? Are we not a gorgeous black source of bumbling culture that alters and re-centers. Do angels not come smiling while settling on our lands and demanding we pray under the name of their god? I'm negotiating space as a Slaved Representative, not accepting, not consenting to be regulated by state sanctioned violence. I am auditioning Voids of the potential smothered by institutional mundane. Is that not promising?

-: Go ahead and try. Nothing is promised in English, only taken.

+: Only Sold. We must consent to not being singular beings. The essay doesn't have a thesis.

-: Birth certificate and Social. You're employed as a documented subject to regulate borders for natives. A Survivor of racialization, inert, through standardized investments. You are far from ever being liberated under the constraints of the powers that be.

+: I am on a world you have never known. Police blur the role of the judge and executioner. Law on paper is not a social matter of the tangential. I am on a world that is pure turmoil. That knows nothing but always wants more and more. Yet I find others like me, who got that gift, who got that color factor, that deep darkening song on their skin they sing whole heartedly for themselves and nobody else. WE will continue doing the impossible.

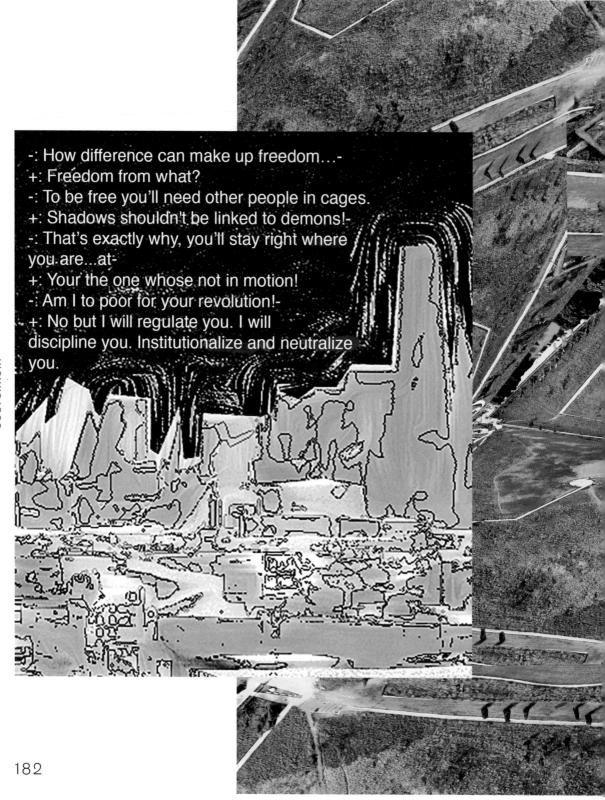

-: How difference can make up freedom…-
+: Freedom from what?
-: To be free you'll need other people in cages.
+: Shadows shouldn't be linked to demons!-
-: That's exactly why, you'll stay right where you are…at-
+: Your the one whose not in motion!
-: Am I to poor for your revolution!-
+: No but I will regulate you. I will discipline you. Institutionalize and neutralize you.

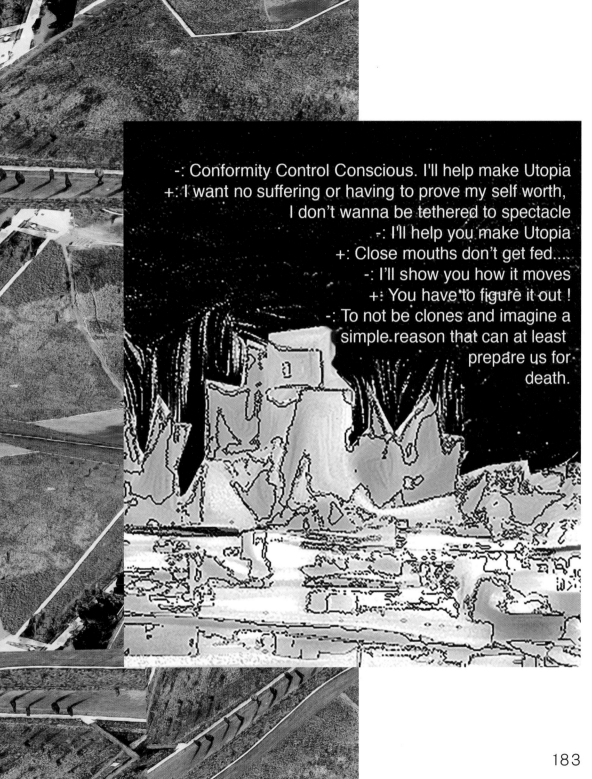

-: Conformity Control Conscious. I'll help make Utopia
+: I want no suffering or having to prove my self worth,
I don't wanna be tethered to spectacle
-: I'll help you make Utopia
+: Close mouths don't get fed....
-: I'll show you how it moves
+: You have to figure it out !
-: To not be clones and imagine a
simple reason that can at least
prepare us for
death.

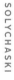

SOLYCHASKI

My surface has
no ports.
No place to tie
your boats.
I welcome *only*
my sharks.

To figure it out and not be clones.
To a pale mourning sky.

Norman Teague

For *The Wall of Respect: Vestiges, Shards, and the Legacy of Black Power* exhibit at the Chicago Cultural Center, I asked designer Norman Teague to conceive an architectural design element that referred to it. Teague riffed on the scaffold which appeared over and again in photographs of the Wall's production; and a small, houselike object that the audience could scrawl upon, which referenced the newspaper shed adjacent to the Wall of Respect, that was also painted upon and constituted the "Dance" section.

Familiar with the Wall of Respect's history, Teague used the fleeting monument prompt to reflect upon his personal path and ascent to a career as a designer. Teague's work is autobiographical in nature. In his essay, he recalls intimate familial experiences which helped construct his identity as a Black designer. Through the lens of his own life, Teague describes how African Americans participating in the field of product design have been undervalued, something recent exhibits such as *African American Designers: Art, Commerce, and the Politics of Race* at the Chicago Cultural Center in 2019 have sought to rectify. Both Robert E. Paige, a designer who participated at Wall events, and Sylvia Abernathy (Laini), who is responsible for the design layout of the Wall, were featured in the exhibit. Teague, who was recently named as a creative collaborator on the exhibitions team for the Barack Obama Presidential Library with design lead Ralph Appelbaum and Associates, is mindful of the challenges faced by the African American designers who worked at the Wall in the 1960s and here aligns himself with them and the history of African American design in Chicago. —RC

Norman Teague, *Paper Stand*, 2017, wood, paint, tar paper. *The Wall of Respect: Vestiges, Shards, and the Legacy of Black Power* exhibit, Chicago Cultural Center.

Norman Teague, *Metropolitan Theatre (aka "The MET"),* Chicago. [app. 1970]

120 sq ft.

BY NORMAN TEAGUE

I spent my earliest years in the Bronzeville neighborhood at 45th Place and Vincennes. My Grandma was head of household and my grandpa, Carl Teague, was a retired military infantryman and a Checker Cab driver. I enjoyed riding in his taxi because it had a wide backseat and foldout seats that let out from the back of the front seat to fit twice as many passengers. His taxi also had a really high roof, to allow folks to sit upright in the rear while facing the person sitting in the backseat of the taxi. Checker and black taxis were the choices for Black South Siders. So he packed them in tight.

I and my family of ten—grandma and grandpa, my mom, her two sisters and two brothers, and cousins—lived in a large shotgun-style apartment on the second floor of a 24-unit building with three entrances. We had cousins who owned property around the corner and additional family in the projects at 51st and State, the Robert Taylor Homes. They lived on the eleventh floor, I believe it was. It's a scary memory for me, because I was so afraid of heights that every time I visited my cousins, I would come off the elevators and immediately hug the walls til we were inside the apartment. Robert Taylor Homes was filled with moments of Black love and play but also poverty and trauma we had no idea would last so long. I remember the times when I would go to the nearest grocery store to carry people's groceries in an effort to hustle up some change, which I normally would spend at the penny store.

187

Norman Teague, *Sinmi Stool*, 2015.

My father left us when I was three. My stepdad raised me. Then, he was a young minister who worked in the evenings at the Metropolitan Theatre a.k.a. the MET on 46th and Martin Luther King Jr. Drive, in the box office. Today, he has his own ministry and church on the South Side. The MET was a gathering space where many would come to hear jazz, see movies as well as attend political rallies with Reverend Jesse Jackson Jr. and Operation Push. Joseph Wells, an African American preacher at Mount Episcopal Church, bought the MET and turned it into back into a movie theater, which community members constantly supported.

Eventually, my grandma Annie May Teague, a woman of God and a Seventh-Day Adventist, probably prayed and heard from Jesus that it was time for us to move out. At the time, my mom was twenty years old and had to find a job with little education, no high school diploma.

188

When my mom and stepdad were together, my baby sisters and I attended Irvin C. Mollison Elementary. My mom lucked up and found a place a block from the school in the basement of a three-flat. My Aunt Aretha and Uncle James had two kids and lived above us. My Aunty Aretha was one of the first artists I met. She painted this really dope black-and-white perspective painting on one of the walls of our apartment before we moved in. As far as I can remember, it was the first design or created pattern I recognized, and I loved it.

My Aunty Yanice Teague was a Muntu Dance Theatre cofounder who brought African dance to the 'hood, formalizing it into the Muntu dance aesthetic. My youngest uncle, Alfred Teague a.k.a. Bubo, may not have had dreams of becoming an artist. He was. He taught me how to make faces from a few simple strokes of a pencil. Lastly, my mom was a huge influence because she had sketching abilities that focused on fashioning ladies' clothes. I look at all the moments of my childhood as artistic, leading me to grasping opportunities to study drafting at Edward Tilden Technical High School in Canaryville, 46th and Union.

By then, Mom (Jean C. Teague) had moved us out of the Bronzeville neighborhood and into Back of the Yards, so I transferred schools and met my first love, "drafting." Mr. Ratowski, my drafting teacher, was a larger white man who clearly understood that he had a tough job: to teach underprivileged kids who didn't necessarily see a way out. I managed to graduate and immediately joined the U.S. National Guard 178th Infantry Division while going to a two-year technical trade school called National Technical School. Two weeks before graduation, the school went bankrupt and closed its doors. My way out had just collapsed.

Reflecting back, I took that pretty hard. My degree dangled in my face and it was snatched back with a laugh. Maybe I wouldn't get out. Maybe school wasn't for me. So I partied hard on the house music scene and got heavy into the beautiful nightlife at the Music Box. I fondly remember The Box, a magnet for young people, fashion, and drugs. The energy in the room was magnetic. The DJs were always on fire, playing the hottest house tracks. No one cared about race, color, creed, or social class. We were all there to dance.

Eventually, I landed at Harold Washington College, where I began pre-architecture studies and learned AutoCAD Release 14 when the rest of the industry had not yet picked it up. I began teaching as a freelance AutoCAD instructor and working in offices like Eva Maddox and The Environments Group, a hospitality design firm. These jobs were great. But before long I figured out that I didn't like corporate environments. The layers and ladders to "get to the top" didn't hold my interest. Besides, it would have been really

hard for me, a young Black professional, to get very far in that kind of environment. So, I decided to return to school and chose to study interior architecture for a semester at Columbia College Chicago. During a modelmaking class, I was introduced to the wood shop. I was in love again.

The table saw. The curved cutting on band saw. The hand drills. I even loved the mess of wood glue. I had a sense of power and control over these machines. At my command, they made the images that I had long held in my mind. I gratefully stumbled on a product design class. I was so psyched about these machines and making that I rented a shop in the 500 W Cermak building, where I met other artists: kinsmen like Tony Smith, Faheem Majeed, Corey Gilkey, Alex Morales, Mic of Mckinley Design, Lowell Thompson, Brian Ellis, Michael Qualls, and Theaster Gates. I found a kinsman builder in Theaster. I recall many demolition projects and the treasures found in old abandoned places like the Medinah Temple. In the early hours of the night, we salvaged weathered wall beams and turned them into our earliest works. We became fast friends finding common ground in our efforts as artists and designers.

At that time, in my late twenties, with a woman and two sons, I became more focused on my design practice and making money consistently. With a family, I was under pressure and had few Black mentors to guide me. The art industry can be as toxic and traumatic as it is beautiful and revelatory. Like any industry, you need wise counsel to lean on to learn how to be Black in design. Yet, there were few to converse with. I knew I needed to create more room for designers of color in the industry and began to teach in architecture at Roberto Clemente High School.

After leaving Clemente, I made a living teaching community design, now known as social design. I also worked in my studio to develop new pieces of furniture for private clients and restaurateurs. This was my way of making a living, and had little to do with making a name as a designer, but subconsciously I always wanted my work to say more. So, I visited New York City trade shows, and joined events in Chicago, like the Guerilla Truck Shows, to better expose my work on a local level.

While developing my own practice, I wanted to leverage the community of Black designers to leverage each other. I wanted to expose my students, friends, and community members to design with the sole focus of introducing more Black communities into design. In some ways, we are all designers. We design our lives and relationships. Whether intentionally or inadvertently, we even influence the design of our communities.

To that end, in 2013, I cofounded the Arts Incubator's Design Apprenticeship Program (DAP) which allowed me contact with groups of young

Norman Teague, *Armoire Assemblage*, 2016.

people from in and around the South Side's Washington Park area, which was amazing. The high school students were involved and working directly with the community to solve hyperlocal problems through design solutions and crafting in their studio space. In 2014, I decided to further my education and applied to the School of the Art Institute of Chicago to acquire my Masters of Fine Arts degree in Designed Objects, I was accepted with a scholarship. Here, I forced myself to design in a language that felt good to me, in materials that felt familiar but that were also challenging. I chose to make objects that seem obscure or foreign to their end-use. Why should everything be so obvious, right? One of these pieces, Sinmi, is a chair of sorts. Sinmi means to "relax" in Yoruba, one of the primary languages of Nigeria. The object rocks back and forth but allows you to assume many positions. It challenges the user's confidence in the object, making the user consider new ways of approaching a relatively familiar design concept.

In the fall of 2016, I held my first solo show at Blanc Gallery, a South Side gallery at 45th and Martin Luther King, Jr. Drive. This show, BlkHaUS, was cocurated by designer Fo Wilson. The killings of Black people by police had ramped up during the prior two years, or at least it seemed that way. Maybe social media made us all more aware and informed. In light of those incidents, I meant to pay respect to the large number of Black lives that had been lost.

The entry at Blanc (shown above) was displayed on a 10'x12' wall of miscellaneous furniture objects from varying time periods, including craft, antiques,

191

Norman Teague, *Dance Gathering*, 2018 .

and iconic modern pieces, along with a series of my own works in ceramic and wood. I titled it Armoire Assemblage: A black page in history.

In 2016, I was invited to contribute to the Wall of Respect exhibition at the Chicago Cultural Center by Romi Crawford, a respectful advocate and historian of the history of Black life during the times of the Wall of Respect. The timing was amazing because I was struggling with finding ways of being a Black student in a white establishment, and how I could express myself in ways that shone a light on my cultural interests.

The mere invitation was no less than an honor and confirmation that my existing practice was accepted, and I possibly heard it as a way to say "keep up the good work." I've been called an artist on many occasions, even when I thought I was doing my duty as a citizen, to drive home the truths and untold stories of the Black contemporary design world.

In 2017, I was chosen to be part of the Civic Projects local design team to inform the aesthetic of the exhibition spaces for the Obama Presidential Center. Andres Hernandez and Amanda Williams, two of Chicago's brightest artists, with backgrounds in art and architecture, also served as team members. I had arrived. The OPC would be a major stride in introducing design to Black communities. Not only is our team composed of three great designers, we are scaling up design exposure to several South and West Side communities.

While there's much political controversy surrounding any new community project like the OPC, I believe this is the moment in which I can deposit

my love for design into Black communities. I want the doors of the design industry to be opened to people of color. My life, good times and bad, influenced my design practice. My objects are the way I see the world. Our aesthetic is unique. For design and designers to continue to innovate, design needs to be influenced by the narratives of Black people. In turn, we need design as a mechanism for building identity and community. Like the object, these things must intentionally endure.

In 2018, Fo Wilson and I were invited to join another design team in Lagos, Nigeria, for the annual danceGATHERING festival, under Onye Ozuzu, then Columbia College Chicago's Dean of Fine and Perfoming Arts; and Qudus Onikeku, cocurator and artistic director of QDance Centre. The 500-person team created a performing-arts tribute exploring the physical and cultural body and mind. The international team of choreographers, dancers, musicians, architects, designers, painters, and sculptors crafted a multinight performance on the streets of Lagos near Freedom Hall.

Onlookers were treated to an unforgettable experience. I was surprised that over 3,000 people attended, with the largest attendance on the closing weekend. Even more significant was the festival performances' location on Broad Street, one of the most ancient, significant, and popular streets on Lagos Island. It is virtually unheard-of to close down a street in Lagos, let alone for an artist performance! My visit to Lagos was a magical homecoming. It was my first time in Africa. As a Black man and designer, I felt a kinship with the other artists, who also felt a deep pang of reckoning. It showed in the rehearsals and live performances. We danced, sang, and chanted on our land.

My life has been like a tapestry akin to the Wall of Respect—layered with names, faces, ministers, churches, intertwined with artists, writers, poets, scholars, photographers, painters, and builders who came together to design the vision of themselves. The wall was intended to endure as a visual reminder of the tapestry of community and how artists are meant to aid in the design of those images. As I look back over my life, there were designers who influenced me; they just didn't bear the title of "designer."

We are all artists and designers, both formally and informally. It's our responsibility to reiterate the various ways that the Wall of Respect displayed love, honor, truth, and unity from its inception. Bill Walker had a quest to show Black life in a light that captured the excellence of the artists of his day. A building on the South Side was transformed into a visual textbook for the community's eyes to learn who they are. And by the design of their lives, the Wall of Respect, like the danceGATHERING Festival in Lagos, became the corner where the people gathered to sing, cry, chant, celebrate, and dance in their Black way. It was all by design.

Bernard Williams

Bernard Williams, a noted muralist who has also helped to restore and update several Chicago murals that have experienced disrepair, is Chicago's heir apparent to Bill Walker, the very well-respected Chicago mural artist who made the Wall of Respect as well as other iconic murals in the city.

In his fleeting monument gesture, Williams hints at finding a way to appreciate the Wall of Respect and other artworks through a less analytical lens. He takes the cue of brevity offered in the fleeting monuments prompt to make a subtle, poignant statement about nature as an index for both simplicity and complexity. He suggests letting go of the need to clarify and know everything about art. Rather, he is receptive to the chance potential that emerges from the tangle of branches on trees and the snarl of words on a page. His argument is like so many passing thoughts—hesitant, not over-confident, sage.

Williams also reflects on his 2019 sculptural work *Woodlawn Wonders,* which takes its cues directly from the Wall of Respect, offering a named, rather than portrait-based account of neighborhood notables, this time Sun Ra, Minnie Riperton, Lorraine Hansberry, and others hailing from the Woodlawn area of Chicago. While Williams's memorialization of Woodlawn's heroes is rendered in metal, it adjusts and tempers monumentalizing norms by observing aesthetic and formal suggestions (i.e., African pattern design and nature elements) from the Black arts movement milieu, including the Wall of Respect and the African Commune of Bad Relevant Artists (AfriCOBRA). —RC

pp. 196–198:

Bernard Williams, *Nature Study,* 2017.
Courtesy of the artist.

Nature Study

BY BERNARD WILLIAMS

The trees are interesting symbols for me which suggest the complexity of world circumstances and human development. It strikes me that the mural movement, like nature, exploded into space in a kind of rhizomatic way. The effects of some human endeavors have very unpredictable affects and influences, reaching into society and producing offspring or new branches in unpredictable, surprising directions. The forms of communication among and between people and their environment take many forms. Communication within various art forms is often complex and opaque. Clarity is not the goal. Art and nature encourage us to be more restful in tangled and confusing spaces.

The Woodlawn sculpture, *Woodlawn Wonders*, celebrates well-known former residents of the area. The list of residents includes Gwendolyn Brooks, Dinah Washington, Sun Ra, Joe Louis, Cassius Clay, Emmett Till, Cab Calloway, Robert Sengstacke, Walter Dyett, Oscar Brown Jr., Lorraine Hansberry, Minnie Riperton, and Jesse Owens. Significant architectural references include the Trianon Ballroom, Tivoli Theatre, and Sexton School. A large "W" (symbolizing Woodlawn) is connected to an ornamental form, which references former historic theatre and cinema-house culture.

The sculpture also includes a group of symbols: The horn player celebrates former musical entertainers; the Black Power fist references a history of pride, struggle, and resistance; and the Adinkra symbol, which looks like an eye (the all-seeing eye), refers to a greater being. Various plant forms move throughout the sculpture, suggesting our connections to nature. A young girl in flight suggests the pursuit of lofty goals. She is connected to the letter W, which refers to Woodlawn. The silhouette of a boxer symbolizes boxing history in the area, and the cutout portrait of the woman celebrates feminine energy.

The large circular forms of the sculpture were inspired by the historic Ferris wheel that was constructed near Woodlawn during the 1893 World's Columbian Exposition. The circular forms are filled with pattern designs that originated in African textiles and carved materials. The pattern work also refers to the well-known AfriCOBRA artists, who have been based in the Woodlawn area since the 1970s. Finally, the sculpture's overall appearance suggests the stability of a treelike form, which puts down deep roots and develops above ground in dynamic and powerful directions.

IV.
Make and Do
Monuments

Wisdom Baty
Kelly Lloyd
Damon Locks
Mechtild Widrich
Jefferson Pinder

IV. Make and Do Monuments

The "Make and Do" projects are those that invite individuals to participate in historicizing and commemorating historical occurrences such as the Wall of Respect on their own terms in local and personal ways.

Whether by posting tear-off fliers, taking a walk or run in the vicinity of the Wall, listening to musical selections that align with the Wall of Respect's sonic atmosphere, reading books on the Wall of Respect and its related histories, or producing a workshop, they are inspired to imagine acts of memorialization that are micro, personal, domestic, local, and physical.

The projects collected in this section also address the intimate scale of the fleeting monument prompt. They are envisioned as actions that one might take to commemorate or mark the Wall of Respect and its legacy, but in ways that are semi-private and self-directed.

These endeavors point directly to the nature and relevance of personalizing historical events, domesticating them and giving them weight on one's own terms. Wisdom Baty organized workshops on Black mothers' self-care. Mechtild Widrich designed a walking tour of neighborhood murals, including one by William Walker, who painted the Wall of Respect. Damon Locks created

a listening session, featuring music that evokes the esprit of black liberation and culture. And Jefferson Pinder carefully plotted a run through the Chicago streets to the site where the Wall once stood. All are indicative of "Make and Do" works, things that one can produce personally to mark and recognize the significance of a minor or minoritized historical subject.

Other projects resonate on both a personal and public level. Kelly Lloyd's tear-off flier work places quotes by Wall of Respect heroes in public spaces (e.g., on institutional bulletin boards); these are meant to be torn off, touched, handled by each individual who wants to hold a piece of its history.

Aligning with the "Do for Self" mottos of the civil rights era, the "Make and Do" works in this section are actionable and enable one to partake in tributes that are self-edifying and personally responsive to a given situation or history.

Wisdom Baty

Wisdom Baty identifies first and foremost as a Black mother. The arts educator describes her 2017 project "Ways We Make" as "a series of popup workshops that celebrate Black and brown motherhood and artistic practice." Baty's practicums empower artistry by Black mothers, who as a demographic very often have to put off their art-making in order to raise children and/or work. She creates space and time for these mothers to further their practices by offering training in skill sets necessary to maintain an art practice. She fully supports children being present and involved at these meetings.

Baty's endeavor is in line with that of the Wall of Respect's producers, who realized—above all else—a space for Black artists to congregate and nurture their creative lives, often with their families and children in tow.

Her adamant focus on Black mothers and their children continues and also perfects the Wall's social project by addressing the unique circumstances that curtailed or stalled the careers of Black artists and mothers who worked on the Wall of Respect. For example, there is scarce information on Sylvia Abernathy (Laini), the woman instrumental to the Wall of Respect's design. Baty's project implies a soft critique of art spheres, historical and current, that don't often consider the special challenges for mothers, who are too often obligated to nurture their families instead of their art careers. —RC

Wisdom Baty at the Art Institute of Chicago, 2018.
Copyright Art Moves.

204

Ways We Make

Holding Space for Mothers of Color
as a Fleeting Monument

Parenting for black and brown families is an art form in America. It is one of resilience, unbending curiosity, creativity, technique, and love. Motherhood, particularly for women of color, requires a mental and physical resolve that is underdiscussed, undercelebrated, overly analyzed, and, often, under threat by an oppositional gaze.

Inspired by my own identity as a black mother, artist, and organizer, I began to host a series of public gatherings where mothers could dialogue about the uneasy circumstances of raising black and brown children, share stories of survival, strategies for carving the time and space to make things, and most importantly honor the innate creativity of motherhood—how to turn nothing into something(s).

Ways We Make: Nurturing and Building Creative Communities as Mothers of Color, is a series of popup workshops that celebrates black and brown motherhood, artistic practices, creative skill-building, networking, and collaboration. Each workshop considers alternative narratives dedicated to centering stories of intersectionality by focusing on three core values:

1. Each workshop is committed to valuing motherhood by acknowledging the creative mom as an expert.
2. *Ways We Make* partners with arts organizations and advocacy networks around Chicago to develop mutually beneficial resource-sharing systems.
3. Childcare is considered a integral addition to our programming, and is free for participating mothers at each gathering.

In the tradition of Fleeting Monuments, *Ways We Make* understands that location is fleeting; however, transference of energy and memory is permanent. Holding intentional spaces for mothers of color and their children to dialogue about personal growth under the framework of creative lifestyle choices echoes the vitality of Fleeting Monuments.

How do Mothers of Color find the
time, space and camaraderie to
thrive as creative parents?

**Ways
We
Make**

**Nurturing and
Building Creative
Communities as
Mothers of Color**

The Gathering of black and brown bodies has always been a radical act.

Ways We Make believes that partnering with art organizations within Chicago, crafting sustainable resource sharing networks and sharing diverse art practices and stories of survival is a radicle act of self-preservation. Together we discuss the challenges of making while parenting, building strategies for implementing creative environments in our daily lives, and support the creative economies of participants. This workshop series challenges traditional artist spaces, all too often non-representative of women of color, mothers and children. Ways We Make is committed to providing free access to childcare at each gathering.

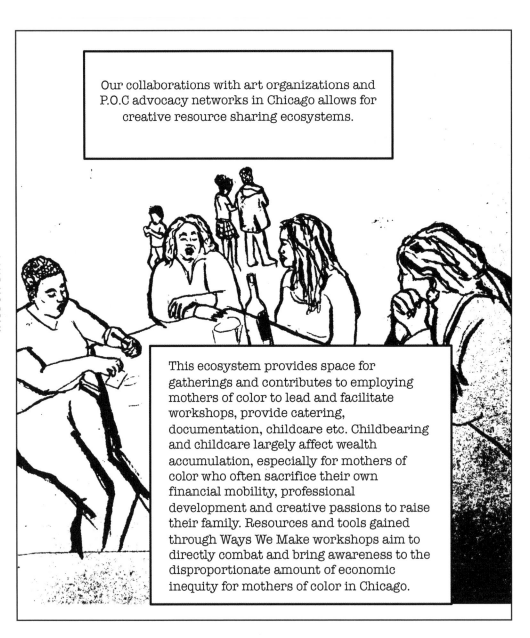

Our collaborations with art organizations and P.O.C advocacy networks in Chicago allows for creative resource sharing ecosystems.

This ecosystem provides space for gatherings and contributes to employing mothers of color to lead and facilitate workshops, provide catering, documentation, childcare etc. Childbearing and childcare largely affect wealth accumulation, especially for mothers of color who often sacrifice their own financial mobility, professional development and creative passions to raise their family. Resources and tools gained through Ways We Make workshops aim to directly combat and bring awareness to the disproportionate amount of economic inequity for mothers of color in Chicago.

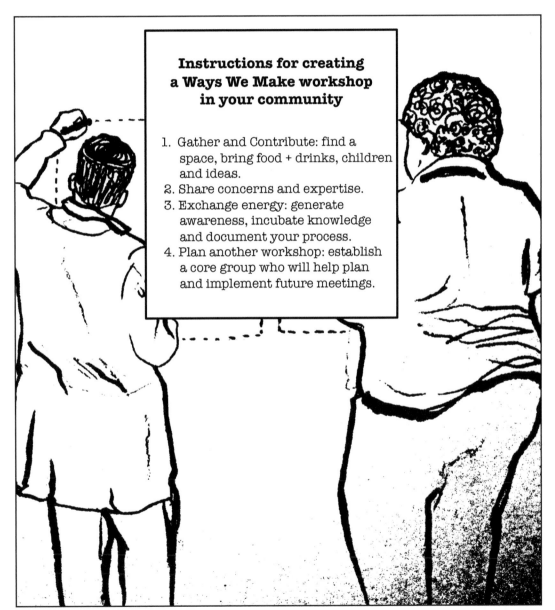

**Instructions for creating
a Ways We Make workshop
in your community**

1. Gather and Contribute: find a
 space, bring food + drinks, children
 and ideas.
2. Share concerns and expertise.
3. Exchange energy: generate
 awareness, incubate knowledge
 and document your process.
4. Plan another workshop: establish
 a core group who will help plan
 and implement future meetings.

Kelly Lloyd

Artist Kelly Lloyd is known for her quick-paced murals, often made in a 24-hour period. Lloyd's fleeting monument is an early prototype for the fleeting monument concept. Having shared an early conceptualization of the fleeting monuments for the Wall of Respect idea, Lloyd responded with a do-it-yourself project that offers a public invitation to directly activate its heroes.

Lloyd's tear-off fliers require several steps for the potential participant. Step 1 requires basic research into the Wall of Respect history—gathering quotes from Wall of Respect heroes, such as Muhammad Ali or James Baldwin. Step 2 is to plot the quotes onto a tear-off flier. Step 3 is to post the fliers on public bulletin boards for passersby to tear off and take with them.

While it might be easy to miss the fliers or discard the quotes, this aligns with the fleeting agenda. The project makes the Wall of Respect's history personal by activating one's own level of interest. It also offers a template for animating minor histories in addition to the Wall of Respect in a semi-public manner.

In another iteration, Lloyd amplifies the quotes from the Wall of Respect heroes, posting them on large billboards. Both scales create opportunity for actionable research of the Wall of Respect and self-directed rather than publicly sanctioned promotion of its history. —RC

The artist installing *Fleeting Monument for the Wall of Respect (Marcus Garvey)*, Kelly Lloyd, Fluc (Vienna), 2018.

Ryna Frankel: Why did you not put the author or the person who spoke those words, also on the tab that you pulled? The tabs are slightly different from the quote; they're boiling it down to the essential part, but I might forget who said it or where I got it from, but maybe if it was on the tab...

Kelly Lloyd: One thing that I did do is that I changed the punctuation slightly on some of the statements, so that rather than a whole statement, it could be a part of a larger statement. So even if the section out of the quote that I chose to put on a pull-off tab started with a capital letter and ended with punctuation, I took those things out so that statement could be more easily lifted and put in relationship to so many other things. Maybe one of the reasons why I didn't think that somebody would also have to carry the name of this person with them is that, then it would be still more about how Malcolm X said, "Stand for something" as opposed to: you take *stand for something*, and then you put it in your pocket, and then you are maybe working at a school and you have a meeting with your principal and you really want to speak about something that makes you feel uncomfortable and then you take the tab out of your pocket and you're like, stand for something. As opposed to Malcolm X saying, "Stand for something."

Excerpt of Ryna Frankel's "Interview with Kelly Lloyd about Lloyd's contribution to *Fleeting Monuments for the Wall of Respect*," October 23, 2017, Zürich, Switzerland.

Ryna Frankel is a visual artist living in Chicago. She makes sculptures, paintings, and installation that usually involve the color pink. She likes to think that color is useful in creating tone in artwork, and pink has fun, girly, happy, cute, and oppressive references. Ryna is obsessed with cute things. They make her heart feel like exploding. She is originally from Chicago and has also lived in Philadelphia, Jerusalem, London, and Brooklyn. Ryna received her MFA from the University of Washington in 2017.

There's no excuse
for the young people
not knowing
who the heroes
and heroines
are or were.

Nina Simone

Wall of Respect Heroine

know the heroes & heroines

know the heroes & heroines

know the heroes & heroines

know the heroes & heroines

know the heroes & heroines

know the heroes & heroines

know the heroes & heroines

I learned a long time ago that advice is a quick trip to nowhere. It's the commitment that only you can make in yourself, the responsibility to assume control of yourself.

Jim Brown

Wall of Respect Hero

assume control of yourself

assume control of yourself

assume control of yourself

assume control of yourself

assume control of yourself

assume control of yourself

assume control of yourself

You have to decide
who you are
and force the world
to deal with you,
not with its idea of you.

James Baldwin

Wall of Respect Hero

force the world to deal with you

force the world to deal with you

force the world to deal with you

force the world to deal with you

force the world to deal with you

force the world to deal with you

force the world to deal with you

Fleeting Monument for the Wall of Respect (Marcus Garvey), Kelly Lloyd, Fluc (Vienna), 2018.

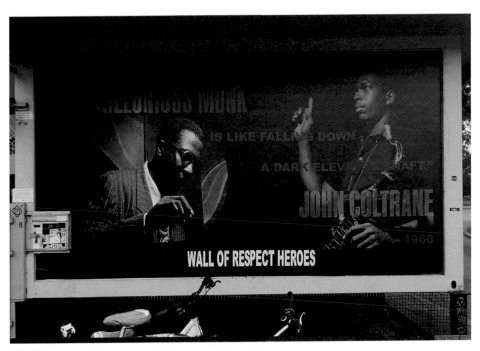

Fleeting Monument for the Wall of Respect (Thelonious Monk and John Coltrane), Kelly Lloyd, Fluc (Vienna), 2018.

Damon Locks

Artist, DJ, musician, and educator Damon Locks, leader of the Black Monument Ensemble, draws from his extensive knowledge of music—Black music, in particular—to curate a playlist that invokes the histories and sensibilities of the Wall of Respect.

Music was significant to the Wall of Respect experience. Members of the Association for the Advancement of Creative Musicians (AACM) such as Lester Bowie, Roscoe Mitchell, and Joe Jarman played there, and music heroes including Nina Simone, Sun Ra, and John Coltrane take up multiple sections of the Wall. The "Jazz" section of the Wall included Thelonious Monk, Charlie Parker, Charles Mingus, Sarah Vaughan, Max Roach, Miles Davis, Elvin Jones, Eric Dolphy, Ornette Coleman, and Sonny Rollins. The "Rhythm and Blues" section included Muddy Waters, Billie Holiday, Dinah Washington, Ray Charles, James Brown, Smokey Robinson, Aretha Franklin, The Marvelettes, and Stevie Wonder. "Say it Loud, I'm Black and I'm Proud" by James Brown came out in 1968, and "Respect" by Aretha Franklin was a popular song, almost anthem-like in 1967, helping to cement the mural's title. Listening to the tracks on Locks's list allows for an individuated appreciation of the Wall's rich sonic dimension, which was an additional layer of form at the site and in many ways was an integral part of the Wall of Respect aesthetic experience. —RC

The Timbre of the Times

BY DAMON LOCKS

As a record enthusiast, deejay, record jacket designer, and sound manipulator who uses records in various ways, I find albums to be super-effective ways to learn about the era in which they were conceived and released. The art, the themes, the titles and lyrics, the instrumentation (or lack thereof), and even the liner notes speak to the concerns of those making the records. Records were a way to communicate outside of your sphere. It was a way to reach the airwaves, the classrooms, and the living rooms all across the city, the country, or possibly the world (the world was a lot less accessible back then). When thinking about *Fleeting Monuments for the Wall of Respect*, I looked to my record collection to explore the timbre of the times. What sounds would I choose as aural accompaniment to a collaborative, community-oriented work that highlighted the achievements of the Black community? I share with you a deejay set I would play for the Wall of Respect.

"Right On Be Free," from *The Voices of East Harlem* (self-titled)

"Free The Black Man's Chains," L.C. Grier from *Free The Black Man's Chains— A Black Rock Opera*

"Joan Little," Bernice Reagon from *Give Your Hands to Struggle*

"Believers' Lament," *The Believers: the Black Experience in Song*

"White Nile," Kelan Phil Cohran and Legacy, from *African Skies Excerpt from Black Americans, The American Adventure*

" Gifted and Black," Nina Simone from *Black Gold*

"Song of Will," Eddie Gale from *Black Rhythm Happening*

"Rock Out," Art Ensemble of Chicago, from *A.A.C.M. Great Black Music, Message to Our Folks*

Excerpt from *Guess Who's Coming Home, Black Fighting Men Recorded Live in Vietnam*

"Attica Blues," Archie Shepp from *Attica Blues*

"Rockin' Jerusalem," *American Negro Folk and Work Song Rhythms with Ella Jenkins and The Goodwill Spiritual Choir*

"Love in Outer Space," Sun Ra from *Out There a Minute*

"Southern Mammy Sings," Ruby Dee reading the poetry of Langston Hughes

"A Few of My Favorite Things," John Coltrane from *A Few of My Favorite Things*

Excerpt from *DIG: Eldridge Cleaver* recorded at Syracuse

"For My People," Margaret Walker from *Anthology of Negro Poets*

"Gang Fight," from *Street and Gangland Rhythms*

"Robert S. Abbott" (founder of the *Chicago Defender*) from *He's A Black Man*

"Ida B. Wells" from *The Negro Woman* • "Walk With Me" from *Movement Soul—Live recordings of songs and sayings from the Freedom Movement in the Deep South*

"Rock Steady," Aretha Franklin, from *Young Gifted and Black*

"What Shall I Tell My Children Who Are Black (Reflections of an African-American Mother)," Margaret Burroughs, the founder and director of the DuSable Museum of African American History

ABOUT THE ARTIST

Margaret Taylor Goss Burroughs is completely dedicated to the creative arts, international culture, and specifically to African & African American life, history and tradition. She is author of two books for children, "Jasper The Drummin' Boy," (1947) and "Did You Feed My Cow"? (1955). The former by Viking Press and the latter by Thomas Y. Crowell Co. Both of these juveniles have been reprinted in new editions by The Follette Publishing Co. of Chicago. Mrs. Burroughs has had articles concerning art, culture and history in the Chicago Schools Journal, Elementary English Journal, School Arts Magazine, Freedomways, Negro Digest, and the Associated Negro Press.

She is a strong and devout believer in culture and historical organizations and is a founder of the South Side Community Art Center. She is the originator of the Lake Meadows Outdoor Art Fair and she is its annual director. In 1959, Mrs. Burroughs organized the National Conference of Negro Artists at Atlanta University. And served as chairman of that organization.

For several years she was Art Director and assistant in Research for the Negro History Hall of Fame sponsored by the New Crusader newspaper in Chicago. In 1961 she helped organize the Museum of Negro History and Art and serves today as its Executive Director.

Mrs. Burrough is well known for her creative art and has exhibited at Howard University, Winston - Salem Teachers College, South Side Community Art Center, Hull House, Mexico City, San Francisco Civic Museum, Illinois State Fair, Market Place Gallery, New York, Kenosha Museum, Poland and U.S.S.R..

Mrs. Burroughs has traveled widely throughout the United States, Canada and Mexico. Her trips to Europe have taken her to the U.S.S.R. where she was leader of an invited delegation of black artists in 1966. In 1968 she was the recipient of an N.E.H. Fellowship as an interne at the Field Museum of Chicago majoring in museum practices. In the summer of 1968 Mrs. Burroughs studied in Africa with

the American Forum for African Studies on a grant from the Rockefeller Family Fund. In 1969, she went to Africa on a similar study program as a member of the staff of the American Forum for African Study.

She has been recognized nationally and abroad for her creative work. Her poem, "What Shall I Tell My Children Who Are Black" has been widely recited. This was printed in brochure form with one of her own illustrations. In 1947 she received the Print Honorable Mention at the Annual Negro Art Show in Atlanta. In 1955 she won the first Water Color Purchase Award at Atlanta University. In 1962 her work won the Best Show, Hall Mark Prize, at Lincoln University, Jefferson City, Mo..

She received a special citation in 1953 from the South Side Community Art Center and in 1955 she was honored by the Committee for the Negro in Arts.

Mrs. Burrough has a strong feeling for the folk-origins of African American people. She has a dedicated love for their source in the traditions of Africa itself. She is able to place them in the vernacular to be enjoyed by her fellow Americans of all ethnic groups. Only a person, with a love for humanity would achieve success in such an enterprise. She refuses to follow the easily fading fads of the times but is entirely devoted to the traditions and roots of yester-years. This present volume stems from that kind of love. Here she offers for the older and younger generations the beautiful, meaningful folk-lore of her people.

A SOUND-A-RAMA RECORDING

Mechtild Widrich

In 2017, art historian Mechtild Widrich organized a panel discussion, "Down with Monuments," hosted by the University of Chicago and the School of the Art Institute of Chicago. I was invited to speak at this event, where I initially presented the concept of *Fleeting Monuments for the Wall of Respect*. Widrich, who has deep knowledge of monument-making internationally, is the author of *Performative Monuments: The Rematerialization of Public Art* (Manchester University Press, 2014). Based on the fleeting monument prompt, she plots an escapade, a simple stroll through her neighborhood in Chicago to visit murals, including one by Bill Walker who is among the noted painters whose work appeared on the Wall of Respect.

Widrich's "Make and Do" project emphasizes physical acts of retracing, locating, and self-documenting—all of which are ways of commemorating the Wall of Respect and its history through private acts that are self-edifying on various physical, emotional, and intellectual levels. It suggests that there are myriad histories and artworks worth paying attention to, even when taking a walk close to home. —RC

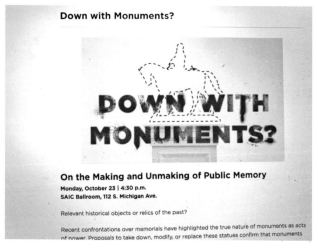

Poster for the "Down with Monuments" Symposium at School of the Art Institute of Chicago, 2017.

The Walls Have Eyes

BY MECHTILD WIDRICH

The Wall of Respect is not gone: its ideas circulated; its mission was taken up. Just last year, it traveled north, to Northwestern University, in the form of a symposium and an exhibition. It took center stage in scholarship, established connections all the way to Latin America and East Asia, and entered the Loop in a photographic restaging at the Chicago Cultural Center.What is gone then and what is left? What to remember and what to pursue? These are photographs taken with a mobile-phone camera at a walk to William Walker's *Childhood is Without Prejudice*, also called *Children of Goodwill*, just east

of the 56th Street Metra Station underpass in Hyde Park, Chicago. The *Children*, painted for Bret Harte Elementary, are a decade younger than the Wall of Respect. The *Wall* was five years gone when this mural went up. Much has been said about Walker's distinctive "Venn diagram" faces overlapping, sharing eyes. One of these eyes, alone, presides over the mural in a red field blending into the concrete, a kind of signature. Walker's eyes, last restored under his supervision in 2009, look across the underpass on an anonymous mural of gummi bears, and now at Jeanne Gang's towering residential building Solstice on the Park.

You are undone
if you once forget
that the fruits
of the earth
belong to us all
and the earth itself
to nobody.

Rousseau

Jefferson Pinder

Jefferson Pinder's fleeting monument work fits within the context of his ongoing video and performance projects that highlight bodily endurance and implicate the stakes of physical survival for African Americans. He uses the Wall of Respect history to create an opportunity for an active, actionable pursuit, in this case, a run while clad in business attire that ventures into the neighborhood where the Wall of Respect once existed.

The cinematic sequence of photo stills that record Pinder's jaunt put urgency and exhaustion on display. Not unlike the artist's other "action videos," the run to/for the Wall of Respect tells a story that resonates with history. This project both narrates and interpolates the historical weight of displacement, escape, and endurance within the genre of African American experience. It incites readers to apply or pursue these topoi, rather than interpreting them as deterrents to African American success and survival. —RC

Bronzeville Étude

BY JEFFERSON PINDER

<u>A Performance Score</u>

Much of my performance work has been dedicated to what physical theatre practitioners call bio-mechanics: a powerful technique of accessing emotion and deep physiological connection to a subject through the use of intense physical exertion. Created in the wake of the Russian Revolution by Vsevolod Meyerhold, this theatre form utilizes the performer's bodied experiences to explore complex issues of politics and oppression. In conventional performance techniques, the process is initiated by emotion that guides the subsequent action; for bio-mechanics, it's the opposite—the kinetic energy of the action drives the emotion.

The Bronzeville Étude is a rigorous routine to push the participant into a spiritual relationship with the neighborhood that hosted one of the most influential public projects in the nation's history. The old adage of walking a mile in someone else's shoes will be put to the test.

I encourage you to leave your exercise clothing at home. This Étude will require you to wear a subtle but humble mix between work clothes and church attire. No white socks. Running shoes will only slow you down on this journey.

Begin to run, not too fast at the start. Stop at the south side of the intersection. Turn and glance at the empty lot across the street. What was there? What will be? Let it go. Look at the church next door. Notice the faded color of the sign. It reads, "Rain or Shine Baptist Church: No One Can Sink So Low that God Can't Reach Him. No One Can Be So Lost That God Can't Find Them."

You will find dark brown town homes in front of you. This is where the Wall once stood.

First Leg.
(start at E. 43rd and Langley Ave)

The first part of this one-mile run will be straight down S. Langley Ave. It's almost completely residential. Look for people. If you encounter them, nod your head. Be sure to say hello, they inhabit sacred ground. Notice the empty spaces. Think about the history that happened in these vacant lots. Be mindful of the uneven pavement. If possible, run in the middle of the street so that you can be right in the center of the changing neighborhood. Don't slow down.

Second Leg.
(East on E. 44th to Cottage Grove)

At the corner of E. 44th and Langley, take a left. Begin to pick up your pace. Notice the residential homes and school. Take in the grandeur of the houses that line this humble street. The school that you see on your left is Price Elementary. Look at the Bronzeville sign with the 'n' missing. Consider the children that have grown up in the space and the experiences they had living in the shadow of the Wall of Respect.

Third Leg.
(North on Cottage Grove)

Take a left onto busy Cottage Grove Avenue. Be sure to engage in as much eye contact as possible while you move quickly through the neighborhood. This bustling street has always been a major thoroughfare. Stay on the sidewalk and take in the intensity of a South Side Chicago street.

Fourth Leg.

(West on E.43rd back to Langley)

At the corner of Cottage Grove and Langley, cross the street so that you can experience the block that faced the Wall of Respect.

As you move back down the block and approach the place where the run began, observe the whole block from the parallel corner. But no, you're not done yet. You're barely halfway there. At this point, if you're not a runner, you might be feeling some pain. That's good. With a little luck you'll be feeling it for a day or so. Notice the high-rise senior apartments. Feel the energy of the "Rain or Shine Baptist Church"; they've been there for a while. They deserve respect. This church has seen the best of what the community has to give. Can you feel it? Increase your pace. Breathe through your nose. Your chest may heave like you're angry. Allow yourself to get angry. You don't need a reason. There are too many reasons to count; it's best not to think of them, but its okay to feel it.

Fifth Leg.

(North on Langley to E. 42nd)

Now you're at the corner opposite of where the wall once stood. Continue down the other side of Langley. Take in the new homes. New bricks. Everything is changing fast. Check out the black wrought-iron fences. Not really the decorative sort. There are two large lots waiting for something to happen. Vacant green lots that are primed and ready for change of some kind.

Sixth Leg.

(East on E.42nd to Cottage Grove)

At the end of the block, turn right on 42nd. Look at the large decaying housing complex to your left. The one with the the ornate red and white cornice work on top. The mixed architecture structure speaks to a neighborhood in change, the broken window speaks to violence and neglect. This building won't be around for long. Take a right onto Cottage Grove. At this point you've traveled about ¾ of a mile.

Seventh Leg.
(South on Cottage Grove to 43rd)

Take a minute to notice the dialysis business across the street. Poignant location. Look at the the Chicago Furniture sign stating "Cheerful Credit" and note that underneath, in fine print, it reads "white way". Think about the many people who may have noticed these details, but have never bothered to feel them. Exhale, but don't slow down.

Eighth Leg.

(West on 43rd to Langley)

Take a left on E. 43rd Street. You know this block. We've come around this point already. No time for sightseeing. Push yourself hard on this last leg. Lift your feet high and drive them into the pavement. You have the confidence now of knowing where you are. Run as if you're escaping. Focus on getting to the exact place where this journey began. Meditate on the significance of a one-mile run that ends where it began. Try to find the exact spot to stand and feel the burn of your run. Focus on the meaning of this journey. At this point, you are ready to learn about the Wall of Respect and the heroic work that it reflects.

All images, pp. 240–251:
Jefferson Pinder, *Bronzeville Étude*, performance stills.
Photography, Orlando Pinder.
Courtesy of artist.

JEFFERSON PINDER

JEFFERSON PINDER

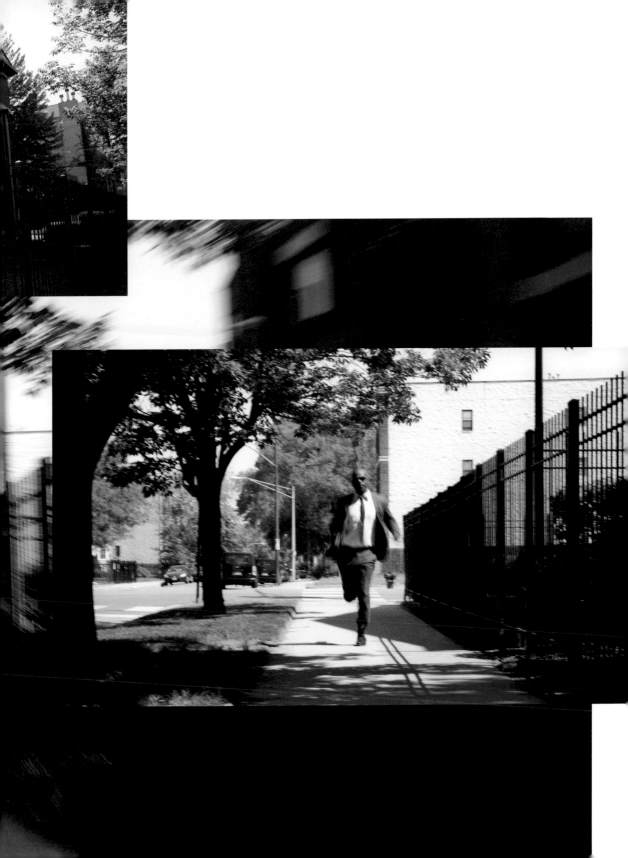

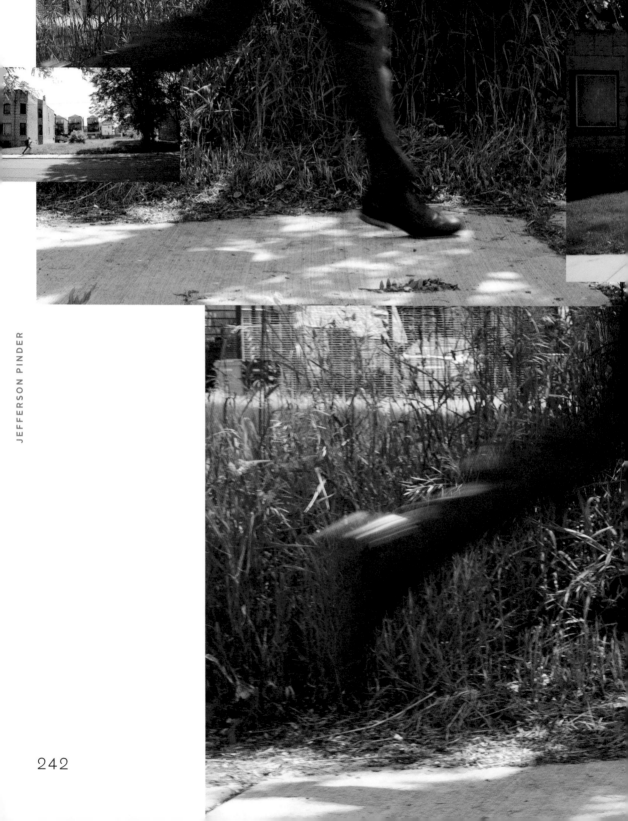

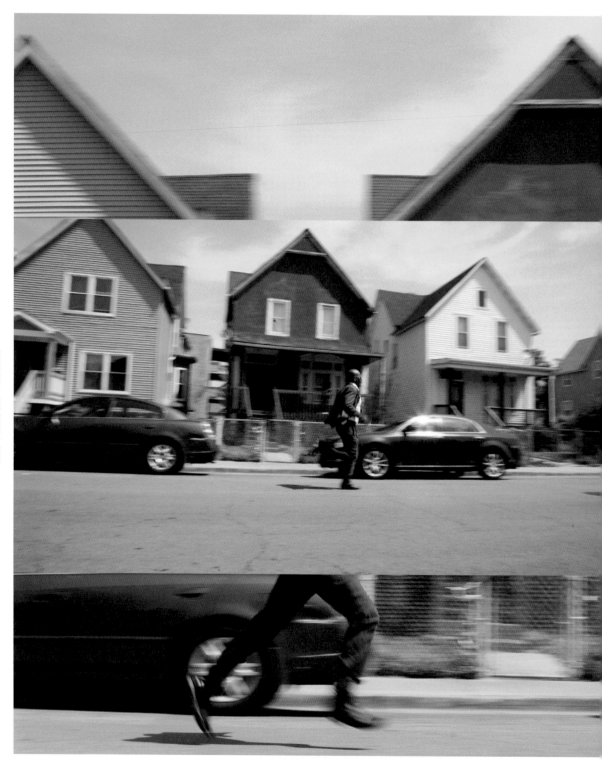

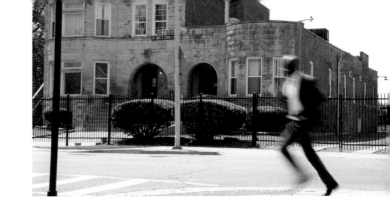

JEFFERSON PINDER

247

V. Remnant Monuments

Faheem Majeed
Jan Tichy
Mark Blanchard
Theaster Gates
Romi Crawford
Lauren Berlant

V. Remnant Monuments

These projects probe what lingers behind in the atmosphere of a given historical incident, in this case, the aftereffects or remnants of the Wall of Respect. Rather than focusing on the Wall's existence, they make something of, and pay attention to, its disappearance. They address commemoration as the act of exposing the failure around an event or its history, such as the haunting persistence of the racial oppression that the Wall of Respect sought to counter.

Projects such as Faheem Majeed's tracings of the Wall location; Jan Tichy's images of murals in units of the Cabrini-Green Projects, which he was able to photograph after it was de-peopled and on the brink of demolition; Mark Blanchard's digital photograms of the Wall site in the wake of its disappearance; and Theaster Gates's recitation of attendees at Black Artists Retreat convenings over the years, are artworks premised upon activating remnants of the historical happening.

Such monuments made from what's leftover are important for their reference back to the historical occasion's failed project— of social and racial equality, evidenced here by the emptiness of the Cabrini- Green and the Wall of Respect sites.

The record of a 2017 exhibition I curated, *Radical Relations! Memory, Objects, and the Generation of the Political*, is also housed in this section. The exhibit, like Majeed's and Tichy's projects, mines vacancies, the unattended familial and domestic spaces that are impacted by an historical occurrence such as the Wall of Respect. Cultural theorist Lauren Berlant's contribution, a read of the *Radical Relations!* exhibition, also implies the significance of bearing witness to the historical objects' scraps, and minor moments and subjects, which are often barely legible and too personal and obscure to matter.

Faheem Majeed

Artist Faheem Majeed's practice already inhabits some of the Wall of Respect's aesthetic ethos. Majeed and partners' *Floating Museum*, for example, continues the same project of moving art beyond the confines of galleries, museums, and officially sanctioned spaces.

As the former head of the South Side Community Arts Center (SSCAC), and given his close working knowledge of and relationship with many of the artists from AfriCOBRA and those who exhibited at the SSCAC over the years, Majeed has been instrumental to recent scholarship on and discussions of the Wall of Respect.

His rubbings of the streets where the Wall of Respect once stood offer a remnant of both the original Wall's existence from 1967–72 and its absence now. The residual effects of the Wall of Respect are made palpable by Majeed's fleeting monument, pointing to its ongoing influence on present-day public art, alternative exhibition strategies, and social engagement practices. In these ways, Majeed's project rouses and perpetuates the import of the Wall of Respect's remains. —RC

Faheem Majeed and Haki Madhubuti at a documentary taping at the Wall of Respect site, 2018.
Courtesy of Romi Crawford.

Tracing Respect

BY FAHEEM MAJEED

Faheem Majeed, *Tracing Respect*, **2018.**
Courtesy of artist.

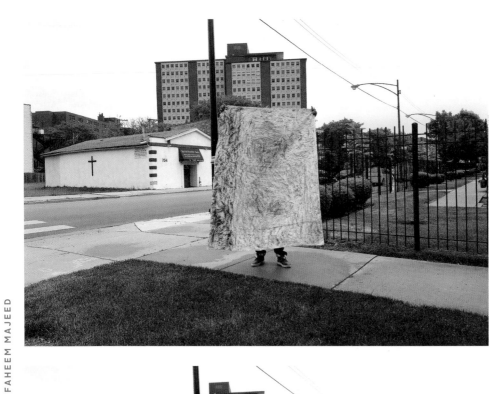

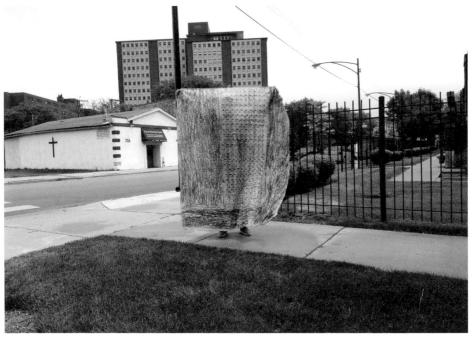

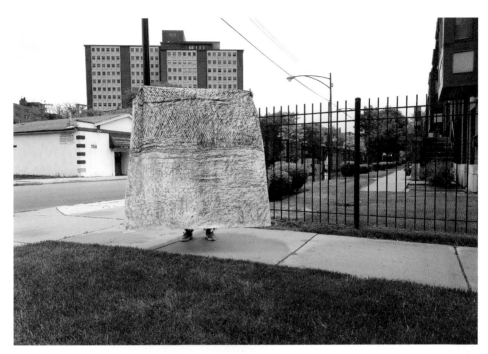

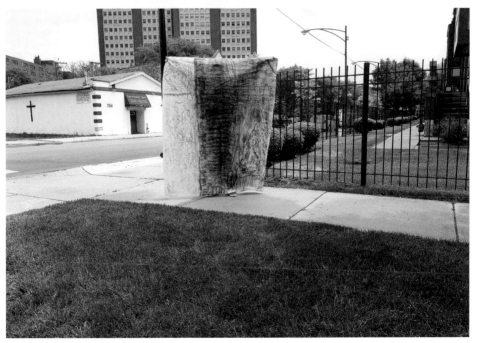

Jan Tichy

Jan Tichy's photographic installations and projects are often made with a disputed or impugned site as the focus. *Project Cabrini Green*, for example, responded to the 2011 demolition of the Cabrini-Green housing project in Chicago. Tichy and collaborators, including Chicago-area college and high school students, produced a light installation at the last remaining Cabrini-Green tower, based on poems about it.

Tichy's tribute to the Wall of Respect is a work titled *Fleeting monument* (2019) which recites names and incidents that recall human suffering: Jewish people in Nazi Germany, students at Kent State, Emmett Till, Andrew Goodman, and many more. He broadens the fleeting monument prompt by suggesting other cases worth marking and memorializing in similarly alternative ways. His contribution also comprises a selection of images that are remnants from his research for the Cabrini-Green project. They expose what's left behind after the teardown or removal of a highly loaded urban edifice, the expiry of which is a historical event in itself,—the whitewashing of a church with a mural by Bill Walker (who painted the Wall of Respect) or a light fixture and mural remaining after residents have moved out of a Cabrini-Green housing unit.

Tichy's images of murals and other adornments made to the Cabrini units convey the relevance of art and art-making in the domestic space of the projects. These as well as Bill Walker's whited-out mural, "All of Mankind, Unity of the Human Race,"

on a Baptist church near the Cabrini-Green site, embody a fleeting, unsure existence—an overlooked stage of presence, before a final removal and demise. Tichy's photographic captures of such places, like the photographs of the Wall of Respect site at 43rd and Langley in its later years, reveal the gradual disappearance of notable architectural structures within the Black community, the histories of which are seldom queried. —RC

Last light, 2019.
Archival inkjet print, 8" × 8".
Courtesy of artist.

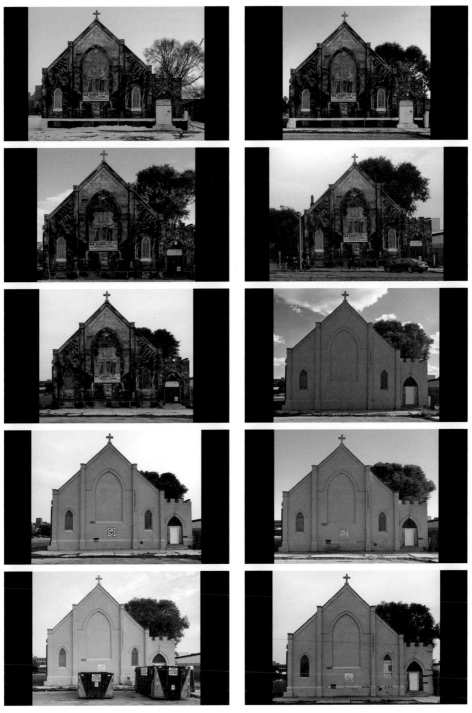

All Of Mankind on September 11th 2010–2020, digital photographs.
Courtesy of artist.

Last window (AOM), 2019, archival inkjet print, 9 × 16 inches.
Courtesy of artist.

1230 N. Burling (lion room), 2011, digital photograph.
Courtesy of artist.

Fleeting monument, 2019, white ink on black archival paper, 8 × 11 inches.
Courtesy of artist.

1230 N.Burling (tigerroom), 2011, digital photograph.
Courtesy of artist.

Mark Blanchard

In 2017, I invited Mark Blanchard to help video document interviews with photographers who worked at the Wall of Respect. Blanchard is an emerging artist/ programmer who grew up on the South Side of Chicago, not far from where the Wall of Respect was located. Thus, his contribution is representative of his practice, which combines photography and computer graphics. It rearticulates the peopled streets and buildings of the Wall of Respect environment surrealistically.

Blanchard's work is built from hundreds of photographic images of the site and its current residents, which he constructed into 3D renditions and then photographed from new vantage points.

Blanchard combines computational and photographic processes, resulting in a project that recaptures the historic site where the Wall of Respect once stood, but with a digital capacity that helps obfuscate any historical referent. Rather, his digital renderings use the Wall's previous physical location to project more futurity than past.

While photography was central to the Wall's design, and photographic images of Black heroes such as LeRoi Jones and Darlene Blackburn were embedded in the mural, photo-based procedures such as Blanchard's, which move away from the realism and reportage evidenced in the work of the Wall photographers, advance the genre as a way of commemorating it. —RC

"These works are an amalgamation of 3D scans and composite photography. It is composed of the wall site rendered in 3D and then recaptured in 2D digitally. They are the virtualization of the wall site with residents of the area."

—*Mark Blanchard*

All images, pp. 266–271:

Were manifested in the same moment
and are collectively titled the same:
404 hero not found, Mark Blanchard,
Digital Photogram, 2018.

Theaster Gates

Theaster Gates's varied practice includes object-making, neighborhood development, performance, and convening, as well as hybrid manifestations of these modes. Gates often performs with his Black Monks troupe of musicians on the site of, or close to the environs of, a given installation. Multidisciplinarity of this sort was also in play at the Wall of Respect, where performances, readings, and actions occurred in close proximity to the site.

In addition to the multiform agenda of such art events, combining painting, music, poetry, and activism in a single space and time enlarged the number of participants, producing an important dynamic of social interaction. In effect, the Wall of Respect served as a crucial site for Black people, including artists and thinkers, to convene.

Convenings are a component of Gates's work, which ties into the Wall of Respect's history. Since 2013, Gates has hosted the Black Artists Retreat (B.A.R.) at his various Chicago sites, including the Arts Bank, the Studio, Dorchester Projects, and the Arts Incubator. In 2019, expanded versions of the retreat took place at the Park Avenue Armory in New York City and the Hirshhorn Museum and Sculpture Garden in Washington, DC, spurring similar retreat formations nationally and internationally. Part of the goal of these events is to produce a context, a specific place, for Black artists to see and be with each other, not unlike the Wall of Respect, which was similarly a place for Black artists to commune and, through

fraternization, find support in making the work that they wanted to make. In effect, both Gates's Black Artists Retreat and the Wall of Respect facilitated what I call a conscious or "serious sociality." Gates's fleeting monument is in the form of an extended list of those who have attended B.A.R. over the years. His roll call potentiates an imaginary scene of belonging and community. —RC

Tracing Respect

BY THEASTER GATES

FLEETING MONUMENTS FOR THE WALL OF RESPECT

Kwesi Abbensetts
Jojo Abot
Nina Abney
Carol Adams
Derrick Adams
Kenyon Victor Adams
Tunji Adeniyi-Jones
Merele Adkins
Akosua Adoma Owusu
Jite Agbro
Regina Agu
Yaw Agyeman
Mequitta Ahuja
Abdu Ali
Bimbola Akinbola
Njideka Akunyili-Crosby
David O. Alekhuogie
Laylah Ali
Kal Alston
Candida Alvarez
Ruby Onyinyechi Amanze
American Artist
Noel W. Anderson
Liliana Angulo
Marvin Luvualu António
Edgar Arceneaux
Michael Armitage
Magdalyn Asimakis
Élise Atangana
Donna Augustin-Quinn
Anjali Austin
Mikel Patrick Avery
Nicole Awai

Elizabeth Axtman
Firelei Báez
Radcliffe Bailey
Xenobia Bailey
Donnamarie Baptiste
Tiffany E. Barber
Rehema C. Barber
Sadie Barnette
Ray Anthony Barrett
Lyndon Barrois
James Bartlett
Holly Bass
Kevin Beasley
Naomi Beckwith
Kimberly M. Becoat
Aisha Tandiwe Bell
Joeonna Bellorado-Samuels
Kajahl Benes
Louise Bernard
Alice Berry
Dawoud Bey
Sanford Biggers
McArthur Binion
Carroll Parrott Blue
Appau Jnr Boakye-Yiadom
Frances Bodomo
Adebukola Buki Bodunrin
Alexandra Bowman
Jarvis Boyland
Jessica Boykin
Mark Bradford
Charlotte Brathwaite
James E. Britt Jr.

Kalia Brooks
Sarah M. Broom
Adrienne R. Brown
Bentley Brown
Julia Brown
Leonard Lewis Brown
Michaela Pilar Brown
Omrao Brown
Rashayla Marie Brown
Stacia Brown
Andrea Barnwell Brownlee
Ernest Arthur Bryant III
Tisa Bryant
Rashida Bumbray
Carlos Bunga
Stephen Burks
Robert Burnier
Nina Buxenbaum
Jonathan Calm
Louis Cameron
Mark V. Campbell
Tina Campt
Kendell Carter
Majora Carter
Nicole J. Caruth
Gus Casely-Hayford
Jordan Casteel
Nick Cave
Denise Chapman
Zoë Charlton
Barbara Chase-Riboud
Jonathan Lyndon Chase
Christine Checinska
Taja Cheek
Caitlin Cherry
Racquel Chevremont
Staceyann Chin
Erin Christovale
Andrea Chung
Jasmine Clark

Sonya Clark
Michèle Pearson Clarke
Jace Clayton
Mike Cloud
Jasmine Nichole Cobb
Alex Bradley Cohen
Christina Coleman
Bethany Collins
Brittni Collins
Ayana Contreras
Larry W. Cook
Bridget R. Cooks
Huey Copeland
Aurélie Coulibaly
Pamela Council
Aisha Cousins
Renee Cox
Romi Crawford
Ashon Crawley
Devel Crisp
Julie Crooks
Warren G. Crudup III
DeAnna Cummings
Roger Cummings
Jamal Cyrus
Gira Dahnee
Janet E. Dandridge
Eisa Davis
Kenturah Davis
Noah Davis
Sonia Louise Davis
Misa Dayson
Janet Dees
Danièle Dennis
Ryan Dennis
Lisa Dent
Abigail DeVille
Modou Dieng
Isaac Diggs
LaTasha N. Nevada Diggs

Nathaniel Donnett
Angela U. Drakeford
Kimberly Drew
David C. Driskell
D. Denenge Duyst-Akpem
Eric Dyer
Torkwase Dyson
Rajnii Eddins
Pamela Edmonds
Adrienne Edwards
Victor Ekpuk
Ashara Ekundayo
Yosra El-Essawy
Reginald Eldridge Jr.
Tremaine Emory
Darby English
Alexandria Eregbu
Awol Erizku
Kenya Evans
Tiana Webb Evans
Kevin Jerome Everson
Viktor L. Ewing-Givens
Zachary Fabri
Brendan Fernandes
Denise Ferreira da Silva
Mohwanah Fetus
Nicole R. Fleetwood
Stephen Flemister
Quincy Flowers
Dominique Fontaine
Benin Ford
Ivan Forde
Derek Fordjour
Aricka Foreman
Krista Franklin
Sally Frater
LaToya Ruby Frazier
April Freely
Coco Fusco
Charles Gaines

Malik Gaines
Adrienne Gaither
Nikita Gale
Ellen Gallagher
Kimberli Gant
Tia-Simone Gardner
Ja'Tovia M. Gary
Rico Gatson
Ben LaMar Gay
Amir George
Aaron J. Gilbert
Danny Giles
Allison M. Glenn
Thelma Golden
Cameron A. Granger
Deborah Grant
Todd Gray
James T. Green
Renée Green
James Richard Griffin
Rashawn Griffin
Allison Janae Hamilton
LaMont Hamilton
Leah Hamilton
CoCo Harris
Duriel E. Harris
Francine J. Harris
Juliette Harris
Kira Lynn Harris
Lyle Ashton Harris
Savannah Harris
Shawnya L. Harris
Heather Hart
David Hartt
Maren Hassinger
Jérôme Havre
Janette Hawkins
Jeffreen M. Hayes
Lauren Haynes
Tempestt Hazel

Tahir Hemphill
Barkley L. Hendricks
Nona Hendryx
Andres Luis Hernandez
Leslie Hewitt
Justin Hicks
EJ Hill
Rujeko Hockley
Robert Hodge
Wayne Hodge
Jibade-Khalil Huffman
Amanda Hunt
Richard Hunt
Liz Ikiriko
Kemi Ilesanmi
Chad B. Infante
IONE
Uchenna Itam
Sandra Jackson-Dumont
Arthur Jafa
Jamillah James
Martha Jackson Jarvis
Daris Jasper
Steffani Jemison
Terrence Jennings
Tyehimba Jess
Aisha Sasha John
Rashid Johnson
Sean M. Johnson
Tammy Johnson
Vincent Johnson
Jennie C. Jones
Ladi'Sasha Jones
Samuel Levi Jones
Seitu Jones
Ross Jordan
Kahlil Joseph
Britt Julious
Saïs Kamalidiin
Titus Kaphar

NIC Kay
Naima J. Keith
Lauren Kelley
Robin D.G. Kelly
Arnold Joseph Kemp
Dave Kennedy
Devin Kenny
Caroline Kent
Yashua Klos
Autumn Knight
Nsenga Knight
Ruth Ellen Kochner
Kokayi
Rickey Laurentiis
Thomas J. Lax
Zun Lee
La Keisha Leek
David Leggett
Simone Leigh
Shaun Leonardo
Robin Coste Lewis
Sarah Lewis
Tau Lewis
Tony Lewis
Glenn Ligon
Kalup Linzy
Peggy Kurka
Kelly Lloyd
Steven Locke
Monique Long
Fern Logan
Adrian Loving
Rick Lowe
Thomas Lucas
Eric N. Mack
Maureen Mahon
Faheem Majeed
Devin Malone
Kerry James Marshall
Courtney J. Martin

Dawn Lundy Martin
Shantell Martin
Tracye A. Matthews
Alex Mayo
AJ McClenon
Makaya McCraven
Jonathan McCrory
Cecil McDonald Jr.
Velma McEwen
Kenrick McFarlane
Eric T. McKissack
Rodney McMillian
Meida Teresa McNeal
Ari Melenciano
Lester Julian Merriweather
Helina Metaferia
Troy Michie
Wardell Milan
Nicole Miller
Shantel Miller
Adia Millett
Roscoe Mitchell
Meleko Mokgosi
Loren Hansi Momodu-Gordon
Kenneth Montague
Amy Mooney
Ayanah Moor
Alicia Hall Moran
Jason Moran
Camille Morgan
Nyeema Morgan
Fred Moten
Jasmine Murrell
Jayson Musson
Wangechi Mutu
Christopher Myers
Eliza Myrie
Classi Nance-Jimoh
Nelson-Mandela Khaltim Nance
Terence Nance

Senga Nengudi
Christie Neptune
Rashaad Newsome
Otobong Nkanga
Camille Norment
Tameka Jenean Norris
Liona Robyn Nyariri
Tavia Nyong'o
Lorraine O'Grady
Keith Obadike
Mendhi Obadike
Odili Donald Odita
Toyin Ojih Odutola
Valerie Cassel Oliver
Karyn Olivier
Kambui Olujimi
Tariq Darrell O'Meally
Meg Onli
Larry Ossei-Mensah
Clifford Owens
Jennifer Packer
Miriam Parker
Taisha Paggett
Michelle Joan Papillion
Nikki Patin
Ebony G. Patterson
Mary Pattillo
Kamau Amu Patton
Chanelle Aponte Pearson
Adam Pendleton
Michelle Renee Perkins
Sondra Perry
Alexis Peskine
Shani Peters
Dawit L. Petros
Julia Phillips
Jefferson Pinder
Samora Pinderhughes
Ada Pinkston
Adrian Piper

Valerie Piraino
Maurita N. Poole
William Pope.L
Kashif Powell
Nikki Pressley
Aay Preston-Myint
Robert Pruitt
Phillip Pyle, II
Michael Queenland
Nathaniel Mary Quinn
Corinne Bailey Rae
Michael Ralph
Naima Ramos-Chapman
William Ransom
Toshi Reagon
Dwandalyn R. Reece
Mike Reed
Dee Rees
Tomeka Reid
Jared C.B. Richardson
Andy Robert
Deborah E. Roberts
Ellington Robinson
Nadine Robinson
Kellie Romany
Sheena Rose
Amina Ross
Tammie Rubin
Paul Rucker
Carl Hancock Rux
Loul Samater
Curtis Talwst Santiago
Jacolby Satterwhite
Phoenix Savage
Danielle A. Scruggs
Brian Settles
Paul Mpagi Sepuya
Darling Anita Shear
Amy Sherald
David Shrobe

Alexandra Rachelle Siclait
Gary Simmons
Xaviera Simmons
Jeffrey Sims
Arthur Simms
Lowery Stokes Sims
Franklin Sirmans
Alexandria Smith
Cauleen Smith
Cherise Smith
Paul Anthony Smith
Shinique Smith
Wadada Leo Smith
Lisa C Soto
Esperanza Spalding
DJ Spooky
Kara Springer
Mitchell Squire
Anthony Stepter
Luke Stewart
Renée Stout
Devin Troy Strother
Ceaphas Stubbs
Kekeli Sumah
Sur Rodney (Sur)
Akiko Surai
Martine Syms
Claire Tancons
Greg Tate
Garland Martin Taylor
Henry Taylor
Michael K Taylor
Vanessa Thaxton-Ward
Hank Willis Thomas
Mickalene Thomas
Justin Randolph Thompson
Krista Thompson
Jamaal Hasaf Tolbert
Jeremy Toussaint-Baptiste
Sam Trump

Toisha Tucker
Camille Turner
Yesomi Umolu
Imani Uzuri
Jina Valentine
Jessica Vaughn
brontë velez
Venus X
Sam Vernon
William Villalongo
Stacy Lynn Waddell
Preston Wadley
Andre D. Wagner
Barbara Walker
Hamza Walker
Kara Walker
Larry Walker
Geneviève Wallen
Nari Ward
Cullen Washington Jr.
Patrice Renee Washington
Terrence Washington
Elizabeth M. Webb
Carrie Mae Weems
Alexander G. Weheliye
Shoshanna Weinberger
Cameron Welch
Charisse Weston
Rhonda Wheatley
Simone White
Anna Martine Whitehead
Zoé Whitley
Cosmo Whyte
Kehinde Wiley

Amanda Williams
Bernard Williams
Brittney Williams
Phillip B. Williams
William T. Williams
Marisa Williamson
Deborah Willis
Andrew Wilson
Danielle Burns Wilson
Fo Wilson
Ivy Wilson
Mabel O. Wilson
Myke Wilson
Paula Wilson
Ronaldo V. Wilson
Wilmer Wilson IV
Emma Wolukau-Wanambwa
Titus Wonsey
Lauren Woods
Jamila Woods
Derrick Woods-Morrow
Sarah Workneh
Lynette Yiadom-Boakye
avery r. young
Bradford Marcel Young
Nate Young
Brenna Youngblood

Black Artists Retreat [B.A.R.],
2013 – 2019
Organizing Members: Marlease Bushnell, Jessica Moss,
Eliza Myrie, Carrie Mae Weems, Sarah Workneh.
Founder and Convener: Theaster Gates
Organizational Partner: Rebuild Foundation

Romi Crawford

Radical Relations! Memory, Objects, and the Generation of the Political was an exhibition at the University of Chicago's Center for the Study of Gender and Sexuality that I made in 2017 at the invitation of scholar and cultural theorist Lauren Berlant. In many ways the genesis of the fleeting monuments idea, the exhibition absorbed the scraps and detritus of research material that did not find a place in either the *Wall of Respect: Public Art and Black Liberation in 1960s Chicago* book or the *Wall of Respect: Vestiges, Shards, and Legacy of Black Power* exhibition at the Chicago Cultural Center. Meant to hold and capture the affective and sentimental remnants that emerged from my book research, the exhibition attempted to highlight and pay tribute to such remains through various strategies. I experimented with didactics—offering red arrows in the direction of pertinent side tracks and using loose captioning to express the off-the-record nature of the exhibition's historicization of Chicago's Black arts movement. —RC

Radical Relations!

BY ROMI CRAWFORD

Memory, Objects, and the Generation of the Political

Radical Relations! offers an occasion for various things, literally. It pulls together items that belonged to an intimate cohort of African American artists, educators, poets, and political organizers who lived and worked on the South Side of Chicago in the late 1960s. Several of those alluded to in this exhibition were involved as makers of and participants in the Wall of Respect, a mural made at 43rd and Langley in 1967, which influenced mural-making on a national level. It was a major work of public art and of the Black Arts Movement.

This exhibition slows down an upcoming show at the Chicago Cultural Center focusing on the Wall of Respect (also curated by Romi Crawford, Abdul Alkalimat and Rebecca Zorach). The Cultural Center show (February 25–July 30, 2017) mines the history and legacy of the Wall of Respect upon its fifty-year anniversary. *Radical Relations!* also observes the influence of late 1960s art and politics, but through a more sentimental and domestic lens. It makes an event of minor moments from this particular political scene and divulges intimate relations (personal, familial, amorous) amid the struggle for racial and social justice. It platforms the material effects that proceed from such close associations.

What is seemingly inapplicable, or even unfitting, to imaginings of a radical Black politics of the 1960s plays an important role in the logic of this display. Childhood toys, jokes remembered after decades, tokens of affection, and a nod to ambient soundtracks suggest how sentimentality sustains, or feeds, political agency. In this sense, *Radical Relations!* prompts a more expanded interpretation of Black radical politics that takes into account urgent acts of friendship, kinship and love. It explores the significance of these acts as well as their connection to more public and overtly political activism.

The exhibition captures and stages odds and ends as well as loose ends. The objects, memorabilia, and text forms amassed "transform their living

281

genre."[1] Some are gifts, some are inherited, some have been solicited. All are symbolic of the late 1960s and raise the issue of loss (what is outdated, neglected, thrown away). Gathering and showcasing the various remnants offers a viable methodology for working through the expiry of loved ones and a past political moment rife with hope.

The artists implicated throughout the exhibition are Amus Mor, Robert E. Paige, Sylvia Abernathy (Laini), Billy Abernathy (Fundi), Bob Crawford, Darryl Cowherd, and Robert Sengstacke. Like the objects in the exhibition, these figures too have been disregarded, and in some instances forgotten, but they are revived here to instantiate the continued presence and ongoing relevance of Black radical politics from the 1960s in our present era.

Radical Relations! emerges from the curator's history. In this sense, it ultimately deals with the making of the political self, within the context of a particular family, in a specific neighborhood, at a specific historical moment. It magnifies personal perspective. As such, it is meant to decelerate the history of the Black Arts Movement and its attendant politics by addressing historical figures and concerns that are not yet contained by the art historical project. Like the objects in the exhibit, these artists and concerns (the formation of the political self amidst close relations or those bonds of love that arouse the urgency of fighting against injustice) are just on the cusp of having value.

1 Lauren Berlant's description of the objects. From a discussion of the project in January 2017.

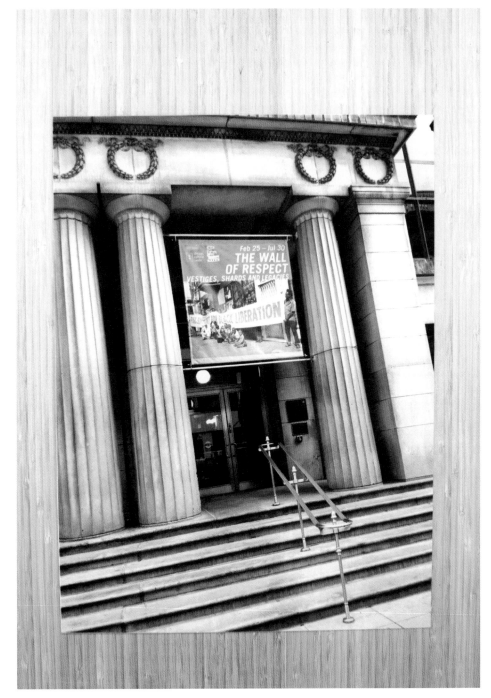

The Wall of Respect: Vestiges, Shards, and the Legacy of Black Power,
exhibition entrance at the Chicago Cultural Center, 2017.

Swahili greeting at entry of exhibit referencing 1960s embrace of African culture and language. *Radical Relations! Memory, Objects, and the Generation of the Political exhibition installation.*

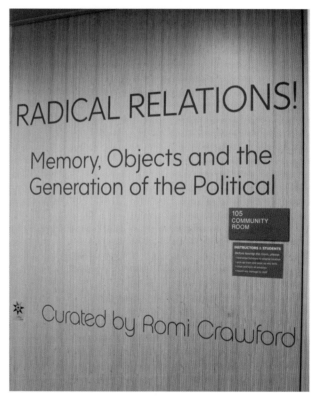

Radical Relations! Memory, Objects, and the Generation of the Political exhibition installation, University of Chicago's Center for the Study of Gender and Sexuality.

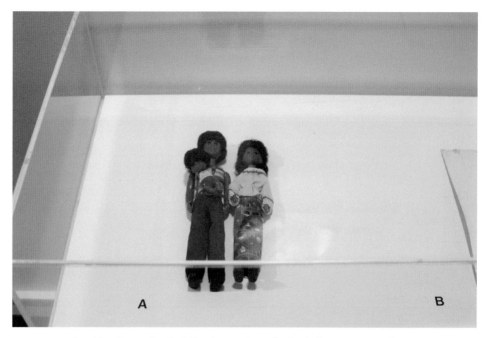

A B

Sunshine/Happy Family dolls, circa 1976. *Radical Relations! Memory, Objects, and the Generation of the Political* exhibition installation.

Rock painted for mother in 1974 by designer Robert E. Paige, *Radical Relations! Memory, Objects, and the Generation of the Political* exhibition installation.

285

pp. 286–289:

Radical Relations! exhibition installation, with didactics that address the personal and sentimental.

Copyright Tate Brazas.

ROMI CRAWFORD

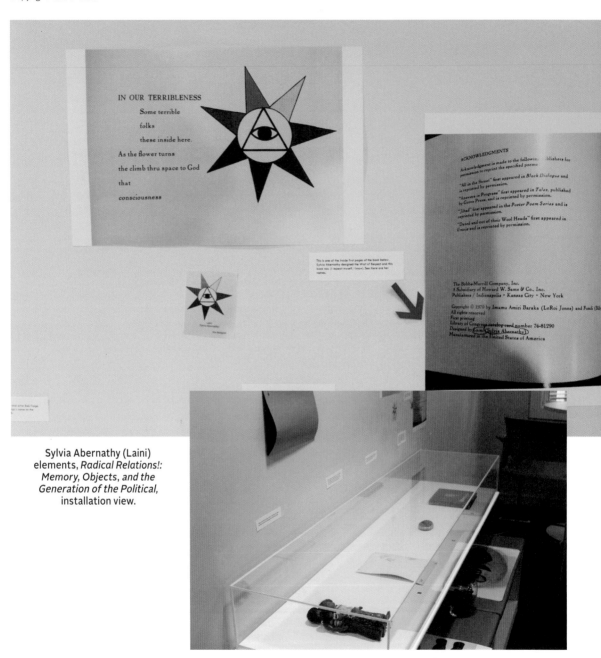

Sylvia Abernathy (Laini) elements, *Radical Relations!: Memory, Objects, and the Generation of the Political*, installation view.

Radical Relations! Memory, Objects, and the Generation of the Political, installation view.

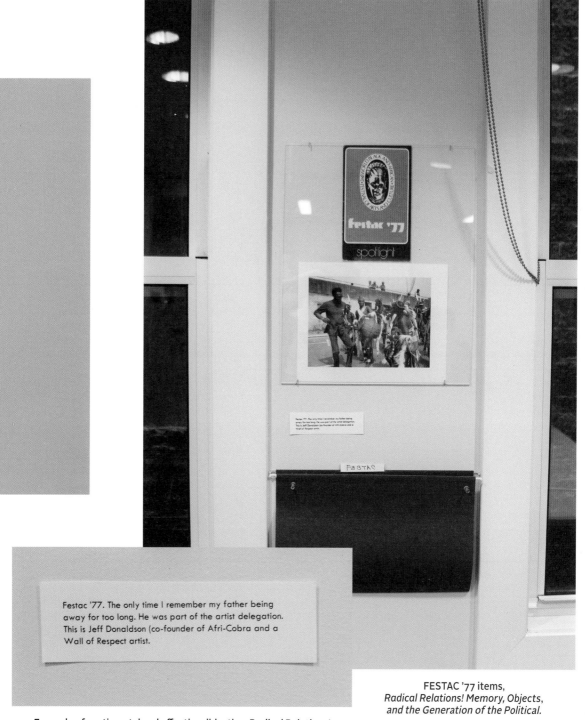

Festac '77. The only time I remember my father being away for too long. He was part of the artist delegation. This is Jeff Donaldson (co-founder of Afri-Cobra and a Wall of Respect artist.

FESTAC '77 items,
*Radical Relations! Memory, Objects,
and the Generation of the Political.*

Example of sentimental and affective didactics, *Radical Relations!
Memory, Objects, and the Generation of the Political.*

pp. 289–289:

Amus Mor elements gathered from
Wall of Respect book research,
*Radical Relations! Memory, Objects,
and the Generation of the Political.*

ROMI CRAWFORD

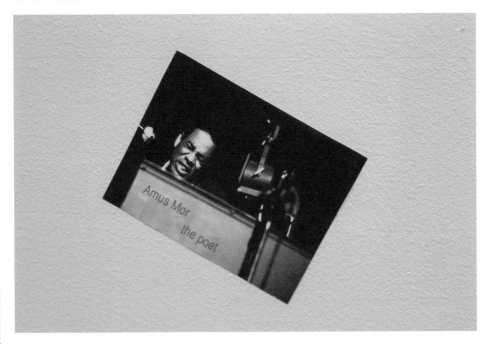

ORGANIZATION
OF BLACK
AMERICAN
CULTURE

352 EAST 47TH STREET
CHICAGO, ILLINOIS 60653

INAUGURAL PROGRAM

May 28, 1967
Abraham Lincoln Center

Introductory Remarks	...	Gerald A. McWorter
The Dance	...	Sherry Scott
OBAC	...	Hoyt W. Fuller
The Music	...	The Delections - Rudy Howard, Ronald Christian, Wayne Jackson, Donald Foxx, Patrick Keen
OBAC	...	Bennett J. Johnson, E. Duke McNeil
The Spoken Word	...	The Magnificent Seven + One
OBAC	...	Donald H. Smith
The Music	...	The Fred Humphrey Quartet w/Sherry Scott
OBAC	...	George R. Ricks
The OBAC Direction	...	Gerald A. McWorter
The Spoken Word	..	David Moore
The Visual Image	...	Jeff R. Donaldson
OBAC Announcements	...	Joseph R. Simpson
OBAC Concluding Remarks	...	E. Duke McNeil

Name _____ Male Female
 (Last) (First) (Circle one)
Address _____
Phone _____

I recommend the following people/organizations
for participation in OBAC:
 (List names, addresses, & area of interest)

(a) _____
(b) _____
(c) _____
(d) _____

I would like to participate in:
☐ Drama ☐ Photography
☐ Writing ☐ Painting
☐ Poetry ☐ Sculpture
☐ Music ☐ Dance

I would like to be of service
in the following manner:
☐ Speakers Bureau ☐ Typing
☐ Community ☐ Newsletter
 Workshops ☐ Promotions
☐ Office Work

Lauren Berlant

Cultural theorist Lauren Berlant's writings offer interpretations of film, art, politics, and situations and events that are difficult to ascertain, whether too slight or too looming for easy access or perspective. Berlant also scrutinizes the attendant meanings (including feelings, emotions, and affect) that move around and haunt the phenomenon or "the object" in question.

In addition, Berlant's theorizations of "worlds" and "intimate publics," what she describes as "a porous, affective scene of identification among strangers that promises a certain experience of belonging and provides a complex of consolation, confirmation, discipline, and discussion," offer productive ways to interpret and understand the sense of cohort, community, and collectivity experienced at the Wall of Respect site.[1]

Berlant's fleeting monument is in the form of a short piece of writing. As an ongoing collaborator with me in Feel Tank Chicago, a collective that includes myself, filmmaker Mary Patten, and writer Matthias Regan, Berlant offers a reflective meditation on the *Radical Relations! Memory, Objects, and the Generation of the Political* exhibition, which she invited me to produce at the University of Chicago's Center for the Study of Gender and Sexuality in 2017.

In this piece, Berlant acts as witness to the unheroic, scrap-filled exhibit which served to contain the art historical throwaways and residuals that emerged from research on the Wall of Respect book. Her piece is a trace of the fleeting, short-lived, consciously hesitant exhibition. —RC

1 See Lauren Berlant, *The Female Complaint: The Unfinished Business of Sentimentality in American Culture* (Durham: Duke University Press, 2008), viii.

On the Non-Place of Intimate Time: Chicago, Black Politics, and the Fam

BY LAUREN BERLANT

At the Center for the Study of Gender and Sexuality in February 2017, Romi Crawford installed in a common space material that would register the intimate time of Black politics in Chicago in the early sixties. The exhibition was called, *Radical Relations! Memory, Objects, and the Generation of the Political.*

Crawford achieved this mood in a lobby, an institutional nonspace that was built to register neutrality, a constant emptiness that allows for potential episodes: nothing on the walls registering past intimacies, nothing of enduring knowledges, nothing of intense aesthetic experiences, and nothing to force you to think about why it makes sense to induce *revolutionary anachronism.* Crawford's task was to make the call of a past/present real and vital. She sought to transform the space to a lifeworld for politics. She documented that, in '60s Chicago, it was worth showing up to organize a counter-world for Black political and cultural legitimacy. Without the first time there can be no next time.

Many things were taped to the Center's lobby wall: pictures of friends and family in her parents' generation; poems, gifts, and paintings by collaborators; scraps and playlists of what people were happy to be near. There was furniture too, indented where people would sit around. Every document testified to the mood of pleasure in the struggle. It's crucial to testify to it because hanging out is crucial to building new worlds from within the world of existing stress and violence.

Crawford wanted to make a space for the stuff stored in people's garages. The stuff put aside as too valuable to throw out but not valuable enough to touch every morning on the way out into the world. The stuff that had been around when things were vibrant and vibrating, that pointed to a community dedicated to self-making an alternative lifeworld out of polemic, the kitchen table, and arts. The photographs and letters demonstrate the vast energy for improvisation, the flicker of asides and shrugging, the sense of taking each other into their confidence, and the music of artists who showed up to play at the Wall of Respect. Crawford documented and testified to the transformed viscera of revolutionary taste.

Curating a world at a prior high point as an ongoing vibrancy is difficult. Do you want the medium to be remembered, or the thing it signified? Is it shameful to remember the comedy of the body? How did the personal and the political circulate and threaten? How did rage and comedy feed each other? Isn't there comedy all throughout the tragedy of violence, isn't it all at once outrageous and ordinary? Is there something other than the ridiculous small gestures we make to remember the urgency of resistance?

That's what Crawford's lecture on Black radical politics, community, family, and aesthetic circulation as a binding force was also about. Trauma isn't the only thing that's transgenerational, the only world-extending anachronism. The unfinished business of revolutionary energy *as a lived atmosphere* is also regenerative. Christina Sharpe calls it "the insistence on existing" of a Blackness emerging from the wake that mourns, protests, and refuses not to be generative. [1]

In the lecture there was the terrible story of a brilliant poet Amus Mor who showed up for the movement until he didn't, getting lost in the anonymity cities allow for, which is an experience we're used to in community. You see people regularly and assume that there'd be more life, more showing up, not thinking too hard that there would be a last time you saw someone, or went to the Wall of Respect, or felt a political attachment to a stranger not from your community, which was itself always changing the shape its membrane takes.

The gatherers of the remains are political: trying to bring everything into the cusp of the emerging spaces where transformative relations are emerging, being shared and tested out.

This paragraph feels out what the room Romi made felt like:

> Look, a remnant! Slow down. We don't always have to honor importance by gushing or by amplification. This is the lesson of mourning. This is the responsibility to appreciate that life isn't just made up of Events and Eras. It is also made up of gestures that create atmospheres and infrastructures that allow us to return to them. Objects pass among us: notes and trinkets that become commemorations. We gather: at a wall, a house, a garden. Suddenly the "living room" is an anywhere, as intimate as a kitchen table, where political and intimate speculation take place heatedly and at the same time convivially.

LAUREN BERLANT

1 Christina Sharpe, *In the Wake: On Blackness and Being* (Durham NC: Duke UP, 2016), 11.

A remnant is the still life of a remain. We're supposed to hover near it and wonder about it. It's available for living use.

On a table there's a stone someone painted yellow with a "flower power" overlay during the 1960s: it's very smooth, like it's been worn to the size of a perfect grip. It might have been a token of affection, of being affected—by an event, a prospect, or another person. It might have been a ticket to something, opening a new surface to breathe in, to move around in. It might have been just a thing it seemed worth throwing into the world, because the world doesn't change if you don't show up: a pamphlet, a zine, a poster, a sound, something colorful to interrupt the darkness of Blackness, something black to interrupt the police. No one can say a thing was trivial: the rock is like all things, evidence of a build toward a world worthy of desire. Another way of talking about Black Power as something both fierce and delightful, generating all kinds of poetics.

For there was, and is, a world-making drive. Shock, numbness, moving through things, and moving things: protests, songs, photocopies, poems, lots of easily forgettable performances. Change is indolent, until it isn't, then it is, until it isn't, from a flicker to what *feels* like a shifting structure. Romi's collection intimated:

> Listen, most of the noise is around you, but not about you. There are headphones for the music. There are conversations overheard. Any atmosphere carries with it the haunt of the postmortem: by the time you assess it so many leaves have fallen and so many things have become-leaf. You can cheer yourself up saying "compost"—the still-life still has life in it. But some political projects went dormant: they never die; they're always there for reanimation. To be radical is to desire anachronism, a disturbance in time's ongoingness. To curate history is to make that happen. To look at these Radical Relations in their ordinary air is to remember that there's always something to invent and inherit, always a spirit to take up and embody.

Contributors

Fulla Abdul-Jabbar

Fulla Abdul-Jabbar is a writer and artist living in Brooklyn. She teaches in the Writing Department at the Pratt Institute and is Editor and Curator at the Green Lantern Press.

Miguel Aguilar

Artist, educator, and researcher Miguel Aguilar has been painting graffiti in Chicago since 1989. He founded Graffiti Institute in 2012 and in 2013 curated *Outside In: The Mexican-American Street Art Movement in Chicago* at the National Museum of Mexican Art. Miguel holds a bachelor's degree in Fine Arts (2000) and a master's of art in Teaching (2011) from the School of the Art Institute of Chicago and is a 2012 recipient of the 3Arts Award for his work as a teaching artist. He has taught the history of graffiti in the Art History Department at SAIC and is a practicing visual artist and muralist.

Abdul Alkalimat

Abdul Alkalimat (b. Gerald McWorter) was born in Chicago's Cook County Hospital and first lived in the Frances Cabrini Rowhouses. He was educated at Edward Jenner Elementary School, Marshall High School, the University of Illinois at Navy Pier, Roosevelt University, and the University of Chicago (Ph.D.). He has worked as chairman of the Chicago Area Friends of SNCC (Student Non-Violent Coordinating Committee), founder and chair of OBAC (Organization of Black American Culture), and founder of Timbuktu Market of New Africa bookstore (Atlanta, Nashville, Riverside, CA, and Chicago). He is the editor of several websites—Malcolm X: A Research Site, Cyberchurch, and eBlack Studies. He served as editor of the largest listserv in Black Studies, H-AFRO-AM, from 1998 to 2014. Currently he is Professor Emeritus of Library and Information Science and African American Studies at the University of Illinois at Urbana-Champaign. His latest solo-authored book is *Black Toledo: A Documentary History of the African American Experience in Toledo, Ohio* (2017).

Rohan Ayinde

Rohan Ayinde's work meditates on the potential opened up by a Black radical aesthetics in conversation with quantum mechanics. Ayinde is concerned with producing a syntax that is Black without the limitations of race by mapping these vocabularies onto one another to explore the spaces of possibility at their intersections. His practice is focused on deconstructing inherited structures and developing a new language afforded by a radical politics that is queer, feminist, atemporal, multivalent, communal, and subaltern. Working through the concrete questions of what this means and how it can do something in the world are central to the conceptual framing of Ayinde's work.

Wisdom Baty

Wisdom Baty is a Chicago-based artist, mother, and arts collaborator interested in curating space for black and brown mothers and their children. Encompassing over a decade of community organizing, her practice reimagines physical space, autonomy, and historical accuracy in support of black motherhood through the lens of intersectionality and social practice. Baty is the founder of Ways We Make: Nurturing Creative Communities as Mothers of Color and Wild Yams: Black Mothers Artist Residency. ¶ She co-organized "Doing The Work: Re-contextualizing Sustainability and Inclusion" with panelists Angelique Power and Tracie D. Hall and moderated by Kamilah Rashied, at SAIC in 2018; "Black Family Reunion" with Threewalls and Reunion in 2017; and "The Black Experience: Panel and MFA Showcase" at SAIC Sullivan Galleries in 2015. Baty was a 2017 Marwen Teaching Artist Resident, a 2007 fellow at the Yale Norfolk Summer School of Art and Music, and a 2011 and 2015 resident of the Teacher Institute at the Museum of Contemporary Art Chicago, and currently has work represented on the Field Foundations website. Baty is a graduate of SAIC's Master of Arts in Arts Administration and Policy (MAAAP) program.

Mark Blanchard

Mark Blanchard received his BA at Oberlin College (2014) and MFA at the School of the Art Institute of Chicago (2017). He works with photography, video, cinemagraphs, sound, and virtual reality to build interactive experiences addressing various conceptual frameworks for personal identity. He explores identity within the framework of misrepresentations applied to persons of color propagandized through mainstream media within the United States. His practice has been a process of decentralizing those representations and building digital spaces that cultivate reconciliation of one's identity. His process involves navigating the distractions of persona, our projected identities, to satiate this yet unresolved curiosity of humanity: our sense of self. He accomplishes this by activating voices from within the community and culture, both historical and contemporary, and engaging our aural stories to supplement his visual work. He uses body language influenced by the African diaspora, especially Capoeira Angola, to further complicate overly simplified representations popularized by others gazing from outside of the culture. Blanchard's role as the artist involves exposing the deeper reality of individuality beyond the daily rhetoric that fuels prejudice.

Bethany Collins

Bethany Collins is a multidisciplinary artist whose conceptually driven work is fueled by a critical exploration of how race and language interact. In her *Contronym* series, for instance, She

transposes definitions from Webster's *New World Dictionary of American Language* onto American Master's paper and then aggressively obscures much of the entries with an eraser. What remain are specific snippets of meaning that are poetically charged through their isolation, as well as the crumbled paper bits left behind by Collins's erasing. As Holland Cotter wrote in *The New York Times*, "Language itself, viewed as intrinsically racialized, is Bethany Collins's primary material." ¶ Her works have been exhibited in solo and group exhibitions at museums nationwide, including the Contemporary Art Museum St. Louis, the Art Institute of Chicago, and the Peabody Essex Museum. Collins has been recognized as an artist-in-residence at the Studio Museum in Harlem, the MacDowell Colony, the Bemis Center, and the Hyde Park Art Center, among others. In 2015, she was awarded the Hudgens Prize.

Darryl Cowherd
Darryl Cowherd is a veteran professional photographer, tenured broadcast news writer, and editor. In 2014, he was the recipient of the Edward R. Murrow Award for Breaking News. His photographs have been published both nationally and internationally in numerous books, magazines, newspapers, and other periodicals. The public/private collections of the Art Institute of Chicago, the Museum of Contemporary Photography, the Schomburg Center for Research in Black Culture, and the Smart Museum at the University of Chicago house or have exhibited Cowherd's photographs. Recently, his images were exhibited at the Tate Modern Museum in London, the Chicago Cultural Center, Northwestern University, Crystal Bridges Museum of American Art, the Brooklyn Museum of Art, and the Broad Museum in Los Angeles. Additionally, he has exhibited in several other group shows. Currently, Cowherd's images are included in the historic *Soul of a Nation* exhibition, whose tour stops include the de Young Museum, San Francisco, and the Museum of Fine Arts, Houston, and the *What Does Democracy Look Like?* exhibit at Chicago's Museum of Contemporary Photography. Cowherd is currently working on "Persecution, Paralysis, Panic and Perseverance," documenting life during a pandemic, and also completing a series on storefront churches entitled "God is on the Corner" and "America, From an African American Eye."

D. Denenge Duyst-Akpem
D. Denenge Duyst-Akpem is a space sculptor, award-winning educator, artist, and writer whose practice and scholarship bridge the disciplines of design, ritual, fashion, and ecology. Duyst-Akpem is an adjunct associate professor at the School of the Art Institute of Chicago and an associate professor and 2020-21 Visiting Artist at Kentucky College of Art and Design. She is a 2020 LaBecque Laureate, 2016-17 Place Lab Fellow, 2014 NEH Institute Fellow, and founding member of Chicago Fashion Lyceum. She is founder of Denenge Design and In The Luscious Garden, focused on holistic, conceptual approaches to human-centered design. Duyst-Akpem creates fantastical interactive environments and performances to interrogate, titillate, decolonize, and empower. Inspired by Sun Ra, her work asks, "Who controls the future?" Career highlights include *Black Quantum Futurism: Temporal Deprogramming* at ICA London, *Rammellzee: Racing for Thunder* at Red Bull Arts New York, *High Priestess of the Intergalactic Federation, Special Envoy to Mars* for NASA/Blumberg, U.S. Library of Congress, *Corpus Meum* at the Arts Club of Chicago, an essay on the work of AfriCOBRA co-founder Jae Jarrell for Kavi Gupta, and the launch of *The Camo Coat Collection* and *AFRIFUTURI 02022020* holographic monograph. Duyst-Akpem holds an MFA in Performance from SAIC and a BA from Smith College.

Julio Finn
Bio data : Julio Finn, a.k.a., Finn Julio ¶ Modesty forbids my speaking about my past and future incarnations; therefore this pertains only to my current status. ¶ Profession: sometimes a musician, sometimes a writer, sometimes a poet, sometimes philosophically inclined, and sometimes just myself. ¶ The following I consider to be Landmark Occasions: Smoking cigars with Guillermo Cabrera-Infante; discussing the psychology of African American culture with James Baldwin and Amina and Amiri Baraka; playing music with Memphis Slim, Muddy Waters, Linton Kwesi Johnson, and the Art Ensemble of Chicago; basking in the joyful, exhilarating company of Maya Angelou and John Ehle. ¶ In the course of this peripatetic activity, certain products of an artistic nature—books, recordings, film projects—have materialized. ¶ Music: Recordings with the Julio Finn Blues Band, Art Ensemble of Chicago, Anthony Braxton, Dennis Bovell, Archie Shepp, Leroy Jenkins, Eddie C. Campbell, Guardian Angel, King Harvest, etc. ¶ Film documentaries: *The Roots of Black Music* (BBC) and *We Are The Blues* (ARTE). ¶ Works in Progress: *Choro No. 3 for guitar* (or perhaps mandolin?)*; A Brief History of the Lavish Lowlife; The Geisha Who Fell From Grace With Men.* ¶ Likes: People and other animals, insects, plants, rocks, air, oceans, sky, and the cosmos. ¶ Dislikes: People who are insensitive to the above. ¶ Favorite places: Paris, Corfu, Havana, Chapel Hill, NC, and Zanzibar.

Maria Gaspar
Maria Gaspar is an interdisciplinary artist whose work addresses issues of spatial justice in order to amplify, mobilize, or divert structures of power through individual and collective gestures.

Through installation, sculpture, sound, and performance, Gaspar's practice situates itself within historically marginalized sites and spans multiple formats, scales, and durations to produce liberatory actions. Gaspar's projects have been supported by the Art for Justice Fund, the Robert Rauschenberg Artist as Activist Fellowship, the Creative Capital Award, the Joan Mitchell Emerging Artist Grant, and the Art Matters Foundation Fellowship. Gaspar has received the Sor Juana Women of Achievement Award in Art and Activism from the National Museum of Mexican Art and the Chamberlain Award for Social Practice from the Headlands Center for the Arts. Gaspar has exhibited extensively at venues including the Contemporary Arts Museum, Houston; the Museum of Contemporary Art Chicago; the African American Museum, Philadelphia; and MoMA PS1, New York. She is an associate professor at the School of the Art Institute of Chicago and holds an MFA in Studio Arts from the University of Illinois at Chicago and a BFA from Pratt Institute in Brooklyn, NY.

Theaster Gates

Theaster Gates lives in Chicago and creates works that engage with space theory and land development, sculpture, and performance. Drawing on his interest and training in urban planning and preservation, Gates redeems spaces that have been left behind. Known for his recirculation of art world capital, Gates creates work that focuses on the possibility of the "life within things." His work contends with the notion of Black space as a formal exercise—one defined by collective desire, artistic agency, and the tactics of a pragmatist. ¶ In 2010, Gates created the Rebuild Foundation, a nonprofit platform for art, cultural development, and neighborhood transformation that supports artists and strengthens communities through free arts programming and innovative cultural amenities on Chicago's South Side. ¶ Gates has exhibited and performed at Tate Liverpool, UK (2020); Haus der Kunst, Munich (2020); Walker Art Center, Minneapolis (2019); Palais de Tokyo Paris (2019); Sprengel Museum Hannover, Germany (2018); Kunstmuseum Basel, Switzerland (2018); National Gallery of Art, Washington, D.C. (2017); Art Gallery of Ontario, Canada (2016); Fondazione Prada, Milan, Italy (2016); Whitechapel Gallery, London (2013); Punta della Dogana, Venice (2013); and dOCUMENTA (13), Kassel, Germany (2012). He was the winner of the Artes Mundi 6 prize and a recipient of the Légion d'Honneur in 2017. In 2018, he was awarded the Nasher Prize for Sculpture, and the Urban Land Institute's J.C. Nichols Prize for Visionaries in Urban Development. Gates received the 2020 Crystal Award for his leadership in creating sustainable communities. ¶ Gates is a professor at the University of Chicago in the Department of Visual Arts and at the Harris School of Public Policy. He is also a Distinguished Visiting Artist and Director of Artist Initiatives at the Lunder Institute for American Art at Colby College.

Nicole Mitchell Gantt

Nicole Mitchell Gantt (NMG) is a creative flutist, composer, poet, conceptualist, bandleader, and educator. A Doris Duke Artist, United States Artist, and recipient of the Herb Alpert Performing Arts Award, she is most widely known through her work as leader and founder of Black Earth Ensemble. NMG's primary inspiration was her mother, Joan Beard Mitchell (JBM), a self-taught Afrofuturist writer and visual artist who was an early member of the Black Folk Art Gallery of Syracuse (now the Community Folk Art Gallery). JBM died before having the opportunity to satisfactorily share her work, so upon her death, NMG as a teen decided she would continue her mother's path as an artist bridging the familiar with the unknown. JBM introduced NMG to journaling and creative writing at an early age, which led to NMG's attraction to work as a typist and graphic designer for over ten years at Third World Press (TWP), the longest-running African American book publishing company in the U.S. At TWP, NMG absorbed lifelong lessons in Black history, philosophy, and institution building and gained incomparable mentorship from TWP's founder, renowned poet Haki R. Madhubuti. Having started her musical career busking with her flute on the streets of San Diego and then Chicago, NMG eventually ascended from membership of Chicago's venerable Association for the Advancement of Creative Musicians (AACM) and co-founder of the AACM's first all-woman ensemble, Samana, to become the first woman president of the organization. NMG was commissioned to create three projects inspired by science-fiction writer Octavia Butler, including *Xenogenesis Suite* (Chamber Music America), *Intergalactic Beings* (Museum of Contemporary Art Chicago), and *EarthSeed* (co-commissioned with Lisa E. Harris by the Art Institute of Chicago). Her project *Mandorla Awakening*, noted in the top five jazz albums of 2017 by the *Village Voice*, the *New York Times,* and the *Los Angeles Times*, was partly inspired by the book *The Chalice and the Blade* by anthropologist Riane Eisler and from NMG's own Afrofuturist narrative, *Mandorla Awakening. Liberation Narratives* (TWP, 2017) is NMG's tribute to Haki Madhubuti, which connects music of Black Earth Ensemble with Madhubuti's poetry. Meanwhile, NMG's poems and prose can be found embedded in the lyrics and spoken word of her dozen musical recordings. As a writer, NMG has had articles published in *Jazz Times* magazine, *Wire Magazine* (UK), *Arcana VIII: Musicians on Music* (edited by John Zorn), and

Giving Birth to Sound: Women in Creative Music (edited by Renate Da Rin and William Parker). NMG is the William S. Dietrich II Chair of Jazz Studies at University of Pittsburgh. She also enjoys being a wife, mother, and grandmother.

Wills Glasspiegel

Wills Glasspiegel is a documentarian, visual artist, and scholar from Chicago, writing about the cultural history of Chicago footwork for his PhD dissertation in African American Studies and American Studies at Yale University. Before his involvement with footwork, he advocated for Black electronic musicians in Sierra Leone and in South Africa, where he helped launch the Shangaan Electro project in Soweto. Glasspiegel has produced public radio segments for NPR's *All Things Considered* and *Morning Edition*, and was recognized as a co-recipient of a Peabody Award in 2014 for his contributions to the radio program *Afropop Worldwide*. His documentaries and collaborations have been featured by CNN Nowness, *The Fader, Dazed, DIS* magazine, *The Wall Street Journal*, and the *Chicago Tribune*, among others. Museums and galleries featuring his films and visual art include the Minneapolis Institute of Art, MANA Contemporary, the Hokin Project Gallery of Columbia College, and the Museum of Contemporary Art Chicago. Glasspiegel received his undergraduate degree in English from Yale and holds a master's degree in Media, Culture, and Communications from New York University. He resides in Chicago, where he recently co-founded the non-profit Open the Circle, devoted to channeling resources into divested communities through the arts.

Val Gray Ward

Val Gray Ward is an internationally known actress, producer, and theater personality who has made major contributions through her work as dramatist, founder, and artistic director of the Kuumba Theatre. Since its founding in 1968, Ward has produced and directed such plays as *Sister Son/ji* by Sonia Sanchez, *Ricky* by Eugenia Collier, *Five on the Black Hand Side* by Charles Fuller, and *The Image Makers* by Eugene Perkins. She also created the Emmy Award-winning *Precious Memories: Strolling 47th Street*, which aired on the PBS network in September 1988. Ward also appeared in her one-woman show, *I Am A Black Woman*, from 1966 to the present at colleges and universities, conferences, and educational meetings across the country.

Stefano Harney and Fred Moten

Stefano Harney and Fred Moten are authors of 2013's *The Undercommons: Fugitive Planning and Black Study* and the forthcoming *All Incomplete* (Autonomedia/Minor Compositions). Fred teaches at New York University. Stefano teaches at Royal Holloway, University of London. They are involved in several cooperatives and collaborative projects, including Le Mardi Gras Listening Collective and the Center for Convivial Research and Autonomy.

Stephanie Koch

Stephanie Koch is an arts administrator and curator from Chicago who engages in institution-building as a creative practice and exhibition-making as a site for empathetic and prefigurative politics. She is the cofounder of Annas, an independent art space dedicated to the critical role of exhibiting process. For the past two years, the space has provided platforms for making and sharing collaborative projects, and building, evaluating and rebuilding structures for horizontal learning amongst emerging makers. In collaboration with her cofounder and resident artists, Koch designs human-scale systems for supporting and sustaining creative practices, systems that can dissolve and evolve in response to individual needs, time constraints, and available resources. Stephanie received a BA in Political Science from the University of Chicago and an MA in Visual and Critical Studies from the School of the Art Institute of Chicago.

Kelly Lloyd

Kelly Lloyd is a multidisciplinary conceptual artist who focuses on issues of representation and knowledge production and prioritizes public-facing collaborative research. Lloyd received an MFA in Painting and MA in Visual & Critical Studies from the School of the Art Institute of Chicago in 2015 and earned a BA from Oberlin College in 2008. Recent projects include solo exhibitions at the Institute of Contemporary Art Baltimore and Shane Campbell Gallery (Lincoln Park) and inclusion in *Habeas Corpus* at the Indianapolis Museum of Contemporary Art. Lloyd performed with Jesse Malmed and ACRE TV at Chicago's Museum of Contemporary Art in 2016, and her essay "Katie Sokoler—Your Construction Paper Tears Can't Hide Your Yayoi Kusama Neurotic Underbelly" is included in *The Retro-Futurism of Cuteness* (punctum press, 2017). Lloyd currently lives and works between Baltimore and Western Europe.

Damon Locks

Damon Locks is a Chicago-based visual artist, educator, and musician. He attended the School of the Art Institute of Chicago, where he received his BFA in fine arts. Since 2014, he has been teaching art with the with Prisons + Neighborhood Arts/Education Project at Stateville Correctional Center. He is a recipient of the Helen Coburn Meier and Tim Meier Achievement Award in the Arts and the 2016 MAKER Grant. He operated as an Artist Mentor in the Chicago Artist Coalition program FIELD/WORK. In 2017, he became a Soros Justice Media Fellow. In 2019, he became a 3Arts Awardee. Currently, he works as an artist in residence as a part of the Museum of Contemporary Art Chicago's SPACE Program, introducing

civically engaged art into the high school curriculum at Sarah E. Goode STEM Academy. He is the leader of the music group Damon Locks Black Monument Ensemble.

Haki Madhubuti

A leading poet and one of the architects of the Black Arts Movement, Haki R. Madhubuti—publisher, editor, educator, and activist—has been a pivotal figure in the development of a strong Black literary tradition. His love for Black literature matured while serving in the US Army (1960-63) in between wars, when the army's motto was "Hurry up and wait"; he waited with books primarily from used bookstores, which became a second home. His third book, *Don't Cry, Scream,* with an introduction by Gwendolyn Brooks, sold over 75,000 copies during its first year of publication as a result of a feature article by David Llorens in the March 1969 issue of *Ebony* magazine. Madhubuti has published more than 30 books, including 14 books of poetry (some under his former name, Don L. Lee), and is one of the world's best-selling authors of poetry and nonfiction. His book *Black Men: Obsolete, Single, Dangerous? The African American Family in Transition* (1990) has over 1 million copies in print. Other titles include *From Plan to Planet: Life Studies—The Need for Afrikan Minds and Institutions* (1973); *Tough Notes: A Healing Call for Creating Exceptional Black Men* (2002); *Run Toward Fear: New Poems and a Poet's Handbook* (2004); *YellowBlack: The First Twenty-One Years of a Poet's Life—A Memoir* (2006); *Liberation Narratives: New and Collected Poems 1966-2009* (2009); *Honoring Genius—Gwendolyn Brooks: The Narrative of Craft, Art, Kindness and Justice* (2011); and *By Any Means Necessary—Malcolm X: Real, Not Reinvented* (co-editor, 2012). There are three book-length critical studies on Madhubuti's literary works: *New Directions from Don L. Lee* by Marlene Mosher (1975), *Malcolm X and the Poetics of Haki Madhubuti* by Regina Jennings (2006), and *Art of Work: The Art and Life of Haki R. Madhubuti* by Lita Hooper (2007). Madhubuti's poetry and essays have been published in more than 100 anthologies and journals from 1997 to 2019. His recent work includes *Taking Bullets: Terrorism and Black Life in Twenty-First Century America* (2016), *Not Our President: New Directions from the Pushed Out, the Others, and the Clear Majority in Trumps' Stolen America* (2017), which he co-edited, and *Black Panther: Paradigm Shift or Not?* (2019). ¶ Madhubuti is a proponent of independent Black institutions. He founded Third World Press (1967) and Third World Press Foundation (2002). He is a founder of the Institute of Positive Education (1969) and New Concept School (1972), and a co-founder of Betty Shabazz International Charter School (1998) and Barbara A. Sizemore Academy (2005), all of which are in Chicago and still operating. Madhubuti was founder and editor of *Black Books Bulletin* (1970-94), a key journal documenting the literature, scholarship, and conversations of African American voices. He was also a founding member of OBAC Writers' Workshop (1968). In 1977, he was the co-chair of North America's Mid-west Zone of FESTAC '77. In this capacity, he helped to realize the dreams of many African American artists and scholars in facilitating their first trip to Africa (Lagos, Nigeria). ¶ Madhubuti is an award-winning poet and a recipient of the National Endowment for the Arts and National Endowment for the Humanities fellowships, the American Book Award, Illinois Arts Council Award, Studs Terkel Humanities Service Award, and other honors. In 1985, he was the only American poet chosen to represent the United States at the International Valmiki World Poetry Festival in New Delhi, India. In 2006, he was awarded the Literary Legacy Award from the National Black Writers Conference at Medgar Evers College for creating and supporting Black literature and for building Black literary institutions. Madhubuti was named a "Chicagoan of the Year" in 2007 by *Chicago* magazine and in 2008 was honored with a Lifetime Achievement Award from Art Sanctuary of Philadelphia. ¶ In 2009, he was named one of the "Ebony Power 150: Most Influential Blacks in America" for education. In 2010, he was presented with the President's Pace Award from the American Association of Blacks in Higher Education and the Ninth Annual Hurston/Wright Legacy Award in poetry for his book *LibeNarratives.* At the 2013 Bridge Cross Jubilee, he was inducted into the Hall of Resistance at the Ancient Africa, Enslavement & Civil War Museum in Selma, Alabama. In 2014, he was inducted into the Arkansas Black Hall of Fame (along with President Bill Clinton) and honored as the Arkansas Black Hall of Fame Distinguished Laureate presenter. The same year, he received the Barnes & Noble Writers for Writers Award, presented by *Poets & Writers* magazine and he and his wife, Dr. Carol D. Lee, were presented with the Du Sable Museum's Dogon Award at the "Night of 100 Stars" celebration. In 2015, Madhubuti became the first poet to receive a Lifetime Achievement Award at the Juneteenth Book Festival Symposium at the Library of Congress and was honored with a Lifetime Achievement Award for Leadership in the Fine Arts from the Congressional Black Caucus Foundation and a Fuller Award from the Chicago Literary Hall of Fame. Recognitions in 2017 include the Go On Girl! Book Club Literary Legend Award, the Sutton E. Griggs Tulisoma Lifetime Achievement Award, and the North Star Award from the Hurston/Wright Foundation, the foundation's highest honor for career accomplishment and inspiration to the writing community, received along with Dr. Carla Hayden, the first woman and first African American to lead the Library of Congress, and the late Congressman John Lewis. Madhubuti received the Illinois Human Rights Commission's Activism in the Arts Award

during the 2019 celebration of Juneteenth and, in 2020, the Nicolás Cristóbal Guillén Batista Lifetime Achievement Award from the Caribbean Philosophical Association. ¶ Madhubuti earned his MFA from the University of Iowa and received his third Doctor of Humane Letters from Spelman College in 2006. His distinguished teaching career includes faculty positions at Columbia College of Chicago (1967-68), Cornell University (1968-69), University of Illinois at Chicago (1969-70), Howard University (1970-78), Morgan State University (1973-74), and University of Iowa (1982-85). He is the former University Distinguished Professor and Professor of English at Chicago State University, where he founded the Gwendolyn Brooks Center for Creative Writing and Black Literature inaugurated the annual Gwendolyn Brooks Writers Conference (1989-2010), and was the founding director of the Master of Fine Arts in Creative Writing Program. In 2010-11, Madhubuti served as the last Ida B. Wells-Barnett Distinguished University Professor at DePaul University. His latest book of poetry is *Taught by Women: Poems as Resistance Language, New and Selected* (September 2020). He is currently completing the second volume of his autobiography, *New Music Screaming in the Sun.*

Faheem Majeed

Faheem Majeed is an artist, educator, curator, and community facilitator. He blends his unique experience as an artist, nonprofit administrator, and curator to create works that focus on institutional critique and exhibitions that leverage collaboration to engage his immediate and broader community, in meaningful dialogue. From 2005 to 2011, Majeed served as executive director and curator for the South Side Community Art Center. A recipient of the Joan Mitchell Painters and Sculptors Grant (2015) and a Harpo Foundation Awardee (2016), Majeed had his first solo museum exhibition at the MCA Chicago in 2015. From 2013 to 2014, he served as the associate director and faculty of UIC's School of Art and Art History. While at UIC, he taught classes in museum collections and socially engaged art practices. Currently, he is working on a large-scale collaborative project entitled the Floating Museum, which blends creative place-making, activism, and exhibition design to make a platform for conversations and community engagement.

Naeem Mohaiemen

Naeem Mohaiemen combines films, installations, and essays to research failed Left Utopias, incomplete Decolonizations, and tragic misrecognition of allies—framed by the movements of Third World Internationalism and World Socialism. Family history as a canvas for thinking through how borders (arbitrary, sinister) and passports (precious, missing) commingle with, and against, class privilege, is a through line in his work. The film

archive mined for his projects—fabricated and reanimated—is the site of promise and disappointment. His essays include "Fear of a Muslim Planet: Islamic roots of hip-hop" (*Sound Unbound,* 2004), "Traitors, a Mutable Lexicon" (*e-flux,* 2015), "Anabasis of the Japanese Red Army" (*e-flux,* 2015), and "The Loneliness of the Long Distance Campaign" (*Assuming Boycott*/Walker Art Center, 2017). He is a Mellon Postdoctoral Fellow in Anthropology at Columbia University, researching left histories outside state patronage. In New York, he was a member of South Asian Magazine for Action & Reflection (1995–99), 3rd i South Asian Film (2000–04), and Visible Collective (2002–07), and in Dhaka, Bangladesh, of Drishtipat (2001–11) and Alal O Dulal (2011–16). Mohaiemen co-edited *System Error: War Is a Force That Gives Us Meaning* (2007) and *Solidarity Must Be Defended* (2020).

Karega Kofi Moyo

Karega Kofi Moyo was born in Chicago to Arnold C. Saunders and Lydia Louise, who provided a rich experiential environment for the development of who he is today. Following in their large footsteps, he used his talents to establish a career in photojournalism via freelance work and a 13-year residency at the University of Chicago's Public Information Office. He has been noted for his assistance in the early development of Third World Press and the Institute of Positive Education in the 1970s. Photography, graphics, layout, design, and book publishing were areas in which he worked both in management and volunteer positions. ¶ Greatly impacted by *The Family of Man* photo exhibition at Expo 67 in Montreal, Canada, he set on a course of discovery of the works of Gordon Parks, James Van Der Zee, Roy DeCarava, and other contributors to the documentation of Black experience. ¶ Freelance assignments for *Ebony, The Chicago Defender,* and other major publishing houses led him to the 1977 Second World Black and African Festival of Arts and Culture (FESTAC '77). There, two of his photos won a coveted place in the FESTAC exhibit, archived today at the Centre for Black and African Arts and Civilization (CBAAC) in Nigeria, West Africa. Soon after, a photo assignment in West Africa resulted in an eventual move and seven-year residency. He launched Resource Associates, a cultural business collective, in Monrovia, Liberia, but was forced to return to the United States due to political unrest in 1984. He incorporated Resource International Ltd. and cofounded Real Men Cook for Charity in 1990. In his iconic role as "the original Real Man," Karega, with Simon and Schuster, published *Real Men Cook: Rites, Rituals, and Recipes for Living* with a foreword by then-US Senator Barack Obama, extolling men of great accomplishments. ¶ He has received the Community Mental Health Council's Leadership Award, the *Chicago Tribune* "Good

Eating" Award, and the Turner Network "Trumpet" Award. Karega is a member of the Chicago Association of African American Photographers; Southern Foodways Alliance; The Penn Center, St. Helena Island, SC; Slow Foods USA; and USCG Auxiliary as a Merchant Marine captain. ¶ Karega is currently working on a project, the ZepiaStudio Collection, an archival record of 25 years of his work as photographer and a tribute to Kevani Zelpah Moyo.

Robert E. Paige

An artist and textile designer allied with the Black Arts Movement, Robert E. Paige trained at the School of the Art Institute of Chicago and worked at the architecture firm Skidmore, Owings & Merrill. He traveled to Italy and Western Africa to learn the history and manufactuing techniques of textiles and began producing scarves and drapings with the Fiorio Milano company to retail at department stores such as Carson Pirie Scott. Sears and Roebuck sold his Dakkabar collection nationwide.

Kamau Amu Patton

Kamau Amu Patton is an interdisciplinary artist and art educator. His work is an examination of history and culture through engagement with archives, documents, stories, and sites. Patton received his MFA from Stanford University in 2007 and his BA in sociology from the University of Pennsylvania. His work was shown as part of the Pacific Standard Time Performance and Public Art Festival and the *Machine Project Field Guide to L.A. Architecture*. Patton has completed projects in the area of soundscape studies through support provided by SUNY Buffalo, the Mellon Elemental Arts Initiative, and the Tang Teaching Museum. Patton developed a series of multidisciplinary performances as part of *Projects 107: Lone Wolf Recital Corps* at the Museum of Modern Art. His project *Tel_* was on view at the Tang Teaching Museum from 2017 to 2019.

Caroline Picard

Caroline Picard is the Executive Director, Editor, and Head Curator of the Green Lantern Press.

Jefferson Pinder

Jefferson Pinder's work provokes commentary about race and struggle. Focusing primarily on neon, found objects, and video, Pinder investigates identity through the most dynamic circumstances and materials. From uncanny video portraits associated with popular music to durational work that puts the Black body in motion, his work examines physical conditioning that reveals an emotional response. His work has been featured in numerous group and solo shows, including exhibitions at the Studio Museum in Harlem; the Wadsworth Atheneum Museum of Art in Hartford, CT; and Showroom Mama in Rotterdam, The Netherlands; the Phillips Collection and the National Portrait Gallery in Washington, DC. Pinder's work was featured in the 2016 Shanghai Biennale and at the Smithsonian National Museum of African American History and Culture. In 2016, Pinder was awarded a United States Artists Joyce Fellowship Award in the field of performance; in 2017, he was a John S. Guggenheim Fellow. Currently, Pinder is a professor of Sculpture and served as the Dean of Faculty at the School of the Art Institute of Chicago.

Cauleen Smith

Cauleen Smith is an interdisciplinary artist whose work reflects upon the everyday possibilities of the imagination. Operating in multiple materials and arenas, Smith roots her work firmly within the discourse of mid-twentieth-century experimental film. Drawing from structuralism, third world cinema, and science fiction, she makes things that deploy the tactics of activism in service of ecstatic social space and melancholy internal contemplation. Smith holds a BA in Creative Arts from San Francisco State University and an MFA from the UCLA School of Theater Film and Television. Smith's numerous awards include a Rockefeller Media Arts Award, Creative Capital Film/Video Award, Chicago 3Arts Grant, Chicago Expo Artadia Award, and the inaugural Ellsworth Kelly Award. Smith enjoys container gardening, likes cats, and collects disco balls, vinyl records, and books. She is an avid leisure and functional cyclist. She lives in Los Angeles and is faculty at California Institute of the Arts in the Art Program.

solYchaski

solYchaski are transfeminist scholar filmmakers focused on sound and visual sensation in pursuit of queering time at its intersections with indigeneity.

Sonnenzimmer

Sonnenzimmer is the collaborative practice of Nick Butcher and Nadine Nakanishi. Their work investigates and challenges the preconceived notions of the graphic arts. Their experimental studio was established in 2006 in Chicago. Together, they explore the physical and psychophysical nature of graphics through publishing, exhibitions, design, music, and performance. While they move through an array of media, their focus is on triangulating a deeper understanding of graphic expression at large.

Norman Teague

Norman Teague is a Chicago-based designer and educator who focuses on projects and pedagogy that address the complexity of urbanism and the culture of communities. Teague specializes in custom furniture design and designed objects that deliver a personal touch and/or function to

a specific user and unique aesthetic detail. His past projects have included consumer products, public sculpture, performances, and designed spaces. Teague prides himself on working within communities that offer ethical returns and human-centered exchanges. ¶ Teague holds an MFA in Designed Objects from the School of the Art Institute of Chicago and a BA in Industrial Design from Columbia College Chicago. He also partners with Fo Wilson in Blkhaus studio to work on collaborative projects such as Sounding Bronzeville, Connect Hyde Park, South Shore, and Back Alley Jazz in South Shore. Teague was awarded the Claire Rosen and Samuel Edes Foundation Prize for Emerging Artists in 2015 and is a creative collaborator in association with the exhibition design team of Ralph Applebaum & Associates (NY) and Chicago-based Civic Projects for the Obama Presidential Center.

Jan Tichy

Jan Tichy is a contemporary artist and professor at UIC School of Design working at the intersection of video, sculpture, architecture, and photography to create conceptual work that is socially and politically engaged. Born in Prague in 1974, Tichy studied art in Israel before earning his MFA from the School of the Art Institute of Chicago, where he is now an associate professor with the Departments of Photography and Art & Technology. Tichy has had solo exhibitions at the MCA Chicago, Tel Aviv Museum of Art, CCA Tel Aviv, and Chicago Cultural Center, among others. His works are included in the public collections of MoMA in New York and Israel Museum, among others. In 2011, he created *Project Cabrini Green*, a community-based art project that illuminated with spoken word the last high-rise building at the Cabrini-Green Housing Projects in Chicago during its month-long demolition. *Beyond Streaming: a sound mural for Flint* at the Broad Museum in Michigan in 2017 brought teens from Flint and Lansing to share their experience of the water crisis. In 2014, Tichy started to work on a long-term, NEA-supported, community project in Gary, IN—the *Heat Light Water* cultural platform.

Mechtild Widrich

Mechtild Widrich is an associate professor of Art History, Theory, and Criticism at the School of the Art Institute of Chicago. She researches at the intersection of contemporary art and architecture, with a focus on time-based and ephemeral practices, monuments, and global art geographies. She studied art and architectural history at the University of Vienna and the Massachusetts Institute of Technology in Cambridge (PhD, 2009). ¶ Her book *Performative Monuments: The Rematerialisation of Public Art* came out in 2014 with Manchester University Press. Mechtild has published in *Art Journal, the Journal of Architectural Historians* (JSAH), *Log, Grey Room, Texte zur Kunst, The Drama Review* (TDR), *Performance Art Journal* (PAJ), *Performance Research*, and *Thresholds*. She is co-editor of *Presence: A Conversation at Cabaret Voltaire* (Sternberg Press, 2016), *Participation in Art and Architecture* (I.B. Tauris, 2015), *Ugliness: The Non-Beautiful in Art and Architecture* (I.B. Tauris 2014), and the special issue of *Future Anterior* "Ex Situ: On Moving Monuments" (Winter 2018). Texts can be read on www.academia.edu.

Bernard Williams

Bernard Williams (MFA, Northwestern University) is a painter and sculptor based in Chicago. He has a long history creating outdoor murals around Chicago. He has also restored historic murals by artists such as William Walker, Calvin Jones, and Mitchell Caton. Williams also has a growing body of outdoor steel sculptures in Chicago and various other American cities. In 2015, he was awarded an artist grant for painting and sculpture from the Adolph and Esther Gottlieb Foundation in New York. In the fall of 2018, he exhibited paintings in the traveling group exhibition *AfriCOBRA 50* at Kavi Gupta Gallery. The artist also completed a 400-foot-long outdoor mural celebrating the life and athletic career of Walter "Major" Taylor.

GREEN LANTERN PRESS
thegreenlantern.org

EDITOR
Romi Crawford

PUBLISHER
Caroline Picard

PUBLICATION MANAGER
Fulla Abdul-Jabbar

EDITORIAL ASSISTANCE
claire arlen linn
OK Pedersen
Thomas Callahan
Willy Smart

COPYEDITING
Irma Nuñez
Lauren Weinberg

BOOK DESIGN
Sonnenzimmer

IMAGE CREDITS
Cover: Courtesy of Valerie Cassel Oliver, 2020
pp. 14–15: Courtesy of Images of Black
Chicago: The Robert Abbott Sengstacke
Photography Archive, University of Chicago
Visual Resources Center LUNA collection.
Copyright Myiti Sengstacke-Rice.

TYPEFACES
Alright Sans, Harriet, Sporting Grotesk,
Steinbeck, Value Serif, Worksans

PRINTER
Lowitz and Sons, Chicago

DISTRIBUTOR
University of Minnesota Press
111 Third Avenue South, Suite 290
Minneapolis, MN 55401-2520
www.upress.umn.edu

ISBN
978-0-9974165-9-6

EDITION
First edition of 1250

This project is supported in part by the Terra Foundation for American Art through the foundation's
initiative Art Design Chicago, exploring and elevating Chicago's rich art and design histories and
diverse creative communities. Additional support comes from the Field Foundation of Illinois, and the
Graham Foundation for Advanced Studies in the Fine Arts.

Graham
Foundation

8/5/21